MASSACHUSETTS CRANBERRY CULTURE

MASSACHUSETTS CRANBERRY CULTURE

A HISTORY FROM BOG TO TABLE

Robert S. Cox & Jacob Walker

AMERICAN PALATE

Published by American Palate
A Division of The History Press
Charleston, SC 29403
www.historypress.net

Copyright © 2012 by Robert S. Cox and Jacob Walker
All rights reserved

Cover photo by Jacob Walker.

First published 2012

Manufactured in the United States

ISBN 978.1.60949.513.8

Library of Congress CIP data applied for.

Notice: The information in this book is true and complete to the best of our knowledge. It is offered without guarantee on the part of the authors or The History Press. The authors and The History Press disclaim all liability in connection with the use of this book.

All rights reserved. No part of this book may be reproduced or transmitted in any form whatsoever without prior written permission from the publisher except in the case of brief quotations embodied in critical articles and reviews.

Contents

Introduction	7
1. Deep Time and Low-Hanging Fruit	9
2. Cranberries at the Table	18
3. From Vine to Factory	36
4. Working Cranberries	55
5. Cranberry Work	90
6. Fallout	112
Epilogue	139
Bibliography	141
About the Authors	143

Introduction

There are landscapes, and then there are landscapes. There are the juts and crags of the Grand Tetons, arête on arête in a Wyoming row, and the massifs of the Sangre de Cristos of southern Colorado, where dinosaurs nestle in billows of sand. The Great Plains of Nebraska make vanishing points vanish, and in the gypsum crusts of the Great Basin, the spent ashes of a celestial fire still heat the world white hot. There are landscapes on the scale of the imagination.

In such a world of giants, what then of the swamps and snags of Plymouth County and the flat, fetid bogs of Cape Cod? In a world where living awe springs native from the ground, where power and grandeur and the divine apprehension of geological time are fixed in rock and sky, what place is there for the cranberry heartland? Scoped narrow and mean, the land there rolls and rises in modest swells of sand, with barely an awe to be seen. It prefers scrub to forest, hillocks to hills, and the whole slips gently into ocean, not sky. But there is a strange beauty here unlike the West—the beauty of understatement, the beauty of inclusion. In the West, a visitor looks at land, walks on it or through it, but in the cranberry lands a visitor becomes part of a landscape on a human scale.

This, I think, is the soul of the cranberry.

Cranberry culture is more than the story of turning wild fruit into a cultivated crop; it is the story of how humans have been absorbed into a landscape, how geology, biology, history, agriculture, labor and industry have come together across the years and changed one another through contact. It is an environment of connection, a landscape of the broadest imagination.

1

Deep Time and Low-Hanging Fruit

William Denton believed that the history of the world could be read in a grain of sand. Literally. Starting with the everyday observation that light reflects off objects onto other objects, Denton theorized that the world could act like a giant all-seeing camera and the Earth's surface like a great sheet of photographic film. As events transpired, he argued, light was cast all around, reflecting and refracting, exposing the landscape wherever it came into contact. All that was required, he reasoned, was a suitable method for developing that film—along with patience, suffering patience—to enable us to witness firsthand every act, every scene and the life of every being that has ever been. Every grain of sand would become a perfect snapshot of the past, the images burned not just on the surface but deep within, "only waiting for a suitable application to reveal themselves to the inquiring gaze." How did humans evolve, one might ask, and what killed off the dinosaurs? Pick up a rock, Denton said; develop the image, and the results would be there to be seen as clear as day. How did a trilobite swim or glaciers flow or nations first emerge? The facts were written in stone and held there "with astonishing tenacity" for all time.

And here was Denton's singular contribution to geological science. Part longhaired poet and serial self-publisher, part radical reformer and Spiritualist, Denton refused to be shackled by the conventions of ordinary chemistry when seeking a method for developing these rocky pictures. Clairvoyance would light the way. With his wife, Elizabeth, and sister, Annie Cridge (both Spiritualist mediums), Denton spent months

communing with the natural world, psychically connecting with rocks and stones to reveal a grand history of volcanic eruptions, seismic tremors and upheavals in the lives of countless plants and animals. While other scientists labored to reconstruct the past through painstaking analysis of imperfect remains, Denton witnessed it all firsthand with photographic precision. He had discovered memory made perfect.

Let us admit it up front: the man was eccentric. Few geologists then or now accepted Denton's discoveries at face value, and fewer still adopted his methods. By few, I mean none. Yet as eccentric as he was, Denton got one thing right. Here in New England, in the heartland of cranberry culture and Denton's adopted home, the landscape is self-remembering. The gentle hills of New England, as the saying goes, have fond memories of once being mountains, mountains that were thrust up to Himalayan heights 400 million years ago when North America collided with Africa and Europe. The hills still recall the sublime violence of those events in layer upon layer of twisted rock folded up like ribbon candy, and they commemorate the orogenic consequences in miles-thick sediments shed from the highlands onto mudflats and vast plains where dinosaurs roamed and the flowering plants first evolved and where humans came in colors. The long, straight valley of the Connecticut River is a memorial too, the northernmost of the rift valleys that once gashed the continent from Virginia to Vermont. An aulacogen, geologists call it, where the crust thinned as the continents pulled apart 200 million years ago and where the new continents almost, but never quite, split in two. All it takes is a suitable method to read the land, as Denton might have said, and patience, steady patience.

New England remembers itself in herds of drumlins and eskers, kettles and kames that wander its map and in a landscape sculpted from mountainous remains by years of glacial action. We may not be eyewitnesses to the great North American ice sheet like Denton, but we, too, can read evidence in the land to see tongues of ice flowing far out onto the continental shelf, leaving behind the quirks and coves that spell our shore. Nantucket, Martha's Vineyard and Long Island are little more than heaps of debris bulldozed out at the glacial front, the detritus of dirty ice. Buzzard's Bay and the famous flexing arm of Cape Cod are the daughters of a mile-thick sheet of ice carving and plucking and scouring and eroding the rock beneath. The Cape is all hummocks and swales, not peaks and valleys, and everywhere there is sand and marsh and swamp.

Deep Time and Low-Hanging Fruit

Since the glaciers at last receded and unburdened New England of their enormous weight, the land has rebounded upward, leaving earthquakes behind to toll in their memory. There are memorials everywhere to our days at the glacial front, from the fossil mastodon that the arch-Puritan Cotton Mather once described as a giant drowned in the Great Flood to the supernumerary rocks that dent our plows and the lonely reptiles and amphibians that call our region home. That New England ekes by with barely fourteen native species of snakes, ten frogs and no lizards at all speaks volumes about how our cold-blooded cousins remember the ice age—a hard and shivering time—and hints at how long it takes to slither back home from the South, where they sought refuge and solace.

Famously, of course, New Englanders have memories as long as the landscape. Twenty years in a New England village is barely an introduction, not enough to forge a native, and the woods surrounding our villages are alive with memorials to natives past. In corners overgrown and abandoned, the past can be traced through odd pathways overcome by new green growth and by the sudden appearance of a plot of straying headstones, carved from slates and marbles that were themselves the product of millions of years of mountain building. Nearly everywhere, fieldstone walls etch spines on the rolling hills—glacial wanderers as much as our snakes. They are reminders that today's thickets of trees were once working fields and pastures separating gentle sheep on the one side from the wild on the other, our modern woods a distant echo of another time, primeval and foreign but so alike. At sea or on shore, in the forest, soil and rocks, New England remembers the story of its past in its mortal remains, each generation past laying claim on the next.

Cranberry Memories

When the Pilgrims first set foot on Cape Cod, even before they saw Plymouth Rock, they may well have stepped on the American cranberry. That they noticed seems doubtful. For all its tasty charms, the cranberry is hardly the sort to attract attention. It is nothing but "a small trayling Plant," a humble vine "that grows in Salt Marshes that are over-grown with Moss," according to the colonial promoter John Josselyn in 1672, neither showy nor self-promoting. "The tender Branches (which are reddish)," Josselyn wrote,

run out in great length, lying flat on the ground, where at distances, they take Root, over-spreading sometimes half a score Acres, sometimes in small patches of about a Rood or the like; the Leaves are like Box, but greener, thick and glistering; the Blossoms are very like the Flowers of our English Night Shade, *after which succeed the Berries, hanging by long small foot stalks, no bigger than a hair; at first they are of a pale yellow Colour, afterwards red, and as big as a Cherry; some perfectly round, others Oval, all of them hollow, of a sower astringent taste; they are ripe in* August *and* September.

This is no extrovert. Even the first historian of the American cranberry and one of its greatest promoters, Benjamin Eastwood, called the wild cranberry a "simple, insignificant-looking plant," a "stunted, barren thing" with fruit bearing a flavor that he fumbled to call "austere." Barely rising a few inches above the boggy surface, these "puny progenitors" of today's puny vines got that way through a long history of evolutionary adaptation, and like Denton's stones, they remember every twist and turn.

The biologist Leigh Van Valen once likened the evolutionary process to the chess game played by the Red Queen in *Alice in Wonderland*, in which the players are always running just to stay in place. Competitors and the environment are dynamic things, highly so, always convulsing and shifting, always requiring change in response, merely to stay alive. There is no rest in this Red Queen world, no calm and no perfection. All is flux and turmoil. Fluffy bunnies never have steel talons, however much they would help them survive; instead, evolutionary change builds on what a species brings to the table, trading off between competing demands for survival, adjusting, adapting and recycling just enough to survive for another generation. Imperfection becomes the very soul of evolution, though over time, for a time, organisms like the cranberry may hone in on a niche where plant and animal, land and climate, are wondrously attuned, connected to one another at the deepest level of life itself.

Known scientifically as *Vaccinium macrocarpon*, the American cranberry is a member of the large and diverse family of heath plants, the Ericaceae, and a close relative of blueberries and huckleberries, as well as an improbable assortment of bilberries, whortleberries, farkleberries, moorberies, cowberries, foxberries, partridgeberries and dangleberries. In fact, the American cranberry is only one of several plants to earn the name cranberry, all red-fruited members of the genus *Vaccinium*.

Deep Time and Low-Hanging Fruit

In New England alone, one finds the European or small cranberry (*Vaccinium oxycoccus*) growing wild, as well as the lingonberry or mountain cranberry (*Vaccinium vitis-idaea*). European colonists soon discovered that the American cranberry could be found all over Massachusetts Bay and Plymouth Colonies, in the peatlands of Cape Cod, at Gay Head on Martha's Vineyard, in the marshy meadows that track the colonies' river systems and especially in the windswept sandy soils near the shore. Then and now, however, it ranged even more widely. From the Canadian Maritimes and Labrador in the north, the wild American cranberry ranges westward to Wisconsin and Minnesota and all the way down to West Virginia and North Carolina, where it clings to life in small populations at higher (and cooler) elevations, left stranded there, perhaps, when the climate began warming at the end of the last ice age.

The European or small cranberry is more adventurous still, having a higher tolerance for cold than its larger cousin. A true citizen of the world, or least the part of it that encompasses temperate, subarctic and alpine habitats, the European cranberry is known by as many common names in as many cultures and languages as inhabit its vast domain. The mountain cranberry tolerates still colder and drier regions, preferring rocky banks to the wetlands favored by Americans. All three cranberries (and there are others) have been gathered wild for centuries wherever they grew, and all are eaten gladly. The small cranberry may be smaller and less tasty than the American, at least according to some berryphiles, but it could be found on British and European tables long before the Puritans saw our shores, and for just as long the lingonberry has been prized in Russia and Scandinavia for the tart kick it imparts. Rumors that a Swedish retailer has asked for the lingonberry to be reclassified as *Vaccinium vitis-ikea* appear to be unfounded. At the northern reaches of its distribution, populations of the American cranberry may converge on the southern reaches of the small cranberry, and where the two converge, hybrids follow.

Well attuned to a Spartan life; the American cranberry is just the sort of fruit to make a stingy New Englander proud, making do with little and making little show of it. The plant itself is a long, trailing vine composed of two basic parts: the runners (the vines that hug the ground) and the upright shoots (called, appropriately, uprights; these are covered with dark green glossy foliage and with flowers and berries in season). When left to their own devices, the runners might be as long as six feet

and create a dense, seemingly impenetrable mat over the ground, but the uprights scrape the sky at only a few inches. Even at that minimal height, they color the ground to match the time of year. As they enter their dormancy during the late fall and winter, the leaves acquire a ruddy burgundy to match the mood, greening up in the warmth of early spring and the lengthening days. When the blossoms arrive in June, the fields take on shades of whitish pink, with the fruits adding sparks of brilliant reds, yellow-whites and bruise-blacks a few weeks later.

Large, uncultivated stands of cranberry are now relatively rare in New England, but patches can still be found in "dune bogs" on Cape Cod, where the vines nestle in the low areas between coastal sand dunes. Although capable of growing in a wide range of soils, the American cranberry is associated in most people's minds with one particular environment: bogs (or what are commonly called bogs). In the cranberry heartland of Barnstable and Plymouth Counties, Massachusetts, the receding glaciers flushed out a steady stream of organic debris that settled into the countless kettles and dips in the land and in poorly drained pockets underlain by nearly impermeable layers of silt and clay. Stagnant and moldering, the organic matter decayed slowly, devouring oxygen from the water column and eventually forming deposits of peat, often considered the ideal subfloor for a cranberry patch.

As much as peat bogs make for a cranberry heaven, bogs are hardly for everyone; in fact, they are not for the casual wanderer at all and certainly not for the weak of will. By definition bogs are wet—often very wet—the water table sitting at or very near the surface. The water itself is often depleted of oxygen, low in nutrients and high in a natural acidity—not promising conditions for the well being of most plants or animals. Making matters worse for any plant with aspirations to height, the bog's surface can be soft and unstable, creating a weak and unpredictable base, and of course plants cannot easily move once they have settled in—other than to fall down, that is. It takes a specialist to call a bog home.

The plants that set up in bogs simply have to adapt. Some, like bladderworts, do well thanks to air-filled spaces that buoy them up in the water, while others, like water lilies or pondweeds, have long, thin roots that snake down to the peat beneath. The surfeit of water—murky, slow-moving water, starved of oxygen—can make it difficult for plant roots to breathe, so some sedges handle the challenge by growing roots every year in only the shallow topmost layer of muck, where a little oxygen can be

found, while the northern white cedar, speckled alder and various willows grow special roots above the waters' rise. To make up for the poverty of nutrients, pitcher plants and their ilk famously resort to carnivory—a vegan's true revenge—trapping insects and other small, unfortunate animals to extract the nutrients that the water does not provide.

A handful of tree species make their home under boggy conditions, including the red maple, silver maple and northern white cedar, their shallow roots spreading over a wide area in search of a firm foundation. Shallow roots may seem counterproductive, since they mean the trees can easily be blown over, but these species work around the problem by cooperating, growing in dense groves where roots become so entangled that even heavy winds and driving rain will not bring them all down. There is safety in numbers when the winds blow. As many New Englanders can attest, when a red maple does fall, it reveals its true determination to live by sprouting back up again, placing the maple somewhere on the scale between heroically persistent and annoyingly stubborn. Some trees, like the black spruce and tamarack, simply set their sights lower, letting their taller neighbors take the brunt of the wind, but even these species have special adaptations to handle the challenges of the bog. Black spruce, for example, have roots shaped like I-beams, giving them unusual strength for their size.

All over the peatlands, low and unassuming plants and shrubs predominate. An old joke asks: what should you do if you get lost in a peatland? Stand up. Shrubs with homely names and hardy dispositions—like Labrador tea, sheep laurel, bog laurel, bog rosemary, leatherleaf, creeping snowberry and cranberries—all stay low to the ground, away from the worst of the wind, and many have thick and leathery leaves that resist drying out and are tough enough to fend off damaging ice, not to mention damaging herbivores. Their roots and rhizomes may grow so thickly together that they form a dense, spongy mat that may inadvertently prevent moose and deer, and even the occasional human being, from sinking into the wet mess beneath. This unintended consequence is our felicity.

Even at the finest level, cranberries are well adapted to thrive in wet, low-nutrient conditions. The underside of cranberry leaves are covered with a huge number of "stomata," special structures that assist the plant in regulating its most basic life functions by opening or closing pores depending on environmental conditions. In the light of day, stomata

open wide to allow for the exchange of carbon dioxide, closing down in darkness to prevent excessive water loss. Cranberries check in with an average of 632 stomata per square millimeter of leaf—exceptionally high, even for a plant that lives under very wet conditions—but the guard cells of these stomata are no paragons of efficiency, adjusting poorly to changes in light, temperature and humidity. Imperfection is the soul of evolution.

But it can be said that cranberries do not go it alone; they are a cooperative fruit, at least in their wild state, interacting with other plants and animals around them in intimate and intricate ways. While many plants have root hairs, fine hair-like extensions that help them absorb nutrients efficiently, cranberries do not. Instead, they absorb nutrients from the soil by working in a mutually beneficial partnership with a naturally occurring fungus, *Phoma radicis*, which permeates the roots, stems and even the seeds. This symbiotic arrangement, a ménage a deux, helps cranberries meet their nutritional demands while benefiting the fungus by providing a suitable place for it to grow. There is less-than-certain evidence that the more fungal mycelia there are in cranberry tissues, the more vigorously the vines grow, but in any event, the cooperative arrangement allows both partners to cope with the challenges of a boggy existence.

Cooperation is not just for roots; cranberries cooperate right across the species barrier. Like any of us who have ever considered the wonders of bees, cranberry growers have long assumed that their plants were pollinated by insects, especially bees, that get plastered with sticky pollen when they come to feed on one flower, shedding it on the next flower when they continue on their botanical rounds. But cranberries are never quite so easy. Like a number of other plants, they are known to be potentially self-fertilizing, meaning that a flower can be fertilized by its own pollen. On a lonely meadow where dates are scarce on a warm spring night, the apparent convenience of this arrangement soon dawned on growers.

Whatever set off the skein of speculation about self-fertilization, it was two research scientists, Roberts and Stuckmeyer, who most elegantly framed the supposed problem of cranberry pollination. In 1942, Roberts and Stuckmeyer hypothesized that the necks of cranberry flowers were too narrow for fat American bees to reach the stigmatic surface and promote pollination. There was none of this elegant flitting from flower to flower, cross-fertilizing as they go. Instead, they surmised, bees must

bumble, sticking their big heads into the flower and clumsily knocking pollen loose from the stamen, where it falls down the narrow flower neck onto the stigmatic surface below. Their imitation of a bee in a china shop leaves flowers to take up the rest of the work on their own through self-fertilization. And in case a critic wanted to propose that maybe pollen was blown from flower to flower, Robert and Stuckmeyer shot that down, too. To them, the pollen appeared too sticky and heavy to take to the air. So with too fat bees and too thin air, it seemed that the only reliable way to ensure a bumper crop for this poor, lowly plant was to do what bees do, only better: apply some hefty agitation to the flowers, knock the pollen loose from the stamens and let the plants do as nature intended.

But the scientists seem to have underestimated their insects. To assess whether bees really mattered on bogs as anything other than battering rams, Farrar and Bain conducted a series of experiments in 1946, when they set out a string of insect-proof cages within which they artificially agitated flowers, while leaving the rest of the bog *au naturel*. At the end of the season, they compared the number of berries formed in caged-off versus open plots, and the results were unequivocal: bees are indeed vital, and agitation alone simply does not work well enough to support commercial cranberrying. Even when thoroughly agitated, bee-free plants yielded an average of only 15 berries per square foot versus 90 to 152 berries per foot for those pollinated by insects.

The bog is a world of connection, uniting past with present and near with far. There, fungi and insects are tied to a deep history of continental ice sheets and the grand sweep of orogenic innovation. The rise of the cranberry in American culture reveals how much our present bears traces of our past, how a world of human making and natural production speaks in a conversation of eons.

2

Cranberries at the Table

[Cranberry sauce] *is eaten with almost every species of roasted meat, particularly the white meats, turkies, partridges, &c. some even eat it with boiled fish, and I knew one person, otherwise a very worthy man, who eats it with lobsters, for supper!*
—*William Tudor,* Miscellanies *(1820)*

In colonial New England, codfish made fortunes while cranberries made sauce. William Tudor might be right that the combination of the two on a single plate could be alarming, but taken together or separate, both became much-loved staples of our regional cuisine almost as soon as there was a regional cuisine to talk about, and both were consumed and exported in great quantities. A tart departure from the often austere Puritan diet—where salt was spice and boiling preferred—cranberries became a prized enhancement to almost any main course and a much-anticipated ending to any meal. Although it would take nearly a century for the renowned Codfish Aristocracy of the northern colonies to solidify and create the stable basis for a political and economic elite, and while it took a century more for Cranberry Kings to be crowned, colonial New Englanders quickly discovered the delights of their native fruit and adopted it as their own.

The esteem in which the Puritan settlers held the cranberry is fairly easy to gauge, but the cranberry is not forthcoming about everything. For linguists, who occasionally worry about such things, even the word itself once seemed mysterious. The great scholar of language Leonard Bloomfield once referred to the word "cranberry" as a rare example of

a compound in which one part does not exist independently outside the compound. While blueberry or cowberry, for instance, yield the perfectly sensible words "blue" and "cow" to go with "berry," Bloomfield scratched his head over "cran." Had he read his William Tudor, he might have had one answer: New Englanders "vulgarly" called the fruit cramberries, Tudor wrote, "from the voracious manner in which they eat it."

But linguists abhor nonsense, and it took another theorist, John R. Krueger, to ride to the rescue of the crans of the world and propose that the mysterious syllable was derived from the perfectly sensible word "crane." As Krueger suggested, a little linguistic alchemy could have transmogrified the long "ay" of crane into a short "ae"—think of crane pronounced by a feckless midwestern teenager. He did not guess alone. Many historians have argued that the name originated because cranberries grow where cranes reside, and some have added, with only a touch of poetical license, that when seen from a certain angle, the delicate cranberry flower resembles the bird's pointy beak and long, graceful neck. The scrupulous editors of the *Oxford English Dictionary* speculated that cran came not from a misdirected twang but "from some Low German source," such as the word *Krônbere*. In the *OED*'s scenario, the word was adopted in North America and, with the first shipments of American cranberries, spread back to England, where the cranberry was "entirely unknown" to English herbalists of the sixteenth and seventeenth centuries. *Krônbere* does, in fact, mean crane-berry, and so to Bloomfield's relief, our crans have been salvaged.

The earliest descriptions of the cranberry by American colonists offer little to assist the curious etymologist. In 1655, the agriculturist Samuel Hartlib wrote that the true natives of New England, the Indians, referred to the fruit as "craberries" (though perhaps his typesetter was skimping on the "n"), while the English colonists preferred to call them bearberries, "because it is thought the Bears eat them in winter," or sometimes barberries (another fruit entirely) "by reason of their fine acid taste like Barberries." The colonial promoter John Josselyn agreed that "Bears use much to feed upon them," and he too used both terms in his widely known book, *New-England's Rarities Discovered* (1672). It is odd, though, that neither Josselyn nor Hartlib recognized that the cranberry encountered in New England (*Vaccinium macrocarpon*) was very much like certain berries back home—tart little fruits that other Puritan settlers may already have known. This is where the Puritans' history

of migration and the cranberry come together to add a spark on our linguistic quest for fire.

More than twenty years before the Puritan settlement of New England, one of the great botanical books of Elizabethan England, John Gerard's *Herball, or Generall Historie of Plantes* (1597), included a familiar description of an English berry known by the scientific name *Vaccinia palustria* and by the common name "Marrish Whortles, or Fen berries"—the plant now recognized as the small or European cranberry (*Vaccinium oxycoccus*). Gerard's description of the plant could just as easily apply to its Massachusetts cousins:

> *The Marrish Whortle berries growe upon the bogs, marrish, or Moorish groundes, creeping thereupon like unto wilde Time, having many small limmer and tender stalkes, laide almost flat upon the grounde, beset with small narrow leaves, fashioned almost like the leaves of Thyme, but lesser, among which come foorth little berries, like unto the common blacke Whortleberrie in shape, but somewhat longer; sometimes all red; and sometimes spotted or speckled with red spots, of a deeper colour; in taste rough and astringent.*

According to Gerard, the vines "grow upon bogs and such like waterish and Fennie places, especially in Cheshire and Staffordshire, where I have found it in great plentie," and they ripen about the end of July and August, slightly earlier than the bear-loved American variety. Marshwhorts and fenberries—which sound like they belong in a children's breakfast cereal—also went by another name in the English counties. Buried in a supplement to an appendix of common synonyms for the plants at the end of the *Herball*, Gerard records that the marshwhort was also called "Croneberry," remarkably like the Low German—or Dutch—word cited in the *Oxford English Dictionary*.

To understand the significance of this minor detail, we should note that Gerard was not an entirely original writer, and his borrowings take us on an interesting journey. A barber-surgeon rather than a high-toned botanist, Gerard borrowed liberally from a translation of the *Nievve Herball, or Historie of Plantes* (1578) written by the great Flemish botanist Rembert Dodoens, who found both red and black varieties of the marshberry growing in "certayne woods of Brabant," a duchy straddling the Dutch-Belgian border, "and Englande." According to Dodoens, the

"blacke are very common and are founde in many places," but the red are dayntie and founde but in few places." More to the point, he noted that in the Low Countries, these plants had aliases galore, including Heydelbeeren, Drumperbeeren, Bruchbeeren in High German and Crakebesien, Postelbesien or Hauerbesien in Low German. Admittedly "croneberry" does not appear on his list—not until it could be removed from Gerard's appendix—but finding so many names in such a small country hints at how popular the berry must have been.

Although it cannot be shown definitively, it is at least possible that the Puritans learned of the (European) cranberry during their years of exile in the Netherlands, carried the term with them to the New World and applied it to the larger, but broadly similar, variety they discovered there. Meanwhile, the word was apparently introduced into England, possibly by Gerard himself. Whether any of the New England Puritans knew the berry while in England is less clear, but possible, even though the majority of Puritan emigrants came from the eastern counties surrounding Essex rather than the western Cheshire and Shropshire, where Gerard found the berries in such abundance. The word "cranberry" itself, though, seems permanently wedded to the Puritan experiment in New England, tracking the history of their migration and telling the story of their peregrinations from their first exile to their final home and, as we will see, beyond.

Perhaps it is too obvious to require saying, but the berries were already well known in America, well known by the native inhabitants, and historians have sometimes claimed that the native New Englanders introduced the invading New Englanders to their charms. Throughout their wide geographic range, all of the cranberries—the large American cranberry, small European cranberry and mountain cranberry—were prized by the indigenous peoples of North America. The Montagnais-Naskapi Indians in eastern Canada relished cranberries in the late fall and winter and even included them in their folklore. The anthropologist Frank Speck recorded a story in the 1920s in which two cranberries were featured as hunting companions who had built a wigwam by the shore of a lake, facing the water where moose were known to swim. One fall day, when both were ripe, fat and juicy, the berries were waiting in their wigwam for their prey when they heard a moose splashing by in the water. The hunt was on. At once, both jumped up, grabbed their weapons and bolted for the door, but being so fat, they got jammed in the opening, side

by juicy side, leaving the moose to saunter on his merry way. If there's a moral to the story, it is one shared with nearly every movie made by the Three Stooges.

Among Native Americans, cranberries were important as a medicine, food additive, dyestuff and food in their own right. Called *a'ni-bimin* (bitter berry) by the Chippewa and *atoqua* by the Algonquin of Wisconsin, cranberries of various kinds were traded widely on the Northwest Pacific Coast and far into the interior, where they were consumed fresh, preserved in water or mixed with the grease of the eulachon (candlefish). During the fall months, cranberries played a sort of diplomatic role for the Halq'emeylem of British Columbia, who allowed other tribes on the Fraser River access to their territories to collect cranberries (the small or European kind), and cranberries are recorded among the Gitksan (Tsimshian), Wet'sewet'en (Athapaskan) and Kwakwaka'wakw, who ate them with hazelnuts, black huckleberries and thimbleberries.

All of the Algonquin tribes of southern New England, where the American cranberry thrived, were skilled agriculturists, living more or less permanently close to their fields of corn, squash and beans, and skilled at preserving foods for later use. After the *Mayflower* moored off Cape Cod in November 1620, a scouting party of Pilgrims went ashore, according to Edward Winslow, and discovered right away how ingenious the Massachusett Indians were in storing their harvest in large quantities:

> There was also a heap of sand…newly done, we might see how they had paddled it with their hands—which we digged up, and in it we found a little old basket, full of fair Indian corn; and digged further, and found a fine great new basket, full of very fair corn of this year, with some six and thirty goodly ears of corn, some yellow, and some red, and others mixed with blue…which was a very goodly sight. The basket was round, and narrow at the top. It held about three or four bushels, which was as much as two of us could lift up from the ground, and was very handsomely and cunningly made.

Corn was only one of many foods preserved for year-round consumption. The explorers also discovered a "bottle of oil," a bag of beans, parched acorns, chestnuts and a range of other things preserved by smoking or by drying in the sun or by the fire, though apparently not by salting or brining (methods preferred by the English). On March 22,

Cranberries at the Table

1621, the Wampanoag sachem Massasoit sent the Pilgrims "some red herring, newly taken and dried, but not salted," and the Puritan leader Daniel Gookin mentions encountering dried "shads, eels, alewives, or a kind of herring," to which Josselyn added dried lobsters, oysters and moose tongue, a specialty reserved for only the elite. Blueberries and huckleberries were dried and "preserved all the yeare," according to Roger Williams (the Puritan exile and founder of Rhode Island), and it is possible that some other fruits were also dried, including strawberries, raspberries, blackberries, currants, plums, haws and grapes.

Amongst all these berries, the cranberry stands out as providing a versatile, flavorful and nutritious supplement to the Indian staples of maize, squash and beans and as an enhancement to a changing plate of fish and shellfish, game, nuts, berries and vegetables gathered from this fertile region. The Narragansetts called the cranberry *sasémineash*, according to William, and they pulverized the dried berries to mix with sweet parched corn to make *sautauthig*, "a delicate dish…which is as sweet to them as plum or spice cake to the English." Pulverized berries were also an essential component of pemmican, a food made by pounding berries with fat and dried meat to create a portable, protein-rich food with a long shelf life. Just as important as their dietary role, the cranberry had significant medicinal value for New England's Indians, who considered it "excellent in conserve against Feavers" and who used it crushed in poultices to help wounds heal.

Yet as inventive as the Wampanoag and Narragansetts were, many of these uses as medicine or food, eaten fresh, dried, crushed or cooked, would have already been familiar to the English colonists prior to their arrival. Dodoens noted that in the Low Countries, the European cranberry was "eaten raw or stued with suger," but he made special note of its renowned medicinal qualities, which sound remarkably like the qualities ascribed to the berries by New England's Indians. Cranberry was effective for treating "hoate and burning fevers," he wrote, "and agaynst the heate of the stomacke, the inflammation of the liver, and interior partes." A juice extracted from the berries called "Apothecaries Rob" helped slake thirst during fevers and agues and was useful "against all evil inflammations or heate of blood, and the inward partes, lyke to the other whortes." Likewise, John Gerard believed that cranberries "take away the heate of burning agues, and also the drought, they quench the furious heate of choler, they stay vomiting, restore an appetite to meate,

which was lost by reason of cholericke and corrupt humors, and are good against the pestilent diseases." It was a miracle fruit that could easily be preserved for long periods when boiled thick with sugar, "which is good for all things that the barriers are, yea and far better."

Both tastier and larger, the American cranberry was quickly recognized as having virtues similar to its European cousins, and in 1655, Samuel Hartlib singled out what would become one of its most important uses, as a preventive against the sailor's scourge scurvy, though he could not help but add that cranberries were also "very pleasant in Tarts." If a sailor was not grateful enough for a fruit that helped to avoid a debilitating disease, he could at least enjoy the dessert. "I know not a more excellent and healthfuller fruit," Hartlib concluded. He so enjoyed the fruit, it seems, that in March 1660 he asked the colonial leader John Winthrop to send a "barrel of crane berries in New England" to his home in London. Winthrop, then in Hartford, Connecticut, wrote that he would gladly oblige in August, "if it be the season for them, and [they] can possibly be procured."

Whether intended for medicine or food, cranberries in these early years were prepared very simply, involving little more for the English than sweetening to cut their acidity and cooking—and often not even that for the Indians. John Josselyn wrote that Indians and English alike prepared them by "boyling them with Sugar for Sauce to eat with their Meate"—much like the Dutch did—adding that they made "a delicate Sauce, especially with Roast Mutton." Like Hartlib, Josselyn also singled out their starring role in tarts, "as with Goose Berries." With sugar flooding the New England colonies from the slave colonies in the West Indies by the mid-seventeenth century—cranberries heading south and sugar north—the fruit's popularity swelled, filling a niche that in English cooking was occupied by the gooseberry or barberry. As cranberries ripened in the early fall, colonists and Indians poured over the marshlands and bogs to gather the fruit in quantity, and they continued the harvest through the winter and into the spring when weather permitted, bringing a welcome and nutritious respite to a bland winter diet.

We know little about the process of harvesting, other than that it did not always go smoothly. In February 1651, Plymouth authorities discovered the body of nine-year-old John Slocombe, who had apparently gotten lost while collecting cranberries and was ravaged by wolves, "haveing the braine not wholly consumed." It is somehow fitting that John Eliot,

the most successful evangelist among New England's Indians, wove the cranberry into a little homily in 1647: "Why are Strawberries sweet and Cranberries sowre? There is no reason but the wonderful worke of God that made them so."

In reading these early accounts, it seems remarkable that long before the cranberry was cultivated and long before a commercial-scale industry arose, two tiny colonies on the edge of the European world could collect enough fruit that the cranberry became a familiar commodity all across the Atlantic. But so it was. Culled wild from the wetlands of Massachusetts Bay by local landholders, farmers and families during a brief few weeks, the berries were carried regionally and then internationally by an ambitious network of traders, finding an active market in the developing urban centers of Boston and (later) New York and Philadelphia and as far away as metropolitan London and the Caribbean. This was no minor side dish for the colonists; it was a defining product. In 1677, embroiled in a long-simmering dispute with London over minting their own coin, the pine tree shilling, the authorities in Massachusetts Bay tried to placate King Charles by sending a symbolic gift of the region's most noted, and notable, bounties: three thousand codfish, two hogsheads of "special good sampe" and ten barrels of cranberries.

In Boston, so close to the boggy heartland, cranberries quickly became the signaling side dish for public celebration. When planning a grand dinner to commemorate the installation of a new president in 1707, for instance, Harvard College purchased eight pence worth of cranberries (compared to six pence worth of onions), along with several varieties of meat (fowl, beef, turkey, mutton, tongue), seven pounds of bread, wine, beer and pies, as well as a few token vegetables such as cabbage, parsnips, turnips and eight pence worth of potatoes—then a great rarity in New England. Thirty years later, cranberries were still on the menu when a new president, Edward Holyoke, was installed. Although the menu had changed in some ways, adding the luxury of a rich dessert to end the meal, the feast still involved the indivisible duo of turkey and cranberry sauce.

And it was not just New Englanders who engaged in consumption and trade. By the first decade of the eighteenth century, William Penn's proprietary agent, James Logan, was shipping "country produce" from Pennsylvania all across the British Atlantic, including cranberries, bread, flour, Madeira wine, beer, apples and cheese. Interest in the fruit

extended to learned circles as well. One of the key figures in international botanical circles of his time, the Quaker savant Peter Collinson received casks of berries for well-placed friends in England as early as 1739, and in 1744 he sent a box of "Cranberries or Oxycoccus" from Pennsylvania to the great Swedish botanist Linnaeus. Perhaps most intriguingly, in July 1753, Collinson wrote to Philadelphia to thank his botanical friend and fellow Quaker John Bartram for the gift of a cranberry plant. It "thrives wonderfully," Collinson wrote, "and is in blossom," noting that it was much like the European cranberry "but much larger." Collinson may have been the first person to raise American cranberry vines successfully in a European garden.

Making such exchange possible is a simple fact that traders soon discovered: with minimal care, cranberries can be made to store well for long periods and to ship without spoilage. An English cookbook of the late eighteenth century, Ann Peckham's *The Complete English Cook; Or, Prudent Housewife* (1777), described a typical method for storage that shows how easy it could be to keep berries for later:

> *Take cramberries when they are near ripe, pick the decay'd ones and stalks out; take bottles that have been dried sometime in the sun, fill and cork them close down, and rosin the corks. You may keep bullace, currants, and damsins, the same way.*

Optimism ran high on the capacity of cranberries for long-term storage, with the understanding that this meant higher profits for berry gatherers and merchants. The author of the *English Art of Cookery* (1791), Richard Briggs, wrote that cranberries could be kept for two years by following simple directions: "Gather your cranberries on a fine dry day, and put them into dry bottles; cork them tight, and put them upright in a cool dry place." Even more optimistically, a contributor to the *Western Farmer and Gardener* in 1839 thought that the berries could be preserved for "several years" if kept dry and tightly corked. Not everyone shares the same idea of fresh.

As cranberries became more visible in a broad marketplace and common fare on tables all over the British Atlantic, recipes making use of them proliferated. Wherever their destination—a feast in Boston, a palace in London or a slave pen in Barbados—cranberries were touted as the go-to sauce for almost any meat, particularly turkey, duck, chicken, roast pork, beef and even the slightly crazy suggestion of bass, a suggestion

ironically made by the author of *The Cook Not Mad* (1831). Balancing natural tartness against the pure sweetness of sugar, the cranberry ruled as sauce and jelly, but cookbook authors soon extolled its virtues as a healthful drink and in tarts, pies and puddings.

Cranberry Sauce and Other Assorted Edibles

William Tudor was not joking when he joked that cranberry sauce could be found on every corner of every table in America. Along with the closely related jelly, cranberry sauce was, and is, enormously popular, and although there are several variations on how to make a good sauce, the basic approach has hardly changed in four centuries. By the time cookbooks began to become popular in the eighteenth century, and particularly after Americans began to write them in 1796, cranberry sauce was included often. Many early authors seem to have assumed that cooks would possess all the basic culinary skills and therefore offered scant detail on how to prepare something as simple as a cranberry sauce, often adding little to Dodoens's statement that they were eaten "stued with suger." These recipes are uncomplicated, not to mention unrelentingly sweet, with the weight of sugar often exceeding the weight of cranberries. In an early Scottish cookbook, *The Practice of Cookery, Pastry, and Confectionary* (1820, originally printed in 1791), Mrs. Frazer offered more detail than many authors on how to prepare a proper sauce:

> *Take a pound and a quarter of sugar to each pound of fruit; clarify it to blowing height; then put in the berries, and give them a boil for fifteen minutes. Put it through a sieve, and pot it up. Cranberry jelly is done the same way, only they require six minutes more boiling—The refuse of these will answer for jam.*

Even such simple guides, however, hint at subtle changes underfoot. Over the next several decades, there was a quiet shift away from sugary sauce to tarter. Esther Howland's *New England Economical Housekeeper* (1845) required even fewer words than Frazer to state that sugar should be proportional to the cranberries and not outweigh them, adding that the sugar should be added just before taking the sauce from the fire. At the end of the century, Fannie Farmer's *Boston Cooking-School Cookbook* (1896) suggested adding twice as many cups of cranberries as sugar, though of course sugar weighs more

than cranberries. The substitution of white sugar for brown during the middle of the nineteenth century—as the more highly refined variety became more widely available—may account for some of this change, but the substitution alone would have made a substantial difference in taste.

Not every cookbook author expected his or her audience to be masters of the culinary arts. Quite the opposite. Many cookbooks from the first half of the nineteenth century are intended to be instructional, not just in foodways, but also in instilling an awareness of solid middle-class values and expectations within the minds of the young and less refined. The most detailed instructions for making sauce came courtesy of Eliza Leslie, the doyenne of Philadelphia cookery and feminine ideals, and from the midwestern author and cookery entrepreneur Fanny Gillette. Leslie was one of a burgeoning number of women in the antebellum United States who helped define the ideal of middle-class womanhood, writing advice books on womanly comportment and literary finesse alongside her popular cookbooks. In 1840, always determined to instruct young women on their duties as homemakers, Leslie laid out with uncompromising clarity the subtle details a middle-class woman was expected to absorb. The care lavished on what was, after all, a side dish and the loving attention to detail are daily rehearsals for the care and devotion demanded of a woman in the middle-class American home. Leslie was as much about the good wife as good food:

> *The cranberries must be large and ripe. Wash them, and in six quarts of cranberries allow nine pounds of the best brown sugar. Take three quarts of the cranberries and put them into a stew-pan with a pint and a half of water. Cover the pan, and boil or stew them till they are all to pieces. Then squeeze the juice through a jelly-bag. Put the sugar into a preserving kettle, pour the cranberry juice over it and let it stand till it is all melted, stirring it up frequently. Then place the kettle over the fire, and pour in the remaining three quarts of whole cranberries. Let them boil till they are tender, clear, and of a bright colour, skimming them frequently. When done, put them warm in to jars with the syrup, which should be like a thick jelly.*

One of the most popular cookbooks of its time, Gillette's *White House Cook Book* (1887), was more basic, but just as precise, and is tied in with

the beginnings of standardized measurements in cooking and the rise of formal cooking schools:

> *One quart of cranberries, two cupfuls of sugar, and a pint of water. Wash the cranberries, then put them on the fire with the water, but in a covered sauce-pan. Let them simmer until each cranberry bursts open; then remove the cover of the sauce-pan, add the sugar and let them all boil for twenty minutes without the cover. The cranberries must never be stirred from the time they are placed on the fire. This is an unfailing recipe for a most delicious preparation of cranberries. Very fine with turkey and game.*

There were more adventurous types, too. In *Miss Parloa's New Cook Book* (1882), an editor at *Good Housekeeping* magazine and founder of two cooking schools, Maria Parloa, offered a rollicking recipe for barberry ketchup that mixed cranberries into a sauce that is a distant and possibly disreputable cousin of the sauce that William Tudor knew. As cranberries gradually edged barberries and gooseberries out of American recipes in the nineteenth century, Miss Parloa insisted that the fruits could coexist:

> *Three quarts of barberries, stewed and strained; four quarts of cranberries, one cupful of raisins, a large quince and four small onions, all stewed with a quart of water, and strained. Mix these ingredients with the barberries, and add half a cupful of vinegar, three-fourths of a cupful of salt, two cupfuls of sugar, one dessert-spoonful of ground clove and one of ground allspice, two table-spoonfuls of black pepper, two of celery seed, and one of ground mustard, one teaspoonful of cayenne, one of cinnamon and one of ginger, and a nutmeg. Let the whole boil one minute. If too thick, add vinegar or water. With the quantities given, about three quarts of ketchup can be made.*

Tarts and Pies

Lauded as a particular delicacy from at least the eighteenth century, and probably much earlier, the cranberry tart appeared in the first cookbook written by an American and published in America, Amelia Simmons's *American Cookery* (1796), and has returned dozens of times thereafter. The popular cookbook author Lydia Maria Child offered a typical antebellum

recipe for a cranberry tart in her *Frugal Housewife* (1830), and like Eliza Leslie, her recipe was partly aimed to inform the behavior of young women. A feminist, abolitionist and civil rights advocate, as well as a poet, novelist and advice merchant, Child's progressive politics spun her recipe in a different direction than Leslie's. Rather than focus on culinary prowess, Child considered cost-effectiveness and nutrition as a means of helping the poor to cope while still meeting the demands of one's role as a wife and mother. "Cranberry pies need very little spice," she wrote:

> *A little nutmeg, or cinnamon improves them. They need a great deal of sweetening. It is well to stew the sweetening with them; at least a part of it. It is easy to add if you find them too sour for your taste. When cranberries are strained, and added to about their own weight in sugar, they make very delicious tarts. No upper crust.*

Child also advised her frugal housewives that even children could be useful: "They can knit garters, suspenders, and stockings; they can make patchwork and braid straw; they can make mats for the table, and mats for the floor; they can weed the garden, and pick cranberries from the meadow, to be carried to market." It is almost as if children were laborsaving devices.

Cookbook authors differed on the key questions of what type of pastry dough to use and whether the fruit filling should be smooth or lumpy. A smooth, strained and very sweet jelly filled Simmons's tarts, while two generations later, Fanny Gillette could not quite decide. She provided not one but two recipes. Her "Newport style," she claimed, was "the true way of making a cranberry pie":

> *Take fine, sound, ripe cranberries, and with a sharp knife split each one until you have a heaping coffee-cupful; put them in a vegetable dish or basin; put over them one cup of white sugar, half a cup of water, a tablespoon full of sifted flour; stir it all together and put into your crust. Cover with an upper crust and bake slowly in a moderate oven.*

Gillette's second offering, a "cranberry tart pie," used puff pastry and involved strips of pastry laid across the top in place of a solid crust. While she advised that the cranberries be mashed smooth, she admitted that "some prefer them not mashed."

OTHER DESSERTS

Along with sauce and tarts, cranberries were popular in puddings of the boiled variety, and they made an appearance in quite a range of other desserts. One of the most important cookbook authors of her day, Catherine Beecher used cranberry frequently, including in a drink made of mashed cranberries (pouring boiling water over them, removing the solids, sweetening the whole and adding "a little wine if allowed"); cranberry tea (very similar except for the addition of a little nutmeg); and a "dish of snow" (grated coconut with currant or cranberry jelly). But Beecher was one of many authors who featured a recipe for boiled cranberry pudding, mixing the berries into a "batter pudding" made with three to six eggs (depending on how economical one wished to be), a quart of milk and just enough flour to make it "thick enough to pour without difficulty." The pudding was then boiled for three-quarters of an hour and served warm.

By the time Fanny Farmer and the Boston Cooking School were in full swing, their version of a "steamed cranberry pudding" would have been familiar to many Americans.

½ cup butter
1 cup sugar
3 eggs
3½ cups flour
1¼ tablespoons baking powder
½ cup milk
1½ cups cranberries.

Cream the butter, add sugar gradually, and eggs well beaten. Mix and sift flour and baking powder and add alternately with milk to first mixture, stir in berries previously washed, turn into buttered mould, cover, and steam three hours. Serve with thin cream, sweetened and flavored with nutmeg.

Maria Rundell's enormously influential *New System of Domestic Cookery* (1807) went rogue on the pudding circuit, offering an original recipe for what is essentially a cranberry-infused rice pudding:

> *Boil and press the fruit, strain the juice, and by degrees mix into it as much ground rice as will, when boiled, thicken to a jelly; boil it gently, stirring it, and sweeten to your taste. Put it in a basin or form, and serve to eat as the afore-directed jelly, with milk or cream.*

For those of us raised on a diet in which cranberries appear only at holiday time, it can be surprising to realize how truly popular the fruit was and how deeply rooted it became in American culture. Straightforward, palate cleansing and healthful, the cranberry was intimately tied to ideas of purity and self-sufficiency and was considered reflective of the bounty of the nation, extracting a valuable product from marshes and bogs, wastelands that would otherwise be useless to the farmer or settler. The Transcendentalist author Henry David Thoreau loved the fruit and collected it wild near his native Concord, Massachusetts, particularly enjoying the frostbitten berries that remained in the meadows after the winter's chill. "No tarts that I have ever eaten at any table," he wrote, "possessed such a refreshing, cheering, encouraging acid that literally put the heart in you and set you on the edge for the world's experiences, bracing the spirit, as the cranberries I have plucked in the meadows in spring. They cut the winter's phlegm and now I can swallow another year of this world without other sauce." There is almost a spiritual quality to Thoreau's berries, an atoning quality; refined by acid taste and frozen hardship, they prepare him for the tangibilities of this world. Thoreau's love of spring-collected berries was shared by others, too. In her 1846 cookbook, Mrs. Cornelius noted that freezing does not injure the berry but makes for "rather an improvement" and for a jelly that might even be called "elegant."

We began this chapter with a quote from William Tudor, whose fixation with the cranberry was not far behind Thoreau's. A titan in Boston literary circles and editor of the high-toned magazine the *North American Review*, Tudor's satirical essay from 1820 was written in the guise of a visiting Frenchman appalled by American taste. Satirizing what he saw as disconcerting trends in lowbrow American culture, Tudor lashed out equally at French culinary arrogance and bumptious American naiveté, with side shots at the Enlightened classes, utilitarian-minded scientists and anyone else standing within ink-shot of his pen:

> *One individual informed me, that the rosy complexion of their women had been attributed to their consumption of this article. Though this*

opinion seemed extravagant, I resolved to try the truth of it, because every argument in its favour should be destroyed if possible. I therefore prevailed upon a servant girl, about fourteen years of age, to eat nothing else; partly by coaxing and partly by menaces, I confined her to this food for a week; at the end of which she grew pale and exhibited feverish symptoms, which is sufficient to prove the absurdity of the supposition. I could pursue the experiment no further, as she threatened to run away, and the most senseless clamour would have ensued, if any ill consequences should have happened to her. For so cold and backward are this people, that they would not sacrifice the life of one individual, to ascertain the most brilliant philosophical truth; and that spirit, which has animated Frenchmen, defying every obstacle, and despising every danger, to the sacrifice of thousands of the human race, to propagate the advantages of splendid discoveries, where antiquated abuses formerly reigned, is almost entirely among them...

The pretend Frenchman quipped that good French cooking would never make headway in America as long as the cranberry ruled, because its "mixture of sweetness and acidity...stimulates their appetite, and prevents them from perceiving the insipidity and staleness of their dishes, and makes them insensible to the advantages of our various rich sauces." *Quelle dommage*. Tongue still in cheek, Tudor fired away at the rational thinkers and do-gooders of his day, turning the classic claim for the value of using wasteland for cranberries on its head:

It might be suggested further to their political economists, that, by disuse of this fruit, a large quantity of meadows, now useless, might be reclaimed and added to their national resources: that a very considerable addition of wholesome food would be thus procured for their horses and cattle, that is now lost by suffering the growth of this pernicious berry, which, in its preparation, requires such a quantity of sugar, as greatly to increase their humiliating dependency on the colonies of foreign nations.

Cranberries were not necessarily an aristocratic fruit and, in fact, they contributed to the lives of the poor as much as those well off enough to be concerned with "humiliating dependency." While grain was the mainstay of a poverty diet in early America, providing over two-thirds of their estimated daily calories, according to the historian Billy Smith, in

the last half of the eighteenth century, poor Philadelphians consumed a surprisingly wide variety of foods, including cranberries in season. As late as 1921, Sadie Tanner Mossell found cranberries in the diet of the poorest of the city's African Americans, who purchased them fresh along with other vegetables such as cabbage, celery, lettuce, potatoes, spinach and onions.

As important as nutrition was, however, the fruit played a still more important role in the economic lives of the poor. In early America and Britain, the cranberry was one of several natural resources that could be harvested from public lands, and during the fall and winter they were a significant product for trade, as well as consumption. In Scotland, according to the botanist John Lightfoot in 1777, the poor collected large quantities of the European cranberry (known as the mossberry or moorberry or *muileag* in Gaelic), which became "so considerable an article of commerce" that the poor derived as much as £20 to £30 worth of the fruit per day in season. The welcome infusion of cash also resulted in the fruit being sent all over Britain for use in "the well-known cranberry-tarts." The poor lived a seasonal life, navigating the bounties and hardships of the year and adapting according to the conditions, hoping simply to survive, and the cranberry filled an autumnal niche.

The historian Sarah McMahon has suggested that beginning in the mid-eighteenth century, the New England diet had gradually become "deseaonalized." Americans today who hold a farm share know how little connection there is between when local crops come ripe and what one sees on supermarket shelves, and we imagine this is a recent phenomenon. Not so. Seasonality was a necessary part of life for everyone in the early years of settlement, when most foods were produced and consumed locally, following the rhythm of the year from the abundance of harvest time through the lean of winter and hardships of early spring, when stores waned to near-starvation levels before the renewal in the warming weather. But as productivity and preservation technologies improved, New Englanders increasingly found their stores getting deeper, providing more—and more nutritious—food through what had once been dark weeks. By the 1790s, salted meats and preserved dairy products like butter and cheese filled out the lean parts of the year, with stored fruits and vegetables not lagging. New Englanders, she argues, who had always had expectations of the table that ran from plain to monotonous, increasingly came to enjoy a varied and consistently plentiful diet. But the sauces made lovingly from cranberries, apples, rhubarb, berries, damsons and

quinces that had once alleviated the monotony during the leanest months retained their special status as a bright intervention in a bleak season.

Other changes in seasonality were harder to digest, as the most basic patterns of life were radically reorganized as industrialization and the growth of cities changed the relationship between Americans and their environment. A new seasonality came to the bogs as a cranberry culture became a cranberry industry.

3

From Vine to Factory

Cape Cod is fertile ground for Kennedys, clams and summer-league baseball, but it would be a stretch to say that it makes for great agriculture. Sandy soils, scrub pine and sea salt are not ideal conditions for large-scale cultivation, and the all-too-brief growing season and capricious weather add a touch of chaos to a farmer's already chaotic life. Yet the Cape has always been a place of alchemy, a place where scant resources and meager lives became the seat of innovation and abundance, where the underwhelming and understated become an affirmation of our once and future past.

However much cranberries were favored during the colonial era, the wetlands in which they teemed were hardly thought of as attractive spots, the soil being too wet, too thin and too impoverished to support most familiar English crops and ill-suited even for grazing cattle or sheep. But if wetlands could not exactly be considered beautiful or bountiful, they could at least be useful. As Fredrika Burrows suggests, the conditions that make a soggy challenge for living organisms also create ideal conditions for a resource vital to the lives of the early colonists: iron. Their problem was simple. A commodity as heavy, bulky and cheap as iron could never be imported from Europe cost effectively, so finding a local source became a priority. Bog iron fit the bill.

Like most things in the cranberry lands, the chain of events by which bog iron is formed extends beyond the edge of memory to a time when New England's rocks, cooked and contorted during ancient episodes of mountain building, decomposed slowly into their mineral components.

Transported by water through the post-glacial landscape, infiltrating the stagnant depths of countless bogs starved of oxygen by the decay of organic matter, iron finds its Eden. Just as the roots of cranberries cooperate with bacteria to make a paradise of the bog, bog iron depends on bacteria that inhabit the depauperate conditions on the bog's bottom, bacteria that oxidize the soluble iron in the water and cause it to precipitate out as a solid. The resulting iron deposits are hardly high grade, but the ore can nevertheless be extracted, refined and transformed into useful implements, from farm tools to kettles, nails and horseshoes and the countless mundane items that English settlers depended on in the conduct of their daily lives.

So it was in 1646 that John Winthrop Jr. established the Saugus Iron Works northeast of Boston, and for over twenty years this first of New England's dark satanic mills fed the metallic needs of a growing colony. In several ways, Winthrop's mill and the several similar concerns that followed radically altered the local environment. Its workers denuded the landscape for miles around, transforming trees into charcoal to fuel the furnaces; they dammed and altered watercourses for power and transport and rent the land to extract clamshells from the coast for lime, rocks for flux and bogs for ore. Winthrop altered the cultural landscape just as profoundly, recruiting skilled ironworkers from England and Scotland, non-Puritans all, whose skills were essential but whose ideas and mode of living were little compatible with Puritan austerity. When the iron deposits at Saugus played out, colonists moved on to strip other bogs in the watersheds south and west of Boston, throughout Plymouth County and Cape Cod, erecting bloomeries, forges and furnaces where water power and resources aligned. The iron they produced bridged our growth from colonial outpost to industrial nation, but as new and richer iron deposits were discovered in the New Jersey Pine Barrens, Pennsylvania and Maryland, and later in the Midwest, the center of iron production shifted inexorably away, leaving behind a land transformed.

As the mills faded, the story goes, and the sites were abandoned, the wetlands reverted to their conceptual status as wasteland—at least until the idea of actively cultivating the cranberry took hold. That would take some time. For generations of Americans, as a writer in the *Observer and Record of Agriculture, Science, and Art* remarked in 1839, the idea of taking an active hand in cultivating a fruit that grew in such natural abundance seemed outlandish. The cranberry, he wrote, was "looked

on as the natural product of swamps which were good for nothing else," and despite the steadily increasing popularity of the fruit in the markets, "the gatherers trusted to nature to keep the supply equal to the demand." The story, though, requires a little elaboration, followed by a little more elaboration.

For the better part of two centuries, it made little sense indeed for Americans to cultivate the cranberry. Facing a new life in what was to them a remote, wild and seemingly limitless land, colonists recognized the strategic advantage of doing no more than was absolutely necessary. Letting pigs roam in the woods to fend for themselves, for instance, made sense when the opinions of neighbors did not matter and when swine, left to their own devices, could be expected to survive and reproduce at their swiney will, all on their swiney own. Although roaming pigs might spark conflict with their Wampanoag and Narragansett neighbors—who objected to seeing their fields and storehouses rooted up and their forests ravaged—for the Puritan farmers, even a small return on a minimal investment spelled porcine profit.

For many years, cranberries fit well into this low-investment, low-risk strategy. With virtually no input in labor outside a brief harvest season, the wasteland bogs rewarded. The colonies of Plymouth and Massachusetts Bay luxuriated in wetlands, where cranberries thrived, and gathering the fruit required little more than sturdy hands and a container to hold the harvest—and perhaps a rake and canoe for the more ambitious. Neither did the work require any particular sophistication, skill or knowledge. Alone or as families, New Englanders traipsed every autumn into cranberry meadows or bogs and gathered away, and the berries they left to age under snow became a prized spring fruit. It was not even necessary to own the land on which cranberries grew. Public lands supplied nearly all that was needed and more, benefitting anyone with initiative to burn and energy to pick.

Although writing at a much later date, Henry David Thoreau's experience gathering cranberries near his beloved Concord evokes the harvesting scene in the decades before cranberries were widely cultivated:

> *I find my best way of getting cranberries is to go forth in time of flood, just before the water begins to fall and after strong winds, and choosing the thickest places, let one, with an instrument like a large coarse dung fork, hold down the floating grass and other coarser part of the wreck*

mixed with [it], *while another with a common iron garden rake, rakes them into the boat, there being just enough chaff left to enable you to get them into the boat, yet with little water. When I got them home, I filled a half-bushel a quarter full and set it in a tub of water, and stirring the cranberries, the coarser part of the chaff was held beneath by the berries rising to the top. Then, raising the basket, draining it, and upsetting it into a bread-trough, the main part of the chaff fell uppermost and was cast aside. Then, draining off the water, I jarred the cranberries alternately to this end and then to that of the trough, each time removing the fine chaff—cranberry leaves and bits of grass—which adhered to the bottom, on the principle of gold-washing, except that the gold was that thrown away, and finally I spread and dried and winnowed them.*

If there was a downside, it was simply that bogs were not well suited to humans, and boggy tragedies were not unknown. The *Boston Evening Post* for June 11, 1739, for example, reported that Daniel Taylor and Jacob Johnson, both in their early twenties, had gone missing while collecting cranberries near the town of Westborough. Before long, a search party discovered their horse tied up near a bog, their stockings and shoes slung nearby, their canoe adrift and their hats afloat in the water. Things did not look good, and not long thereafter, they looked worse. The drowned bodies of the men could be chalked up as yet another product of the bog. In good karmic fashion, however, bogs could be the scene of small triumphs. One year after the double tragedy in Westborough, a "delirious" Mary Dumbleton was found alive near Springfield after weeks astray in the woods, having survived "all that Time upon Buds and Cranberries."

For many decades, the energies of hundreds of New Englanders were turned to gathering cranberries not just for personal use but also for trade, and the ambitions of the mercantile class ensured the excess of our wastelands would not go to waste. A transatlantic taste for the tart and an international market for the fruit were built on small batches of wild berries gathered in scattered wastelands by an uncoordinated herd of part-time pickers. Boston emerged as the first substantial market for the cranberry, a destination for fruit gathered from the meadows and fields along the rivers of Middlesex County as far away as Concord, but New York and then Philadelphia soon enlisted in the cranberry cause. With rising interest in the fruit, colonists in other regions began to exploit their cranberries. The first English settler near Trenton, New Jersey, a Quaker

miller named Mahlon Stacy, mentioned cranberries he had obtained from the Lenni-Lenape Indians in a letter to his brother in 1680, and within a few years, harvesting wild berries became no less popular in West Jersey, as it was known at the time, than in New England.

By the time of the American Revolution, and particularly in the years just after, wild-caught cranberries became eagerly sought in nearly every major American port. Every winter from the Northeast to the Deep South and abroad, newspapers announced the arrival of barrel after barrel for sale alongside the other goods an active port consumes and distributes. While Philadelphia was still occupied by British forces in January 1778, Samuel Kerr of Front Street listed cranberries, along with delicacies such as Lisbon wines, sherry, port and porter, Jamaica and Antigua spirits, molasses, almonds, figs, raisins and lemons. A southerner in 1785 could find cranberries for sale in Alexandria, Virginia, with a shipment of Rhode Island cheese, potatoes, butter, cider, spruce and mackerel and chairs fresh from the workshops of Newport, while Baltimoreans found the berries with a wide range of goods, from New England rum and brandy to spermaceti candles, salt fish, "onions in excellent shipping order," china, looking glasses, chairs and tables. Cranberries earned headline treatment by the firm of Crosby and Norris in Charleston, South Carolina, in 1788, along with virgin honey, citron and sweet oranges, joined by specialty foods, liquors, spices, "East India mangoes" and even anchovies (a dubious food if ever there was one).

Carried aboard ship as a preventive against scurvy, the sailors themselves helped spread a taste for the favored fruit. It is not coincidental that one of the indicators of Captain Ahab's addled state of mind in Herman Melville's *Moby Dick* was his refusal to take stores of the fruit aboard. "Go out with that crazy Captain Ahab?" one whaler exclaimed. "Never! He flat refused to take cranberries aboard. A man could get scurvy, or worse, whaling with the likes of 'im." Like a good Windsor chair or wicked bottle of rum, cranberries spoke of New England, and in good New England fashion they came off not as a luxury or decadent delicacy but as a tart and useful thing.

With a taste for the fruit spreading so widely, the annual gathering on public lands intensified. What had once been a community activity that generated small but essential sums for local coffers became a focal point for competition between communities for access to the prime berry fields—enough so that authorities stepped in to regulate the

traffic. As early as 1789, the New Jersey General Assembly enacted a law prohibiting people from picking cranberries on land not their own between June 1 and October 10, levying a fine of twenty shillings plus an additional ten shillings per bushel picked. "If suffered to remain on the vines until sufficiently ripened," the assembly insisted in justifying the statute, cranberries "would be a valuable article of exportation." The *Southern Patriot*, a newspaper from Charleston, South Carolina, reported in April 1832 that even the State of Georgia had intervened to prohibit off-season picking, though the *Patriot* smirked, "We did not know that cranberries grew in Georgia."

Massachusetts, the motherland, was not immune to the forces of regulation. In May 1820, the town committee in Barnstable on Cape Cod petitioned the General Court to prohibit residents of other towns from gathering at the prime spots on Sandy Neck, and when that request got nowhere with state officials, the selectmen took things into their own hands. In September 1831, the town designated a "Cranberry Day," on which townspeople would be admitted onto public lands to gather at will but before which they would be strictly barred from collecting. Even on that one day, picking would be "by hand only," with no rakes or other instruments permitted, and a quarter of the harvest was to be handed over for the benefit of the town. On the first Cranberry Day, according to the *Boston Transcript*, three hundred men, women and children "had a fine frolic," picking almost half the available berries to the tune of 150 to 200 bushels. In similar fashion, the Gay Head Wampanoag tribe of Martha's Vineyard petitioned the state in 1842 to prohibit their "thoughtless White Neighbours" from swarming their bogs, complaining that whites "have been and still appear to be desirous of taking from us our means of a living and supporting our poor." Poaching cranberries may have been a Massachusetts tradition, but at Gay Head, the poachers interfered with an annual source of revenue ranging from $100 to $300, which the Wampanoags said "principally falls into the hands of the most Indigent of the Women and Children of our tribe who gather the Most of the Berries and which to them is a Staple means of support through the winter." The state approved an Act for the Protection of Cranberries on Gay Head in 1845.

Although the Gay Head ban was intended to protect a resource essential to the survival of the poor, elsewhere the poor felt only the sting of restrictions on gathering. On the mainland, as on Martha's Vineyard,

the influx of cash from the sale of cranberries helped the poor survive the lean months of winter, when employment was as scarce as fresh food. Not surprisingly, the cranberry ban was resisted. In May 1833, the *New Bedford Mercury* reported that Barnstable had won its case against Richard Derrick and his wife for illegally collecting ten bushels at Sandy Neck, but the town was awarded damages of a mere ten cents. "Rather a tart verdict," the newspaper chimed, and they might have added, rather a sharp taste of legal nullification.

The clamor against cranberry bans peaked in 1839, when citizens took to the courts to overturn the Barnstable law. At the height of the conflict in May, the *Baltimore Sun*—no local newspaper—took note that all over the Cape "a most fierce and unrelenting war, for the right to gather cranberries" was raging, half-jokingly likening the conflict to "our great war of Independence and the War of 1812, a whiskey war, an oyster war, a timber war, a negro war, a Mormon war, Indian wars innumerable." As if they knew our present-day condition, the *Sun* added that it seemed "the whole country is in a continual, eternal and never-ending war of words, about religion, politics, and every thing else which can give excitement to the mind of man," with cranberries as just one example. "We think we are *war*-ranted," they concluded, "in saying that we are essentially a nation of *war*-riors."

AN INDUSTRY IS BORN

Like any good myth, there are myths before the myth of how cranberry cultivation began. In the myth most preferred in Massachusetts, the Prometheus of the Vines is said to have been Captain Henry Hall, a Revolutionary War veteran, sea captain and local resident of Dennis, a small town on Cape Cod facing Massachusetts Bay. Hall's property was a suitably challenging place—austere, sandy and underlain by peat—and in about 1816, as the story is sometimes told, the good captain watched as a patch of wild cranberries was buried by sand blown over from a nearby knoll. To his surprise, he discovered that when spring came, the vines responded well to the insult, displaying a noticeable spike in productivity. With wheels turning in his mind, Hall concluded that with a little care, cranberries could be brought under cultivation and improved, and sometime shortly thereafter, he fenced off a patch of vines to keep

cattle out, later transplanting them to create a proper "cranberry yard." In a way, cranberries were not so much cultivated as they had cultivation built around them. Initially disparaged by his neighbors for wasting time on a fruit of the wasteland, Hall nevertheless succeeded, and an industry lurched into being. As Christy Lowrance notes, he and Hiram Hall became the first men on Cape Cod to earn the distinction of paying taxes on cranberry lands. Nothing is worthless if it is taxed.

Benjamin Eastwood, the first historian of the fruit and a grand promoter of cultivation, offered a variant of the same story in his important book, *A Complete Manual for the Cultivation of the Cranberry* (1856). Without identifying Hall by name, Eastwood wrote that the earliest growers near Dennis found that bestowing "a little care upon the vine" resulted in fruit that was "improved in flavor, color, and size." But according to Eastwood, it was "a boy whose father owned a swamp in which the cranberry flourished" who first transplanted vines to the side of a pond, and it was that boy who discovered that they did well. Not coincidentally, one presumes, Eastwood's *Manual* also reprinted a letter from Thomas Hall (no clear relation to Henry), who says that as a boy in 1813, it was he who transplanted vines, though he admitted that these were killed off after only two seasons and buried under sand, with the experiment not renewed until 1840.

As confused as some of the details may be with respect to person, date and outcome, and given the likelihood that more than one individual may have taken a swipe at cultivation, Henry Hall was clearly a pioneer of cranberry culture and one of the most successful of early self-promoters. Although it is difficult to pinpoint precisely the date at which he first conceived of transplanting vines to the side of his pond, the *New England Palladium* reported on November 12, 1819, that Hall had been so successful in his taming endeavors that he had already sent "several barrels" of fruit for sale to New York, "where they are commended as remarkably high flavored and excellent." Given the wide popularity already enjoyed by the fruit, this was considered big news by the press, and as was typical for the time, report of Hall's seismic success triggered aftershocks of plagiarism and piracy in the media. The story rattled across the pages of newspapers in New England, New York and the Mid-Atlantic states, sometimes appearing under the dramatic headline "The Cranberry Domesticated," although the word "transplanted" may still have been the more accurate verb.

Without doubt, Hall's success ignited a fire, and many others followed suit in cultivation. Once it seemed possible to cultivate cranberries rather than simply gather them as nature allowed, growers sensed that controlling the means of production could result in greater predictability, higher yields and superior fruit and thus higher individual profits. Unlike the low-investment, low-risk strategy of previous decades, this approach demanded significant upfront costs in land and labor to prepare the cranberry beds, not to mention the time and effort required to work out the details of how best to grow the vines. Early advocates for cranberry culture, however, shrugged their shoulders and asserted that the effort would be repaid many times over. Sometimes they were even right. In 1828, a farmer in Mendon reported raising three hundred bushels of cranberries on just six newly purchased acres, earning a 900 percent profit on the purchase price of the land in just a single year. Hall's neighbors in Dennis, Elkanah Sears and his son William, were convinced to lay out a yard of their own, and they were followed elsewhere by Alvin Cahoon and his cousin Cyrus, Zebina Small, Asa Shiverick and various Howes and Smalleys.

When the first census of cranberry lands was made in 1854, Barnstable County was easily recognized as the center of a thriving business, reporting 197 acres under cultivation, led by the towns of Dennis (50), Barnstable (33), Falmouth (26), Provincetown (25), Brewster (21), Harwich (17), Orleans (8), Eastham, Sandwich and Yarmouth (5 each) and Wellfleet (2). Ten years later, acreage on the Cape had swelled to 1,074, spurred in part by the demands of feeding the Union army during the Civil War.

The explosion of interest in the cranberry on the Cape did not spring full form from some heavenly mind but was tied instead to more insistently earthly matters. The berry market had been developing for decades, to be sure, and Cape Cod had played a key role in creating demand, but to convince a gaggle of relatively poor farmers to invest in wastelands required something more than inspiration. By the 1840s, when cranberrying truly took off, the Cape had been wallowing in the economic doldrums for years. Steam power and the arrival of metal-hulled ships had cut deeply into the region's maritime economy, bypassing what had in many ways been a marginal region.

But more importantly, the land itself was beginning to give up on the farmers who called it home. The slow strangulation of the iron industry in eastern Massachusetts was coupled with increasingly challenging conditions for agriculture stemming largely from the manner in which

farmers cared for the land. Settlers had long since stripped the Cape of trees for timber, firewood and charcoal, laying bare the naturally thin glacial soils and setting conditions for a destructive cycle of erosion, loss and abandonment. Across the board, farming practices were depleted and destroyed. From burning woodlands for clearance to plowing and planting ill-suited crops like wheat, Massachusetts farmers steadily stripped the land of its topsoil and depleted what was left, unable to do much more than survive when they could and move on when they could not. A limited understanding of the role of fertilizers and soil formation did nothing to stem the loss. The cattle on which they depended for dairy and meat did their part, too, by noshing away at the thin vegetation on the dunes, leaving them to blow out in the wind and creep onto fields, and when sheep culture became a craze in the 1840s, the damage grew even more acute.

The enduring vision of Cape Cod at the moment of the cranberry boom was provided by Henry David Thoreau, who visited there on four occasions between 1849 and 1857. While traveling through Dennis, epicenter of the cultured cranberry, he wrote that he saw

> *an exceedingly barren and desolate country, of a character which I can find no name for; such a surface, perhaps, as the bottom of the sea made dry land day before yesterday. It was covered with poverty-grass, and there was hardly a tree in sight, but here and there a little weather-stained, one-storied house...There were almost no trees at all in this part of Dennis, nor could I learn that they talked of setting out any. It is true, there was a meeting-house, set round with Lombardy poplars, in a hollow square, the rows fully as straight as the studs of a building, and the corners as square, but, if I do not mistake, every one of them was dead.*

The scene in Chatham was little better, and Thoreau could barely refrain from laughing (though not laughing) at what the locals called soil:

> *The barren aspect of the land would hardly be believed if described. It was such soil, or rather land, as, to judge from appearances, no farmer in the interior would think of cultivating or even fencing. Generally, the ploughed fields of the Cape look white and yellow, like a mixture of the Indian meal. This is called soil. All an inlander's notions of soil and*

fertility will be confounded by a visit to these parts, and he will not be able, for some time afterward, to distinguish soil from sand.

The houses in which Cape Codders lived and the fuel they burned came from wood that had to be imported from Maine, and where Cape forests once stood, Thoreau saw that "barren heaths, with poverty-grass for heather, now stretch away on every side." Liberated of ground cover, sands blew wherever the abundant Cape winds commanded. Where trees and bushes once held down the earth, Thoreau witnessed nothing but "an extensive waste of undulating sand." As early as 1825, state authorities recognized that blowing sands threatened to strangle the harbors and responded by planting beach grass in the vain hope of checking their advance. "Thus Cape Cod is anchored to the heavens," Thoreau wrote, "as it were, by a myriad little cables of beach-grass, and, if they should fail, would become a total wreck, and erelong go to the bottom."

Seen in this light, cranberries were a means of stripping success from the mouth of man-made defeat and creating a living from poverty. At both, they succeeded. Previously worthless swampy plots began to sell for $50 to $100 per acre, often bought and sold by retired sea captains, and the cranberry business boomed. In 1846, Faneuil Hall in Boston breathlessly reported that two thousand bushels of cranberries had been sold for $3 each. That one could transform an abandoned iron bog or millpond into a productive asset proved irresistible to New Englanders, and well beyond the Cape, cranberry trials were made. In the distant Connecticut River Valley, the *Northampton Gazette* reported in October 1841 that seventy barrels of cranberries were shipped downriver from Deerfield to New Haven. In fact, by the mid-1850s, Cape Cod had slipped to seventh place on the list of commonwealth counties when it came to acreage devoted to cranberry culture, falling behind Middlesex, Norfolk, Worcester, Bristol, Essex and Plymouth. Poor Barnstable County (the Cape) had less than a tenth of the cranberry acreage of Middlesex and barely half of neighboring Plymouth. Although the numbers may be a bit deceiving, since they include both wild and cultivated berries, the cranberry market proved an irresistible draw across the commonwealth.

With all this excitement, New Jersey was not long in getting in on the action. Benjamin Thomas planted a patch near Burr's millpond, near Pemberton, in the 1830s and was soon joined in culture by William Bradford, Joseph C. Hinchman, Daniel H. Shaw and Theodore Budd.

John I. "Peg-Leg" Webb of Cassville, Ocean County, became the best known of the early growers, for both his skill and his innovative ideas. Having lost his leg in an accident as a young boy—hence the nickname—Webb was said to use his peg leg as a dibble to set new vines. The heart of the New Jersey cranberry belt lay in the south-central part of the state, splashing through the Pine Barrens and Ocean, Burlington and Atlantic Counties—a sprawling land of scrub pine and sandy soil with vast wetlands that had once been the center of an iron industry. During the first three decades of the twentieth century, New Jersey accounted for nearly 40 percent of the nation's crop, though drought, insects, disease and the Great Depression subsequently derailed it from its position.

The fires of cultivation spread to the westward limit of the American cranberry and found what would become a third highly productive center. Long before the arrival of whites, the Anishinaabeg people, among others, gathered cranberries, but once whites arrived, the search for profits soon followed. Chauncy Rust, an early settler near Green Bay, Wisconsin, hired local Indians in 1834 to harvest one hundred barrels to send to New York, and true cultivation in the state was begun as early as 1853, with Edward Sackett of Aurora emerging as the first large-scale grower a decade or so later. John Harrington Stevens, the first white resident of what is today Minneapolis, also had an interest in cranberries, though he did not enjoy the same success. His partner, Jacob Schreiner, wrote to him in January 1850 to relay news of an ill-fated attempt to market cranberries downriver. Having straggled to New Orleans with his berries in tow, Schreiner informed Stevens that he "would have done wise to have sold them at St. Louis, at any price," since the market in Louisiana was glutted. "It was impossible to Sell them at wholesale or in a short time," he wrote, "& I soon found that I wd be obliged to put them in to the hands of a commission merchant or to produce a Lisence to retail…They commenced rotting before the half of them were Sold."

The last significant outpost of cranberry cultivation arose in the mild coastal zone of Oregon and Washington. Culture in Oregon began after Charles Dexter McFarlin had his great bog in Carver, Massachusetts, wiped out by frost in 1874. From this disaster, however, arose the idea of relocating to the West Coast, which he and his brothers had visited during the gold rush and which he imagined as a more temperate and hospitable place. McFarlin brought with him the McFarlin variety of cranberry that he had collected from wild stock prior to 1870 and which

he had planted in Coos County by 1885. Planting in Washington had begun in Pacific County by 1883, brought there by Andrew Chabot, a French Canadian immigrant.

Wherever they were, these early cultivators sought to understand the natural environment in which cranberries grew as a means of emulating and then improving upon it. Born of desperation as much as profit, they observed natural vines for clues on how to raise captive berries, and they experimented widely, sometimes wildly. Since cranberries are known as a thirsty plant, and since wild vines were found on the edge of swamps and ponds, Cyrus Cahoon and Zebina Small thought to plant their vines in standing water, which resulted in the determination that being thirsty and being drowned are not the same thing. Other growers observed that cranberry runners seemed to run away from standing water, leading to a long series of attempts to grow vines on dry upland soils, none of which ended very satisfactorily until many years later. The vines, as Benjamin Eastwood noted, "lingered on for a time, looked sickly, blighted, and stunted in their growth, yielding but little or no fruit." Such a shame, and yet every few years, one grower or another claimed success at growing in upland conditions, only to have success fail.

Growers experimented too with planting vines in different soils. Alvah Cahoon of Harwich, Massachusetts, failed in his effort to convert a loamy laurel swamp into a cranberry yard, and by trial and painful error, he and a string of others rejected clays and marls, pure peat and rocky loam in succession. Heavy soils seemed to stunt the vines, while rich soils—so beneficial to other crops—encouraged the vines to spread but never to get to the business of producing berries. Neither rich nor poor suited the cranberry, and growers soon reached the consensus that a coarse sandy soil, "not common earth," was ideal, particularly when it was laid on top of a thick layer of muck or peat.

This first generation of cranberry growers was both stubborn and remarkably innovative in building their yards, adapting course as their experiments led them. Having observed that bogs were being transformed elsewhere on the Cape into useful meadows for grazing by draining, razing the surface, applying loam and planting grass, cranberry growers began to experiment with ways of controlling water. Most importantly, they determined that building dikes around a yard and draining it with ditches resulted in the ability to control the water level to achieve optimal conditions. Following Hall's observation that a covering of sand

encouraged growth, they learned to spread a clean layer on their bogs every few years to reinvigorate old vines. Observing that cranberries are easily ruined by frost and that the springtime buds were particularly vulnerable, growers learned to flood their fields from October to about June 1 (or a few weeks earlier in warmer New Jersey). The surprisingly delicate vines survived the winter beneath two or three feet of water and a covering of ice, cold but not frozen through, and when the last threat of frost had passed and the flowers were set to bloom, growers would liberate the fields of the flood and let nature take its growing course. Sanding and flooding were thought to have the added benefits of suppressing weeds and controlling noxious pests, and a few growers even recommended a more complicated process of draining the flood around the first of May to "give the vines a start," following up with a short flood three weeks later to "to kill the berry worms."

There was considerable innovation, too, in selecting cultivars for commerce. While dozens of varieties of cranberry have been developed over the years, the two most common varieties still used in Massachusetts can be traced back to the pioneering generation. In 1843, Eli Howes transplanted vines from Basset Swamp in Dennis that produced an oblong fruit that ripened in early October, quite late in the season, and this variety had the added benefit of being resistant to frost and well suited for storage. Nine years later, Cyrus Cahoon obtained natural vines from Nathaniel Robinson in Harwich that bore a very dark, bell-shaped fruit that ripened early in September, well before the threat of frost, and while smaller than the Howes, they were sweeter, with an appealingly intense color. The Howes and Early Black varieties set the alpha and omega of the harvest season, and in a miracle of timing, just as the Early Black season winds down, crews move on to harvest Howes. The horticulturist Justine Vanden Heuvel has shown that even pests respond to differences between the cultivars. The larvae of gypsy moths and, less certainly, the adults of the redheaded flea beetle exhibit a strong preference for consuming the Howes, perhaps because of the higher concentrations of repellent phenolic compounds found naturally in the Early Blacks.

Innovations in water control and leveling were coupled with innovations in planting, harvesting and processing technologies. Amongst a stunning variety of dibbles, rakes, scoops and mowers, few innovations are as elegant as that of Peg-Leg Webb. The first grower in New Jersey to spread sand over his vines, Webb discovered what became known as the bounce principle. Webb

stored his berries on the second floor of a barn and was known to pour them down the stairs to the lower floor to save the effort of carrying them down. One day while dumping his fruit, he noticed that sound berries bounced on the wooden steps, while poor and rotten ones did not. Subsequent years of mechanical wizardry in building better sorting machines have not altered Webb's discovery of the true value of a good bounce.

An Alternative History

The Cape is surely home to the main historical currents of cranberry cultivation, but for every current there is a countercurrent. By the mid-eighteenth century, cranberries were traded not only as edibles but also as botanical curiosities that had their own rules of exchange. For sons and daughters of the Enlightenment, exploring, describing, naming and taming nature were among humanity's highest callings, an intellectual challenge that built reputations (and sometimes fortunes) for the would-be virtuosi of the world and a challenge that fit the mission of spreading reasoned rule to the world through the extension of empire. Knowledge was to be useful, not merely theoretical, and the actions of learned men and women were put to use expanding boundaries of every kind.

As the Enlightenment reached its peak and European empires swelled, the new and virtually unknown American flora proved an irresistible lure to the imperially curious. Plant collectors, gardeners and scientists on the lookout for new wonders to exploit all looked to the west, and learned Englishmen such as Peter Collinson, John Fothergill and John Coakley Lettsome (Quakers all) forged an international network for the exchange of plants and seeds. In America, self-trained botanists like Humphry and Moses Marshall and John and William Bartram (also Quakers) sought to better themselves economically and socially by scouring the fields and woodlands of eastern North America for their patrons in Europe, earning respectability for their discernment in collecting and their eye for the unknown, collecting new species and new varieties that were valued for medicine, esculence, ornament or "fabrication," to use Thomas Jefferson's terms from his *Notes on the State of Virginia*. The cranberry, Jefferson notes, was esculence par excellence.

John Bartram had supplied Collinson with American cranberry vines before 1753, and these were raised with some success in Collinson's

English garden, though they were perhaps never more than a curiosity there. But the plant trade was more energetic than any single individual. A major horticultural firm from Edinburgh, Dicksons and Co., listed cranberry plants for sale in its catalogues for 1792 and 1794; Gordon, Dermer and Co. of London offered both the common European cranberry and the American cranberry to its customers in 1795; and Russell, Russell and Willmott, also of London, included the common cranberry in its catalogue for 1800.

American suppliers cashed in, too. The great American seedsman, Bernard M'Mahon—the man entrusted with raising the seeds and plants collected by Lewis and Clark—offered a whole menu of plants called cranberry in 1804, including (using his nomenclature) the hairy cranberry (*Vaccinium hispidulum*), common American cranberry (*V. macrocarpon*), myrtle-leaved cranberry (*V. pensylvanicum*), racemed cranberry (*V. racemosum*), silvery-leaved cranberry (*V. glaucum*), sharp-pointed cranberry (*V. mucronatum*), variable cranberry (*V. disomorphum*) and clammy cranberry (*V. resinosum*). All, perhaps, would have been nurtured at his Upsal Botanic Garden, a spread in scenic north Philadelphia named after the hometown of the great naturalist Carl von Linné (Linnaeus). In 1837, the pioneering nurseryman on Long Island, William Prince, offered cranberries at twenty-five cents a dance.

From all this interest in the plant—as much as the berry—comes a surprising twist. The breakthrough in cranberry culture did not come from a native of the cranberry meadows or even a New Englander but from one of the best-known English scientists of the day, Sir Joseph Banks. In many ways, Banks was the epitome of British colonial scientists, one who saw the British Empire and its exotic colonies as a playing field for botanical exploration and economic exploitation, the two running hand in hand. Banks had accompanied Captain James Cook on his first voyage around the world from 1768 to 1771, collecting plants in South America and Australia that he brought back to the Royal Botanical Garden at Kew, raising some in the showcase botanical garden he maintained on his personal estate, Spring Grove. As president of the prestigious Royal Society for forty-one years, Banks became the most important patron of scientific exploration in Britain—and perhaps the world—at the turn of the nineteenth century. When it came to plants, he was hard to ignore.

In 1808, Banks reported to the Horticultural Society of London that he had been cultivating the American cranberry at Spring Grove "for

some years," and since "the Fruit of it now become an object of some importance in the economy of the family," he felt obliged to describe its culture. As the name implied, Spring Grove was a place where there was a ready supply of fresh water, enough to sustain "water plants of all kinds." To cultivate the cranberry, Banks built an artificial island in the center of a basin, propping up a circular oak box on posts driven into the center of the pond, twenty-two feet in diameter and thirteen inches deep, submerged five inches below the surface. He bored through the bottom of the box to permit water to saturate the soil, and lining the bottom of the box with stones and rubbish, he layered on a foot of bog earth from Hounslow Heath so that the top seven inches lay above the waterline and the bottom five below.

In 1801, Banks planted cranberry vines in this ingenious setup, and by their second year, they sent out runners that took root during the winter, throwing out uprights in spring that flowered and set fruit. "It was not determined to consider the *American Cranberry* as an article of kitchen garden culture," Banks wrote, "and to give up the whole of the island to it," but within a few years, the vines had taken over the whole island without any new plants being added, yielding twenty-three bottles (at five bottles per gallon) of cranberries in 1806, "very fine *Cranberries*," Banks insisted.

Planting a bed on the side of his pond in similar fashion, twenty feet long and five and a half feet wide, Banks found that his cranberries thrived, yielding sixty bottles of fruit in 1807. He noted carefully that his family's yearly needs for cranberries could be met on a mere eighth of the land he devoted to strawberries, and while he considered his efforts to be still in their infancy, and "not sufficiently established to afford general rules for the regulation of a gardener's proceedings," he pointed out that in seven years of culture, the beds had remained vigorous, producing and ripening well, yielding enough for one cranberry pie for every two and a half square feet under culture. Although the yield was small, intended for use only by his family, it is clear that Banks had thoroughly domesticated the fruit and had done so with the aim of testing the feasibility of commercially viable production.

Published in one of the world's leading horticultural journals, Banks's experiments were noted on both sides of the Atlantic, and it appears that several horticulturists took up the implicit challenge. While the combative political pamphleteer and sometime farmer William Cobbett admitted

that the finest cranberries came from America, he wrote in 1822 that he had also seen them "bearing very well" by the side of a stream in Surrey and argued that the cranberry should be taken under cultivation in Britain, if only to make more tarts and more sauce for meat. In that same year, Thomas Milne extolled the virtues of the cranberry to his peers at the London Horticultural Society, arguing that all of England's demand for the fruit could be met with a minimal outlay of land:

> *If to supply the whole of Great Britain only the produce of one hundred acres were required, it would at least be one step towards making that quantity of waste land useful in some degree, and probably suggest some other improvement in various ways. Should any person be induced to make the trial, there can be no doubt the American cranberry would be the easiest managed, and more productive for general use; but as many prefer the flavor of the English cranberry, there would also be a demands for it on that account, though at a higher price.*

Unlike Cobbett, Henry Phillips asserted that the English cranberry was superior in taste to the variety that was "imported from the northern parts of America, which are now so common in the shops of London," blaming the difference on natural fermentation, which occurs during shipment of the American berries. In his *Companion for the Orchard* (1831), Phillips cited Robert Hallett of Axminster (Devonshire) for having raised four American plants on a dry bed in 1814. Showing that he had understood Banks's methods well, Hallett set out shallow, peat-filled boxes in April 1818, planting cranberries and watering them frequently. The plants thrived, forming a vine-covered bed 150 feet long by 4 feet wide by 1819 and yielding a profusion of fruit.

The West London Gardeners Association for Mutual Instruction was so enamored with the cranberry that it set aside time during its session of November 1837 to discuss the benefits of the fruit to the nation. According to the account of that meeting, reported duly in the *Gardener's Chronicle*, the consensus was that that the cranberry had not yet reached its potential as a boon for the nation's poor, even though the plant had been grown in England for over seventy years (thinking of Collinson) and had been under cultivation for thirty years since Banks's experiments at Spring Grove. One of the members, identified only as Mr. Russel,

dwelt on the advantage which the poor man would derive from its cultivation; spoke of the miserable condition of the peasantry who gathered the wild English cranberry in the vicinage of the lakes of Cumberland; lamented that thousands of acres were lying waste, which, if properly cultivated, might minister to the enjoyment of man; and drew an analogy between the carelessness evinced towards the cranberry, and that exhibited towards the potato, on its first introduction...

[Another member,] *Mr. Fish was anxious to see the labouring man elevated in his condition, but did not think that the cultivation of the cranberry would be greatly productive of such a result; he wished, however, to see a small bed of it in every cottage garden, that the labouring man might have his cranberry tart as well as his gooseberry pie, as a wholesome variety of food tended much to promote the happiness of social enjoyment.*

Whether the cranberry would serve the "laboring man" according to the vision of Mr. Russel or Mr. Fish would be worked out on the bogs themselves.

4

Working Cranberries

American farmers were crazy during the nineteenth century, or at least prone to crazes. Every few years, a new fad or fancy blew through the countryside promising to be the next big thing, the next best way for a poor farmer to get rich. It was Merino sheep in the 1810s that grazed New England's wooded hills into woolen hills; in the 1820s, it was broomcorn that swept the upper Connecticut River Valley. The silkworm and mulberry mania that spun its way through the northeastern states in the 1820s and 1830s fueled dreams of an America free of cotton and the slavery it implied. One after another, crazes ranged. The great cranberry fever of mid-century outlasted all of these, peaking at a time when the impact of cultivation—the domestication of the wild cranberry—and rising demand conspired to fix pretty profits for the industrious. Benjamin Eastwood, one of the cranberry's most ardent promoters, believed the day would soon arrive when the whole nation would follow Cape Cod "in making otherwise unproductive tracts of land both fruitful and a source of gain," including even the spacious West and South, where thousands of acres of sandy waste lay still untouched.

Although he may have missed the mark in estimating the cranberry's southern potential, and while he certainly underestimated what would be a volatile market, Eastwood was spot on in claiming that cranberries were not only an indispensable accompaniment to Thanksgiving turkey but were also favored by the better sort of American. "People have lived to discover its excellent qualities," he wrote,

and since it is so highly appreciated for its culinary purposes, there are those who are willing to pay an almost fabulous price for the berry. It has become in many families a necessary luxury. The wealthy would as soon part with the apple as the cranberry, and it is the rage among the rich, and even those who are not so fortunate, for this fruit, which keeps it up to that price which puts it beyond the reach of the poor.

There is no small irony in finding the price of this humble fruit, once a support for the poor, being driven beyond their means, but the bogs bloomed with many such ironies. The cranberry boom coincided with a time of profound change in the nature of work in America, and these small ironies of life are signals of something larger afoot, something deep in the soul of the nature of work in America. The promoters of cultivation left a rich record of their hopes and plans that inevitably shades our understanding of cranberry culture, and perhaps inevitably the history of how this "necessary luxury" was produced has been read through the words of these advocates. The success of several early growers and their remarkable resourcefulness, ingenuity and perseverance is a story of triumph irresistible to historians and a story that needs to be told and retold as part of how America came to be. But there is another side to the cranberry story, one that revolves around the paradoxical idea of a "necessary luxury," a side that lies in the shadows of the growers, a side that lies in the far less glamorous world of toil. It is perhaps another small irony that the cranberry heartland lies in proximity to the birthplace of the American Industrial Revolution, where the first large factories and mills sprang to life like some newly cultivated plant, drawing on the same combination of water power, cheap resources, cheap labor, cheap land and boundless ingenuity. In this small region, industry and agriculture would be yoked, mirrored reflections of a landscape transformed.

Although it is all too easy to view the past through cranberry-colored glasses, there was once a time when American employers and employees enjoyed a certain intimacy, living and working in proximity, coming together in cottage shops and family farms where labor played out on a human scale. We stood, one time, face to face. But these traditions of work did not long survive. Industrialization and the growth of cities took their toll on the old relations that American workers had built with their employers (at least in some of the northern states), surrendering to a system built on wage labor, economic insecurity, competition and

personal distance. The small family farm that had been the backbone of the economy during the nation's youth began to disappear, replaced by larger-scale, usually mechanized, mass-production operations where employees were no longer individuals but categories. Even for cranberries, which never attained the scale of production seen in crops like wheat, corn, cattle or cotton, changes came. The bogs were part of an ecology of labor in New England, a rhythmic, seasonal dance of the destitute that swung from the bogs to the mill floors and ports and back again; a cycle that swept up young and old, local and immigrant, and merged all in a world of labor and exchange and sometimes strife.

Laying Out a Bog: A How-To Guide

There is nothing natural about emulating nature, and of all the things that early cranberry growers took away from observing the natural world, the most important was how to defeat it. Wild or cultivated, cranberry bogs are not for the timid, and preparing a new bog for cultivation involved nothing short of the application of brute force—particularly during the brutish days of hand shovels and horses. Even finding a suitable site was demanding, requiring a special combination of deep piles of peat or muck, along with abundant nearby stores of clean sand and fresh water. Cranberries presented the three bear dilemma: too hot, too cold, too wet, too dry, too rich, too poor. All were problems. Yet indecisive bears were only the beginning. Early growers had to stare down every plant and pest on the property, wrest control of the water and render the whole as flat as a billiard table, all by hand, before planting could commence. Even then, nature continued being nature while the would-be grower bided time for up to three work-filled years as the vines matured. Delayed gratification they understood, not to mention delayed return on their investment. Not all of the early growers were fastidious when it came to leveling, weeding or flooding, but even for the best, bogs were an endless cycle of harvesting, clearing, draining, picking, sorting, cleaning, screening, packing and shipping. And so, on and on. A bog of a handful of acres was an accomplishment; a dozen acres or more were testament to a determination that would make a billy goat proud. The massive Milestone Bog on Nantucket, at 235 acres, was a colossus that seemed possible only because it was far off at sea.

The cranberry boom of the mid-nineteenth century was aided and abetted by some remarkable publicists who helped initiate novices into the mysteries of the bog-loving berry while spreading enthusiasm for the crop. The cranberry was that much different from other plants that it required its own way of thinking, and from hard-won experience, Reverend Benjamin Eastwood, Joseph J. White and James Webb helped establish a more or less standard framework for cultivation while helping readers unlearn their most deep-seated agricultural instincts. The topsy-turvy world of the bog required uprooting some fundamental ways of looking at the natural world: soggy muck and barren sand were desirable here; rich loam was to be avoided; and poor became productive and rich counterproductive. So it was. One early grower, J.C. Howes, remarked with only slight exaggeration that he "never saw a soil so poor that cranberry vines could not grow in it," hinting at the blessings of poverty. "The poorer the soil," he wrote, "the less trouble I shall have to keep down other grass; no fear of the vines, they will grow where no grass will." For similar reasons, Eastwood believed that a huckleberry, maple or cedar swamp made the best grounds for a new cranberry bog because "less grass and fewer weeds will grow in a swamp after it is first cleared, than in a meadow." On the bogs, a grower aimed low to hit high.

With a suitable location selected, a prospective cranberry king needed next to clear and drain the land and not skimp at the job. The grower Joseph Hall cautioned beginners to "be very careful to clear the ground of all noxious roots and plants" or face the consequences when grass and shrubs regenerated, as maples and huckleberries were notorious for doing. Inundation by weeds, not water, was the primary threat to the low-lying vines. A New Jersey grower himself, White recommended mowing the land and scalping it of bushes and shrubs, and when larger trees stood in the way, he advised severing the major roots and letting the wind do the rest by blowing the tree down. Not only would this save labor, but also the tree would pull the remaining roots right up as it fell. Although it was common practice to burn the brush that resulted from clearance, the frugal White recommended recycling the wood into boxes and other items useful for harvesting and packing fruit. Even in New Jersey, waste had a bad name.

Next, workers attacked the turf itself, not only to ensure that weeds and grasses would not reenact the *Night of the Living Dead* but also to break up the mat of roots that knit the top layer. This required teamwork, not just brawn. The first man went ahead with a heavy turf axe slashing deep

parallel lines across the bog's surface eighteen inches apart, going back to cut between the lines at right angles to make incised squares. The second member of the team followed with a heavy three- or four-pronged rake, catching the turf blocks laid out by the axe-man and flipping them up for removal. Thrifty as always, White advised that the turf, too, could be recycled and assembled into a wall around the edge of the bog.

Draining the now-naked bog required digging ditches, many ditches, starting with a main ditch down the center, four feet wide, and a marginal ditch three feet wide and eighteen inches deep circumambulating the whole. Lateral ditches one hundred to two hundred feet apart, depending on how wet the conditions, were sloped from the surface toward the central ditch and dug to two feet below the top of the muck layer to suit the growing vines. Excavating the heavy earth and hauling it away was no small chore, but getting the ditches right was crucial to a bog's success. Beyond helping to regulate moisture for the growing vines, the ditches had to be big enough to convey large volumes of water to the bog quickly when frost threatened and to drain them just as quickly when torrential rains threatened.

Going hand in hand with the ditches was a series of earthen dikes to retain water. These required growers to move even more dirt, rocks and debris, and the dikes required a dam and sluice gates to allow water in or out as necessary. Less obviously, they also required the bog's surface to be made as flat as possible, since every high spot required that much more water to flood and to provide uniform growing conditions for the vines. A vigorous debate among early growers over whether a sloping or level surface was best for berries was resolved when the value of flooding for preventing damage by frost and pests became clear, and growers came to recognize that the added time and effort was worth the investment, although well into the 1930s many New Jersey growers continued the low-investment strategy of minimally modifying their bogs.

With their bogs now flat and enclosed, growers carted in load upon load of sand. Eastwood recommended using clean beach sand screened to remove the rocks (which played havoc on the knees and hands of pickers), but not just any sand would do. White proposed a simple, confounding test to determine suitability: "Take a portion of the soil and compress it tightly in the hand," he wrote. "If it is suitable, it will fall apart upon being released; but if composed in part of loam, it will adhere together after the pressure is removed." At last it was time to plant.

From Planting to Product

The cranberry, the plant that disdained good soil, was perplexing from the get-go. Rather than planting from seed, growers used cuttings, relying on their natural ability to set root when touching soil. But selecting vines for cutting required some characteristically perverse cranberry logic. When selecting vines for cutting, Eastwood insisted that "healthy" vines appeared "stunted" while "unhealthy" ones were "altogether brighter and stronger." An experienced grower like Thomas Shiverick knew that what seemed like promises of productivity were actually "only symptoms of a disease, which disease means *barrenness*." Healthy vines, it seems, yielded a bumper crop (of leaves and runners), but it took unhealthy ones to make fruit.

After selecting vines, growers ran a wide-toothed, rake-like tool called a marker back and forth across the sandy surface to mark out the bog in a regular, rational grid. "Unhealthy" cuttings were then laid out at the intersections of the grid and pressed into the ground with a specially modified tool called a dibble. Some used dibbles with a single point, pressing one vine at a time into the earth; others used hydra-headed

A cranberry rake, H.R. Bailey Company. *Courtesy of the Carver Public Library.*

Working Cranberries

Two cranberry dibbles and a vine cutter, H.R. Bailey Company. *Courtesy of the Carver Public Library.*

dibbles pressing four cuttings at once, but all cuttings were to be pressed in at a gentle angle to give them the best chance of rooting properly. On many bogs, this job was reserved for men only, not because of the physical strain involved but, according to White, because the work required "a leaning posture" in which women's skirts would "have a tendency to drag the vines out of place and waste them."

Marking bogs and setting vines were not particularly complicated tasks, but they nevertheless required specially adapted tools. This was a novel crop, and given the limited number of bogs, few manufacturers took up the challenge of supplying the niche market, leaving growers on their own to develop and produce what they required. Most of their tools were simple in design and simple to produce through a local blacksmith or carpenter, and most were adapted from designs for familiar tools. Forks, spreaders, markers, rakes and dibbles were nothing new, but when it came to harvesting and processing, growers displayed an innovative streak that complemented their remarkable resourcefulness at making do with what they had on hand.

One of the prime focal points for Yankee ingenuity was building a better berry trap. Unlike most fruits, the ripe cranberry does not simply fall off its pedicel: it needs to be plucked off. Somewhere in the dim recesses of the past, someone came up with the idea that ripe berries could be removed from the vines with a wide-toothed comb, and over several decades growers ran with this idea, developing dozens of designs for wheel-mounted, hand-held and mechanical pickers.

In 1873, wheeled machines began rolling in from that cranberry hotbed of New Orleans, where Richard de Gray patented a picker roughly the size and appearance of a lawnmower. Aware that rakes had been criticized for snarling vines, uprooting plants and leaving fruit uncollected, Gray promised a machine that would "gather or pluck the cranberries from the vines in a rapid and efficient manner" but "without cutting or injuring the vines or tendrils of the plant." Mounted on a roller and pushed along the ground, its spring-mounted teeth at the open front end combed up the berries, after which a revolving rake swept them into a collecting bin at the rear. William Crowell, of Dennis, Massachusetts, patented a smaller, boxier model in 1874 featuring "suitable wires and strippers in front" that were activated by gears when the picker was pushed along the ground, but despite their mechanical wizardry, these machines caught on slowly. The problem faced by Gray, Crowell, Joseph Jenney and other mechanically inclined inventors was the problem of being ahead of their time: without a suitable means of powering them along, wheel-mounted machines were unwieldy and potentially damaging to bog and berry.

While wheels waited, the bogs entered a hand-held heyday. Hand-held scoops had first been tried out in New Jersey prior to the Civil War, when, according to Joseph White, natural bogs "were regarded as public property," and their cousins had been banned in Boston (or at least Barnstable) even earlier, but they were nevertheless a constant focus of innovation. From small, toothy models wielded on the hands and knees to long-handled models resembling garden rakes designed by the Brothers Grimm, hand-held devices came in a stunning array of innovative designs.

When it came to hand-held innovation, no one topped Daniel Lumbert of Centreville, Massachusetts, who was granted at least eight patents for picking machines between 1877 and 1900, along with patents for a corn popper, tool handle fastener, buttonhole cutter, dish basin and broiler. He was a bog-bound Edison, a one-man inventing machine, a titan of the

Working Cranberries

A typical cranberry scoop, H.R. Bailey Company. *Courtesy of the Carver Public Library.*

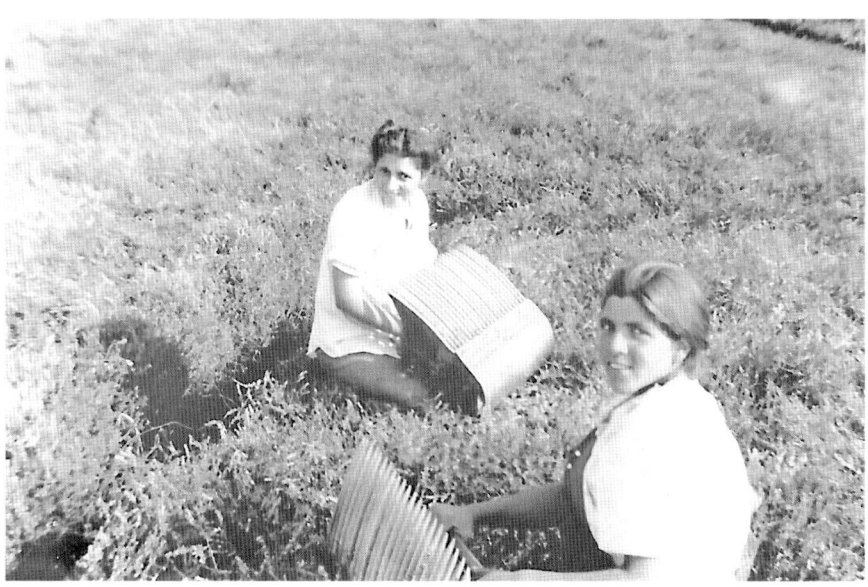

Two women picking cranberries with scoops at East Head, Carver, Massachusetts. *Courtesy of the Carver Public Library.*

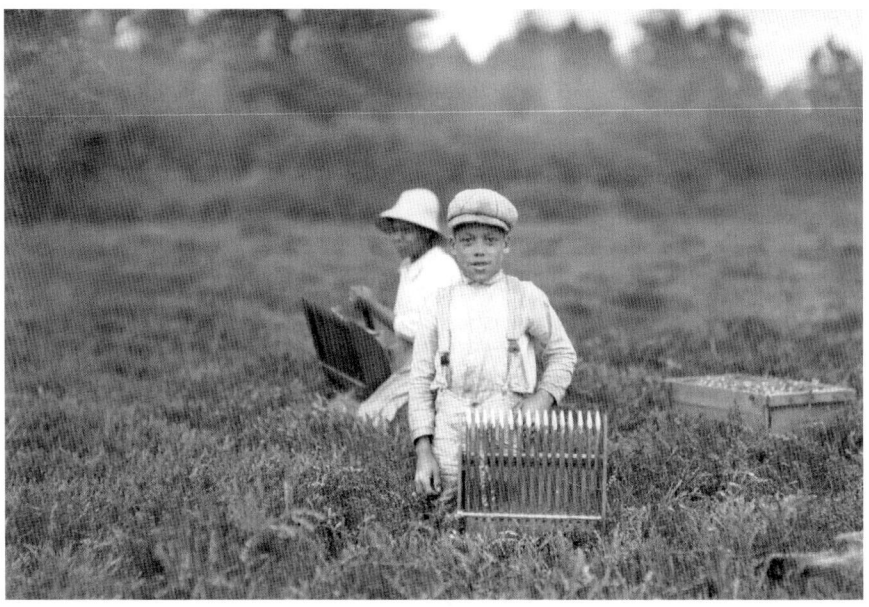

Gordon Peter using a scoop with the metal teeth not covered. Said to be ten years old, he was one of the smallest scoopers. Usually, scooping was done by adults. He had been picking for three years. Makepeace Bog, near Wareham, Massachusetts, 1911. *Photo by Lewis Wickes Hine, National Child Labor Committee Collection, Library of Congress.*

tines. His most successful picker by far was the snap scoop. Roughly the size and shape of a cigar box, open at the front and wielded with just one hand, the snap had a moveable upper jaw fitted over a long set of tines. When the machine was slipped under the vines, the jaws were clamped shut like a toothless alligator, and the whole was drawn back to pull the berries off into the box. In other patents, Lumbert took stabs at designs for water harvesting and an "oscillating front plate," but it was his snap scoop, which required skill rather than strength to operate, that grabbed attention. For many years, the Lumbert scoop was the popular choice on the Cape, particularly for harvesting from tender new vines, and it was often reserved for use by the most efficient, most highly skilled workers.

The most famous scoop of all, however, was the simplest. The earliest surviving patents for cranberry scoops date from just after the Civil War, describing simple machines that look like little more than long-tined combs attached to the open front ends of boxes. Holding the scoop with two hands by a handle on top, a picker simply combed away with a dipping motion. As simple as a scoop was, there were variations aplenty in the size, shape, number and composition of the tines and

construction of the box, and many growers tinkered away to suit their individual preferences. Joseph Weston's scoop of 1873 included a hinged collection box at the rear; Luther and Zebina Hall and William Crowell (nearly Lumbertian in innovation) made improvements in 1878 to avoid the scoop's becoming "so entangled in the vines as to be inoperative"; and the aptly named rocker bottom scoop, introduced around 1900, was an ergonomic wonder. As the usual qualms about damaging vines died down, Joseph White even asserted that by removing old growth and dead grasses, scoops might cause "the bogs to yield more abundantly." Worries about damaged fruit and inefficiency also evaporated. Although scoops could ruin or leave behind as much as 20 percent of the berries—double the waste of handpicking—the increased speed of harvesting was too good to pass up. By the turn of the century, handpicking had slowly withered on the vines, though it still filled a small niche for higher-quality whole fruit. The efficiency of the scoop might even have helped to delay the adoption of mechanized pickers. As long as labor costs remained low, the investment in expensive new equipment could be postponed.

When mechanized pickers arrived, they arrived in a profusion of shapes and sizes, and in their early iterations, they arrived with an apparently inborn tendency to break down in creative ways. Labor shortages during the First World War helped stimulate a renewed interest in mechanical pickers, and before long, a motley army of options could be found ranging from the domestically inspired lawnmowers of Richard de Gray to lumbering tractors. The New England Cranberry Sales Company put its weight behind a tractor-like picker invented about 1920 by a Finnish grower, Oscar Tervo, and marketed by the W.B. Mathewson Co. of Quincy, Massachusetts, beginning in 1925. The Mathewson Picker was a frightening-looking contraption with a revolving cylinder studded with an intimidating array of fourteen rows of recurved steel teeth. As the cylinder spun and the tractor whirred forward, the Mathewson combed a path thirty inches wide through the vines, stripping the berries and transferring them onto a conveyor belt, where they were shunted into boxes at the side of the machine. A single machine with its crew of two—a driver and box handler—could harvest an astonishing two acres per day. Even better, the Mathewson was surprisingly gentle on the berries and bog. Perhaps because it came with a hefty price tag of $2,800 when it arrived on the market (compared to $290 for a new Model T), the Matthewson was adopted by only a handful of larger growers, whose

scale of operations and labor costs made it attractive, but it never found wide acceptance. In addition to the price, the machine was a "mechanical nightmare," prone to frequent breakdowns, as Cole and Gifford point out, and while it was well suited to some varieties of cranberry, it was less so to Early Blacks and other varieties that matted heavily.

As the Mathewson Picker drove on, growers returned to Gray's more compact concept, adding a motor for greater ease of use and efficiency. In a short span after the Second World War, the Stankavich brothers from the beautiful town of Coos Bay, Oregon, introduced the Western Picker, while back east at the Whitesbog Plantation in Browns Mills, New Jersey, Thomas Darlington introduced a walk-behind machine that people refrained from calling the Eastern Picker in favor of the Darlington Picker. These darling little Darlingtons could cover an acre or perhaps an acre and half per day, but they too were met with some trepidation. The reluctance to accept them has sometimes been attributed to an innate conservatism on the part of growers, but there were solid reasons for rejection. Expensive and mechanically finicky, though not quite as much as the Mathewsons, the Darlingtons and Westerns were known to tear up newer bogs, and they inevitably gathered more waste than handpicking did, even while leaving up to 30 percent of the berries behind. When crops were heavy, handpicking turned out to be cheaper thanks to this waste, but when crops were light, machines prevailed. Higher labor costs, overproduction and stagnant prices in the postwar years helped spur the adoption of mechanical pickers, cutting the labor force necessary to harvest almost in half, but both handpicking and machines continued side by side for observant growers to choose as conditions dictated.

Finally, or perhaps not so finally, there was water harvesting, the method beloved by tourists and television. Like a number of wetland plants, cranberries have adapted to the challenges of growing in water, each berry containing four air-filled vesicles (locules) around its seeds that make the fruit float. Detach the berries, the idea goes, and you have a floating mess of fruit that can easily be skimmed off. The identity of the first person to witness floating cranberries was never recorded, nor was the identity of the first person to harvest on water, but the idea is surely old; after all, Daniel Taylor and Jacob Johnson, the young men who drowned in 1739 while collecting cranberries near Westborough, had a canoe with them for a reason, and water harvesting was Henry David Thoreau's preference. For commercial operations, water harvesting was tried out on

occasion before the Civil War before catching on in Wisconsin just after. To harvest the berries, the marshes were flooded, and the crews scooped "on the flood" using long-handled rakes, though a few more inventive sorts devised special machines for work on water.

Growers in the East began to shift to water harvesting in the years after World War II, and a profusion of designs for water harvesters flooded in. Some of these machines operated like waterlogged equivalents of mechanical dry pickers, combing and all, but the most successful machines were called water reels or beaters, which worked by beating the berries off the submerged vines. These were lightly constructed, no-nonsense machines fitted with an axle on which were mounted two or more steel hoops resembling bicycle wheels, and connecting these hoops was a series of steel rods paralleling the axle. As the machine was propelled forward and the hoops spun, the rods beat away, loosening the berries—nearly all of them—which were easily siphoned up when they come to the surface. From the standpoint of cost-efficiency and completeness, water harvesting is hard to beat.

Yet for all its benefits, water harvesting leaves some things to be desired. To begin with, the process requires a great deal of water, which was not a great concern in wet Wisconsin but could be in Massachusetts. More importantly, the name "beater" is unusually appropriate, not only for what the machine does to the water but also for what it does to the fruit. Battered, bruised and blemished, the berries are often rendered unsalable as fresh fruit, and just as bad, the bruised berries deteriorate faster than their dry-harvested cousins, yielding a much shorter shelf life. Fortunately for growers, berries intended for jelly or juice do not have to be beautiful, and the shelf life is plenty long for the fruit to get to a processing plant. As a result, Wisconsin marshes were harvesting more than half their crop on the flood by the 1940s, and since the 1960s, wet harvesting has taken over everywhere, accounting for perhaps 90 percent of the crop today. For that small dry rump, mechanized pickers are the choice, hands down.

After harvesting, the berries were carted off the bog using whatever conveyance was available—or hauled "on shore," to use the nautical terminology favored by early growers. Handcarts, wheelbarrows, mules, specially built bog buggies (rebuilt Model Ts), and narrow-gauge rail systems have all been used, and water harvesters have their own possibilities. To prepare for storage and sale, dry-gathered berries were

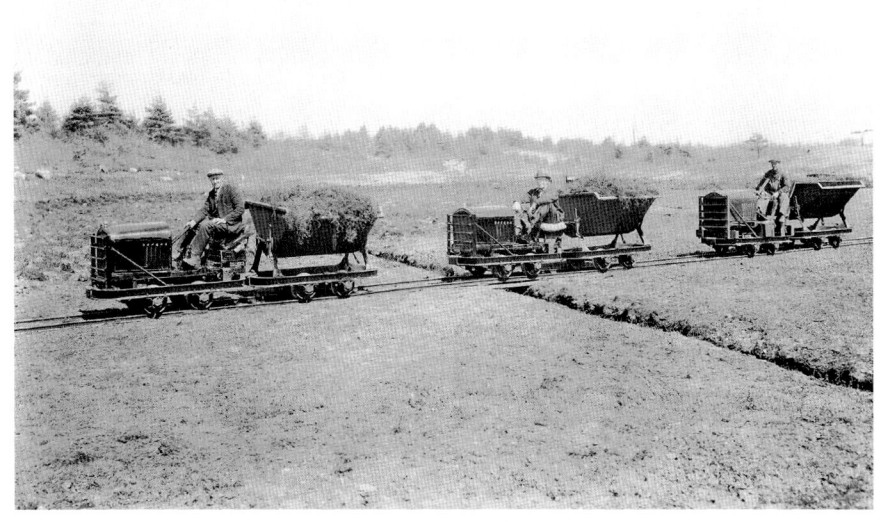

A narrow-gauge railroad in operation hauling cranberry vines for planting, with H.R. Bailey and two unidentified men, undated. *Courtesy of the Carver Public Library.*

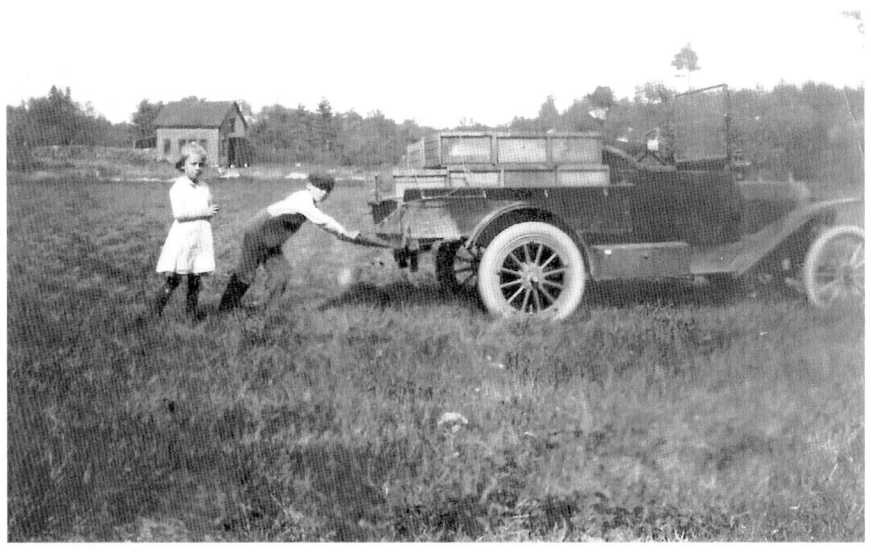

Carting berries ashore, H.R. Bailey, circa 1925. *Courtesy of the Carver Public Library.*

Working Cranberries

generally delivered to a so-called boghouse—which in most cases was no more luxurious than it sounds—where they were spread out on the floor for a day or more to allow them to dry and cool. "If barrelled when wet," James Webb advised, "they will sweat and decay," and of course no one likes a sweaty berry. It was particularly important, according to most observers, to keep them cool (but not frosty) and out of direct light, which sped decay. But lying there dry and cool had its benefits, according to Joseph White, since unripened fruit that was spread four or five inches deep on the floor was found to ripen in a few weeks and acquire a richer, darker color. "This fact was well known to the enterprising inhabitants of the 'Pines,'" he wrote, "who were wont to gather the berries in an unripe condition, in order to secure them before their neighbors." With an eye to economy, Webb suggested that while the berries were cooling and ripening, the second floor of the boghouse could be fitted out as a bunkhouse for employees, the lower room doubling as their cook room.

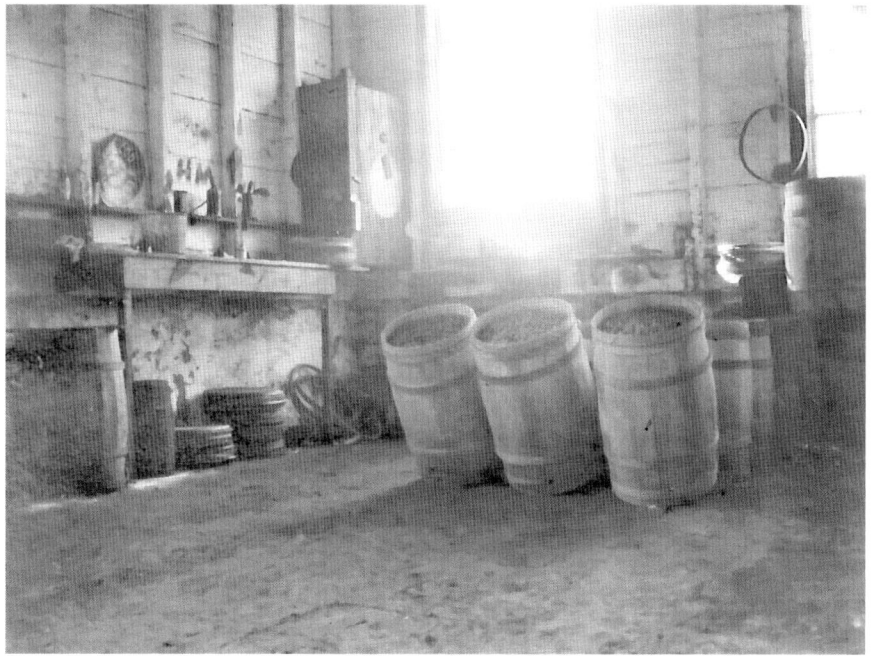

Three barrels of cranberries in a barn shop, undated. *Courtesy of the Carver Public Library.*

Whether picked by scoops, hand or machine, the berries came to the boghouse freighted with leaves, vine bits and spoiled fruit, as much as 10 percent of the volume. To make the berries salable, growers first had to clean, or screen, them. In theory, there was nothing fancy about this operation—just spread out the berries and remove the chaff—but growers tinkered constantly with methods for better screening. At first, they used an unpretentious screening rack or "banjo board," which was little more than an inclined plane about six feet long and three feet wide, with shallow sides and a latticed bottom made of smooth laths spaced about a quarter inch apart. Anyone with access to lumber and nails could make one. Each load of berries was dumped onto the higher and wider end of the rack, and a crew of up to a half dozen screeners, nearly all women, pushed them down the slope, picking feverishly away to remove the debris, the spoiled fruit and the white, unripe berries as the good berries rolled down into a barrel at the end. Seeing that nothing went to waste, growers collected the small, less attractive berries that fell through

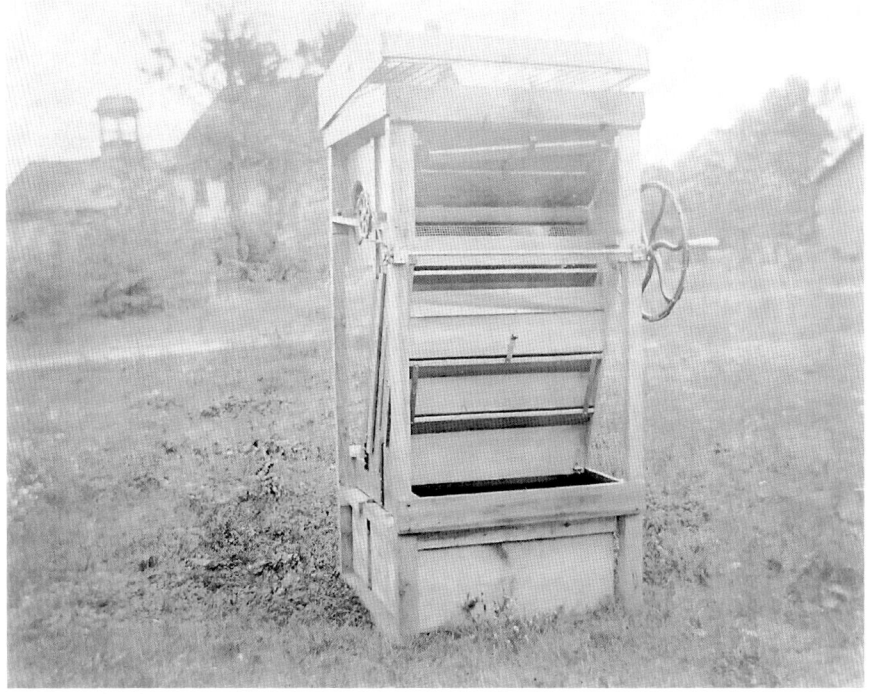

An early cranberry separator, H.R. Bailey, circa 1900. *Courtesy of Carver Public Library.*

Working Cranberries

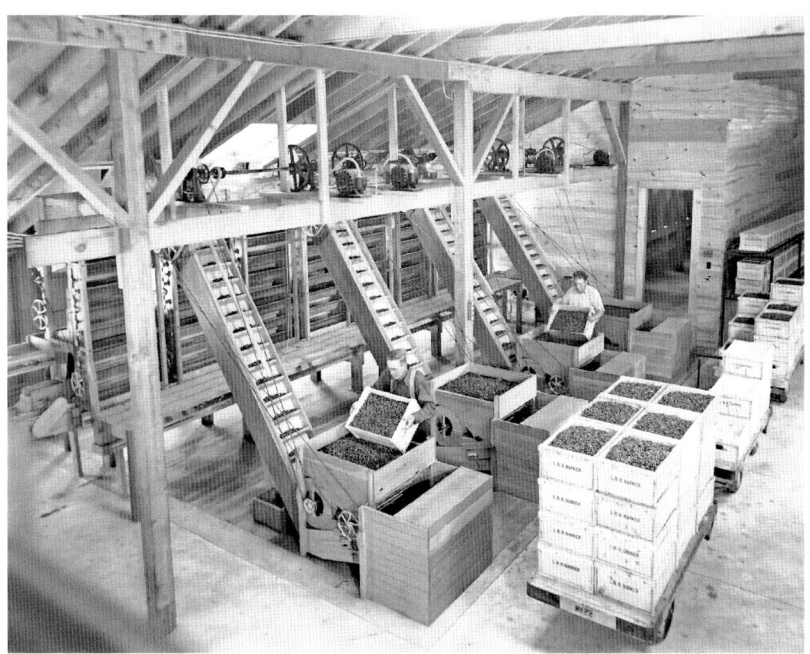

Bailey's Cranberry Separator, L.B.R. Barker, undated. *Courtesy of the Carver Public Library.*

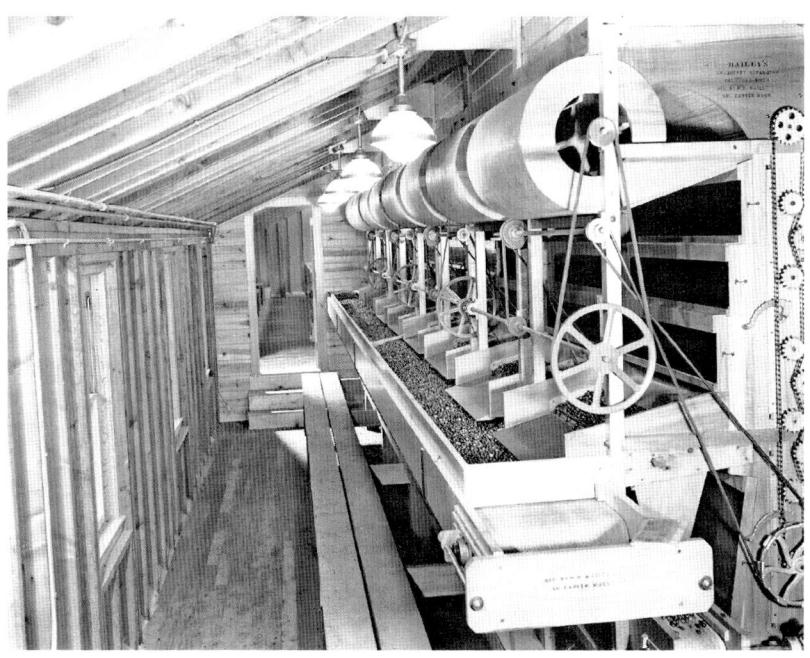

Bailey's Cranberry Separator, circa 1923. *Courtesy of the Carver Public Library.*

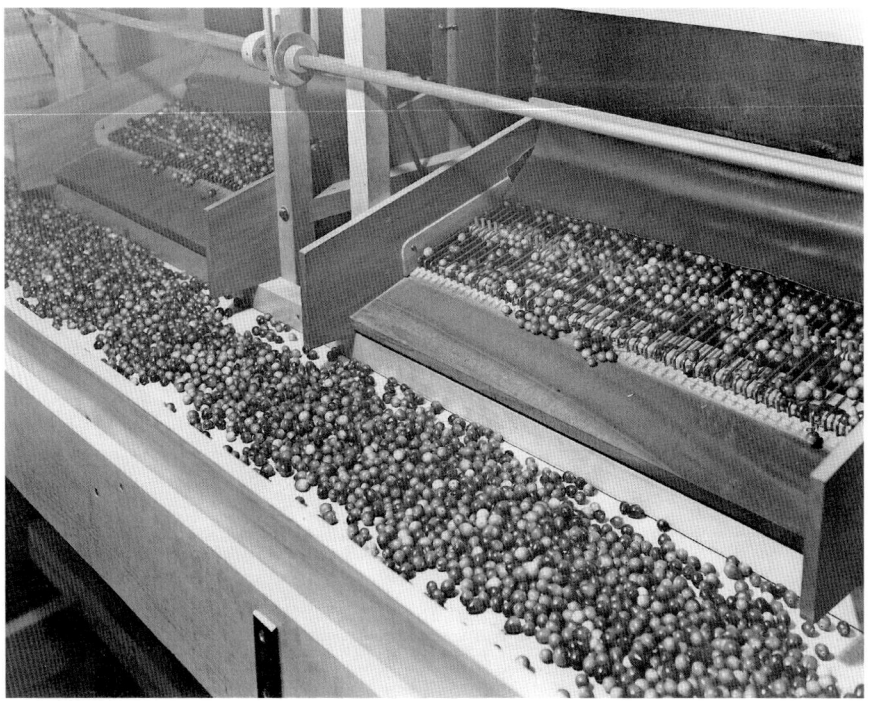

Cranberries on a screening conveyor belt, undated. *Courtesy of the Carver Public Library.*

the slats and sold them for pie. Under a good crust, no one knows how rejected you really were.

When the industry truly took off in the 1860s, growers began to fashion special machines to automate and speed the screening process and make for an even cleaner product. Joseph White took a hint from watching winnowing machines used on grain and proposed mounting a fan so that it blew over the berries as they were poured into a barrel. In principle, the denser berries fell in, while the chaff blew away. Notably, White, the great promoter, refused to patent the invention, presenting his design to the public "for what it is worth." Perhaps as a result, winnowing quickly won favor and was often used in conjunction with screening to get a purer and more valuable product.

Cleaning was a key to profitability and thus attracted an army of the ingenious. In 1881, the Standiford Cranberry Cleaner and Separator was introduced by D.T. Standiford of New Brunswick, New Jersey, at a price of forty dollars, making use of Peg-Leg Webb's bounce principle to separate good fruit from bad—the principle that sound berries bounced

Working Cranberries

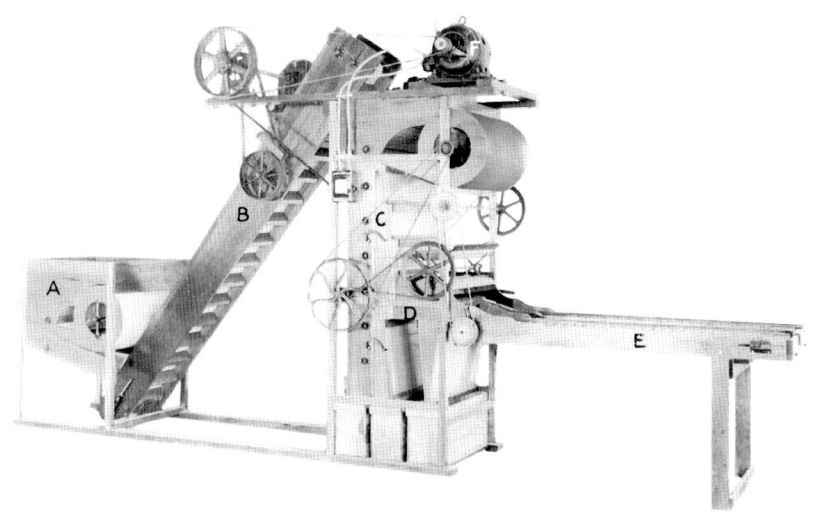

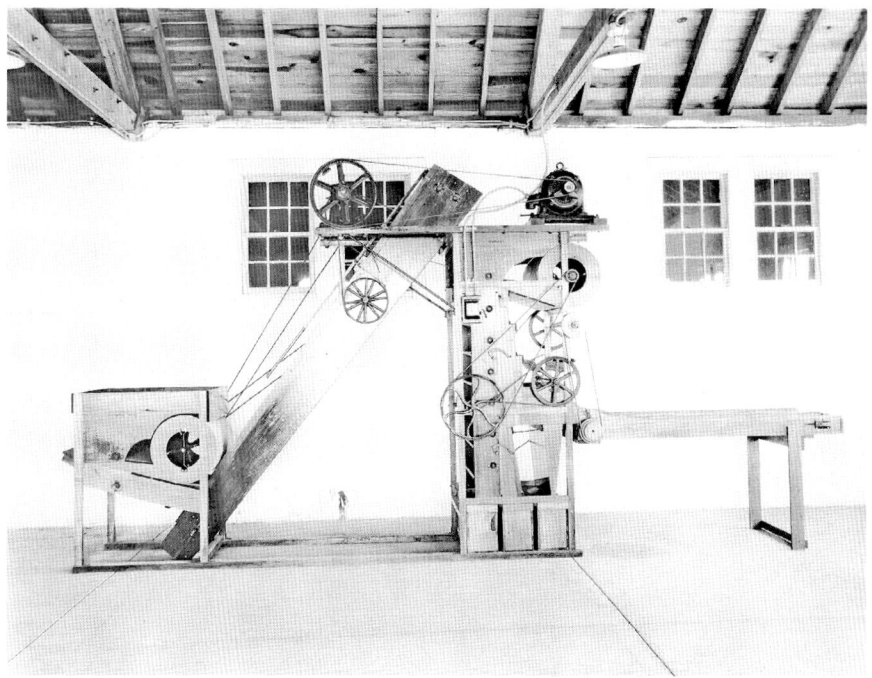

This page: Bailey's Cranberry Separator, circa 1923. *Courtesy of the Carver Public Library.*

when dropped, while poor ones hit with a thud. Mechanical separators like Standiford's could sometimes resemble Rube Goldberg machines, taking berries in at the top and dropping them onto a pane of glass so that bad berries thudded straight down while good ones bounced into another chamber. Tinkering at full tilt, the Buzby Separator followed Standiford, adding a second bounce board for an additional cost of twenty dollars over Standiford's price. No excess is ever enough. The novel, and ultimately failed, Leland Separator took a different tack entirely, shuttling the berries along an inclined conveyor belt where the sound fruit rolled backward while the rotten marched on. Other inventors added winnowing machines at the top to blow away the chaff; toyed with the size, number and placement of bounce boards; or added wire graders at the end to sort out smaller pie berries from the choice fruit. On an elaborate Bailey's Improved Cranberry Separator, berries passed through two or three screening processes before moving along conveyor belts in front of women who handpicked and discarded any unacceptable remnants. Sorting by color also followed, with different regions of the country developing distinct aesthetic preferences. New Englanders had a taste for the dark, while the West Coast had a penchant for pink.

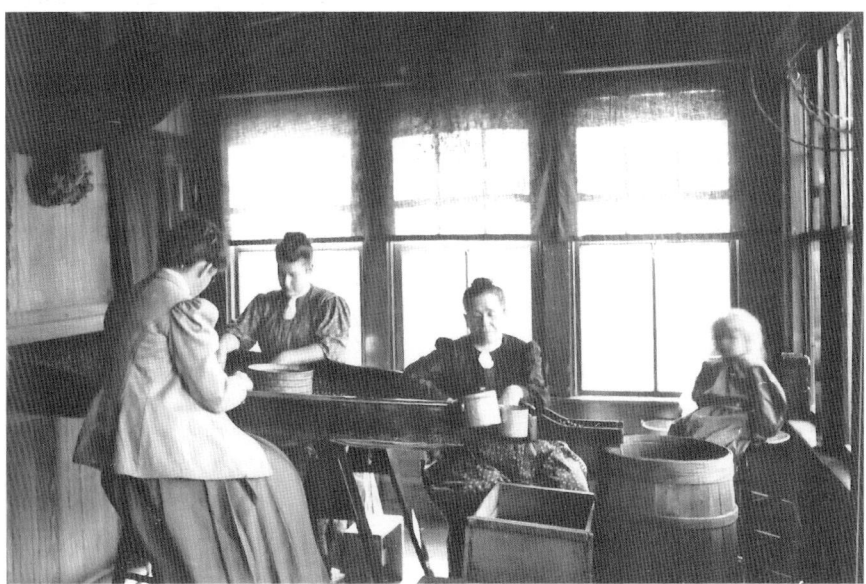

Screening cranberries, Carver, Massachusetts, circa 1900. *Courtesy of the Carver Public Library.*

Working Cranberries

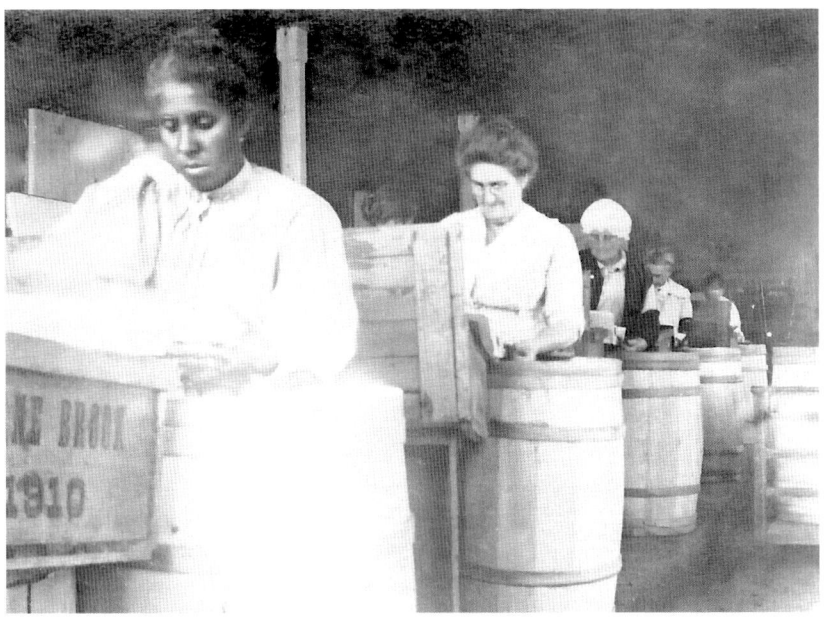

Women screening cranberries, circa 1910. *Courtesy of the Carver Public Library.*

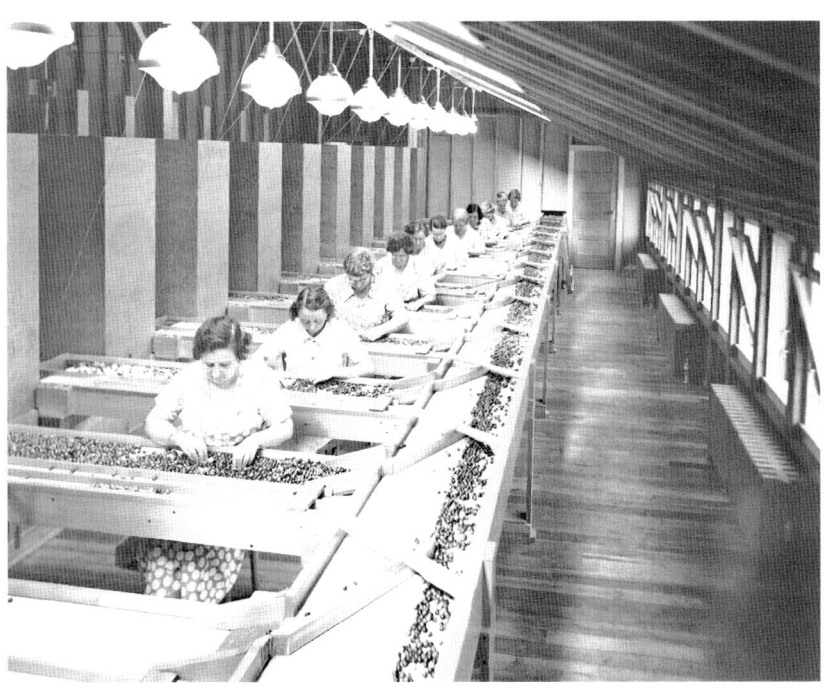

Women screening cranberries in a screening room, circa 1950. *Courtesy of the Carver Public Library.*

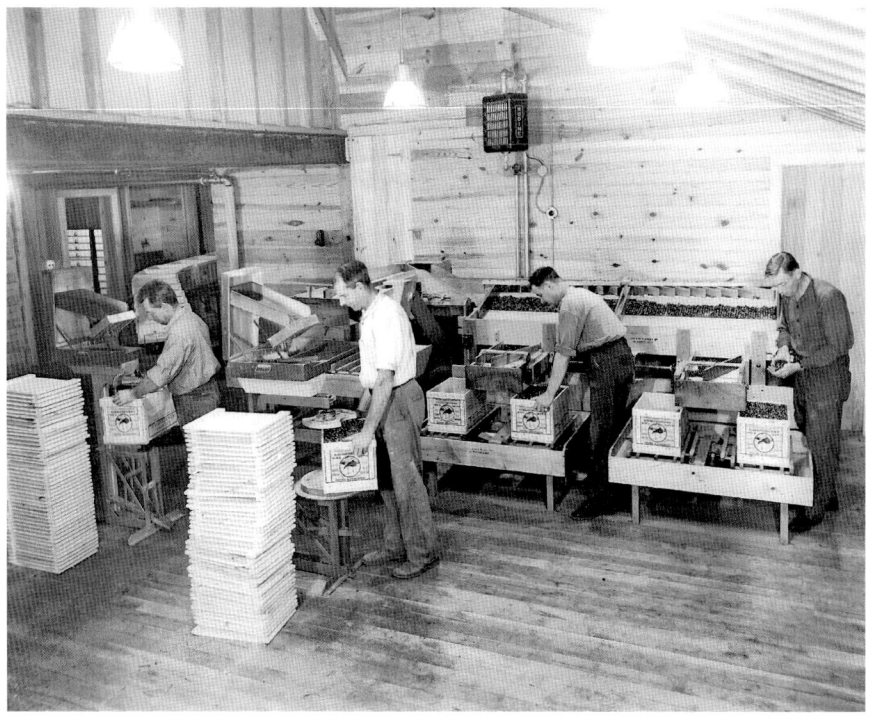

Cranberries being crated for shipment, undated. *Courtesy of the Carver Public Library.*

After all this cleaning and screening, winter work on the bogs began, and although far fewer workers were employed during the bitter months, their work was essential to commercial success. Sometime between October and December, depending on conditions, flooding (or flowing) was required and sometimes several episodes of flooding before the warmth of spring arrived. In a flooded bog, a protective sheet of ice formed during the heart of winter like the head of a frigid drum, leaving a pocket of air beneath. Now, from the time of Henry Hall, growers had been aware that a layer of sand added to a bog every three or four years brought the best out of their vines. Unlike young runners, longer and more mature vines do not readily root when they come in contact with the sand, but burial changes all that, causing even the vines that are longest in tooth to root and renew. They respond lushly. Quite ingeniously, Augustus H. Leland of Sherborn, Massachusetts, recognized in the 1830s that the thick sheet of ice was an opportunity. Walking across the flat surface of the ice, he saw that it would be possible to spread an even layer of

sand without even the possibility of damaging the plants huddled below. When the ice melted in spring, the sand would settle evenly and gently around the plants, and the benefits flowed. If there was any downside, it was that a thick layer of sand reduces the penetration of light through the ice, potentially depleting the oxygen in the water. Growers adjusted to this problem, too, draining the water from beneath the ice so that the plants were embraced by oxygenated air.

There was other work to be done before spring: replacing sluice gates that had been removed or damaged, clearing ditches, fixing washed-out dikes and, if fortune prevailed, clearing new bogs or revitalizing old ones. Even in the loneliest months of the year, the bogs required tending, and tending required workers.

Workers Working

Until the 1880s, most bog workers were recruited locally, and considering the small size of most operations, local labor sufficed. Just as they had descended on public lands in generations past, waves of pickers appeared at bog's edge at harvest time. All it took for help to flock "from all directions," according to Rounds, was a notice announcing when the harvest would begin, and crews would fill up with family, friends and neighbors, a true reflection of their local communities, with "people of both sexes and all ages," as a newspaper reporter put it in 1885, "and all stations in the life of a country town." On Daniel Rounds's bog in Norfolk, Massachusetts, the crews presented a homespun appearance:

> *Two or three were school children a dozen or fifteen years old; three or four were men whose other employment was so irregular or unremunerative that two or three weeks in the cranberry meadows seemed by no means an undesirable task, but the majority of the pickers were women—sturdy housewives of the younger generation, middle-aged matrons, and young ladies of well-to-do families.*

It was not just the neighborhood poor who came. Rounds insisted that "ladies from some of the best families in town" came too, seeking "pin money" and a diversion from the humdrum of daily life. They were "a

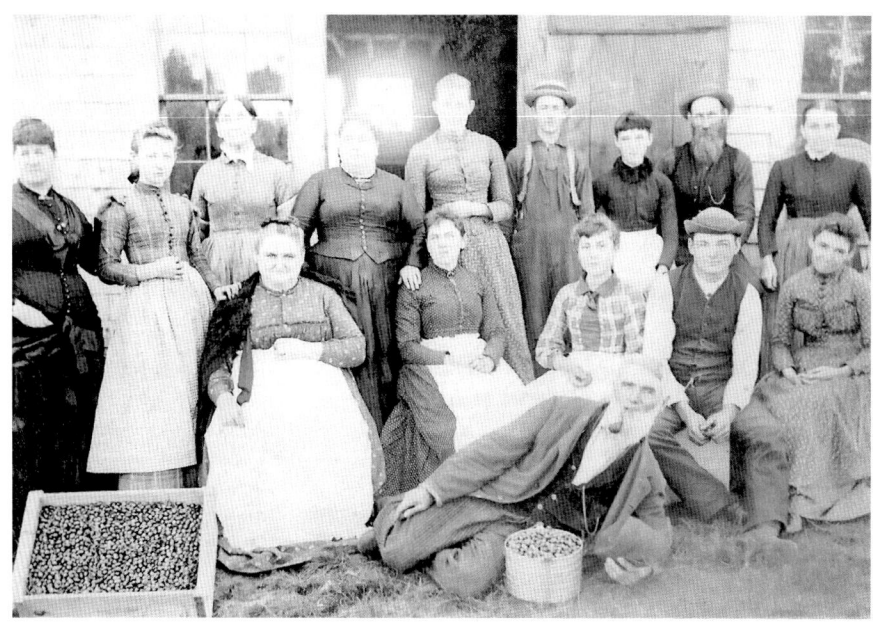

Handpicking cranberries in the Adams-Keith Bog, Summer Street, Kingston, Massachusetts, circa 1895. *Courtesy of the Local History Room, Kingston Public Library.*

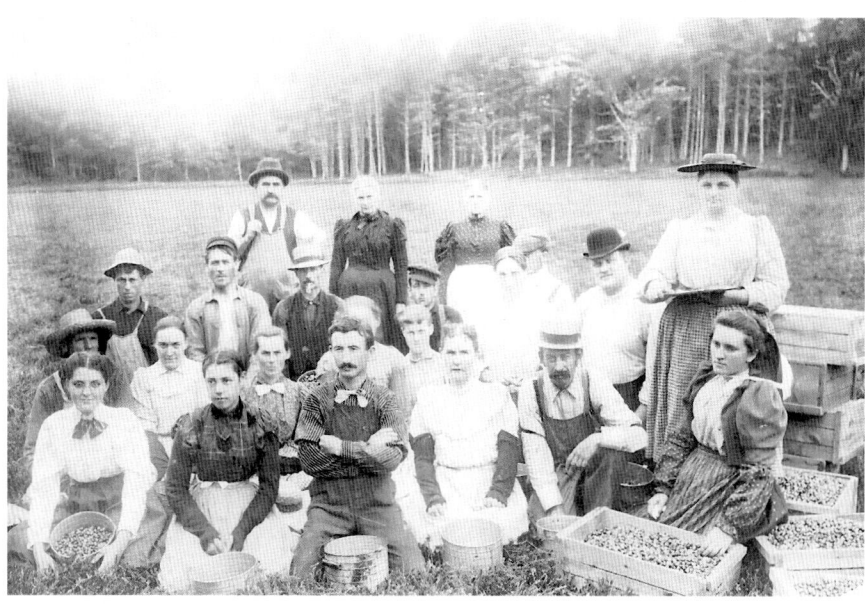

Cranberry workers at the Alfred Shaw Bog, Carver, Massachusetts, circa 1900. *Courtesy of the Carver Public Library.*

jolly set," said Rounds, and many looked "forward to picking time as one of the pleasantest seasons of the year."

For the newspaper reporter, too, jolly was the operative word for the colorful pickers: "Their laughter and merry-making were in sharp contrast with the gloomy aspect of the clouded sky," he wrote, "as were the bright colors of the shawls and hats in contrast with the deep green of the vines about them." Rounds enhanced the festive mood by throwing clambakes on Saturdays—other growers sponsored dances or picnics—and the high spirits and bog's contrarian tendencies turned expectations comically upside down. "One young man talked and laughed freely while picking berries industriously," according to the account, "all the while wearing a hat of unmistakably feminine design, but a fair average was maintained by a young woman who wore a hat of as unmistakably masculine style." It was a surprising sight for the reporter: "None of the workers seemed aware of the presence of a stranger," he wrote, "while all bowed in one direction like faithful Moslems at sunset kneeling toward Mecca."

The camaraderie of the bogs and their hint of the exotic captivated the imaginations of writers, journalists and tourists alike, and the impression of fun and frolic became part of the cranberry story. The harvest in Wisconsin was remembered as a "hilarious outdoor holiday," according to one grower, and during the early years of the industry there, the daughter of another grower recalled sights as exotic in their way as the mecca of the Cape:

> *It was exciting to watch the Indians from the reservation at Valley Junction, and others farther away, drive through town in their double buggies and light wagons hitched to Indian ponies. The vehicles were loaded with tents, gay colored blankets and other belongings, plus the never failing family dog. It was an exciting change from our usual humdrum day.*

On the train from Babcock and Tomah, other pickers came, she recalled, "loaded down with bedding, clothing and children...They were always full of life, singing and laughing as they came tumbling out of the coaches, scrambling about to find the big lumber wagons with hayracks that would take them to their particular marsh." It was all a great lark, and after the turn of the twentieth century, this colorful lark became the stuff of myriad postcards sold throughout Cape Cod and New Jersey.

Yet even such light-hearted accounts contain hints of the changes that were transforming the cranberry business into the cranberry industry. The pickers' camaraderie was surely real, as neighbors came together for the first time in a year, meeting old friends (and drawing pay). But while picking "wasn't difficult," as one commenter observed, "it was rather disagreeable and arduous," and some felt the burden more than others. Even amongst the jolly set on Daniel Rounds's bog, there were workers, "more sedate" than the rest, who "paid strict attention to business and took no part in the jollity."

Picking was no picnic. With or without scoops, it was a whole-body operation. Hand-pickers spent their days kneeling on soft, wet turf, bent forward, grasping a few vines at a time in each hand, palms up, and drawing back to pull the berries off in bunches. Reaching forward, inching forward, shuffling forward, they repeated the action over and over again. Scooping was even more physically demanding, requiring both hands on the heavier instrument, exercising the shoulders, the back and the abdomen in concert as they dipped down beneath the vines and up again. And so on. Eight hours of grubbing on the ground put some very fine points on a very long day, and as the daughter of one Wisconsin grower recalled, it put fine points on the hands especially. "The harsh vines," she recalled as on old woman, "would jab the flesh around the fingernails, causing them to bleed." Pickers learned early to dress for success rather than style, donning a worker's armor against the rigors of sun, wet soil and wire-like plants, sporting sometimes comical combinations of broad-brimmed hats, thick skirts or pants with padding sewn into the knees, long sleeves to protect from the wiry plants and heavy gloves with the fingers snipped off to preserve dexterity. The comedy of a man in a woman's hat and woman in a man's hat takes on a different meaning in light of the necessity of protective gear. It was all a wonderful scene for the casual tourist and onlooker, but no matter how well attired a picker was, the constant dampness, bowing and shuffling left raw and aching bodies to last a season.

More difficult than the physical challenge of work was the challenge of what work had become. No two bogs were run in precisely the same manner, and even on the same bog, two laborers side by side could have very different experiences. Yet for all of them, the fundamental nature of how work was conducted in America—not just on the bogs—was evolving. Increasingly by the 1880s, growers began to adopt labor

practices more closely associated with mills and mass production than traditional farming, and they began to impose ideas about discipline and efficiency drawn straight from the factory floor. The bogs became more regimented, the crews themselves were transformed to such a degree that the idyllic notion of a community acting in gleeful unison became a laughable relic, remembered with the same sense of nostalgia (and same degree of myopia) as antebellum plantations were remembered in the South. It was comforting to imagine a gaggle of jolly young women kneeling for pin money, but the reality was far more complex when the pressures for production and efficiency escalated.

Pin money barely describes the situation for most workers. Well into the twentieth century, most pickers were paid by the quantity harvested—piecework. Early in the game in 1830, Henry Hall paid his crews twenty-six cents per bushel; by the mid-1850s, wages had risen to thirty-five cents; and in the 1890s, the price topped out at around nine cents per six-quart pail, or roughly forty-eight cents per bushel. A top-flight picker at the time of the Civil War could surpass a dollar a day for the six-week season, or even two dollars a day for a "'right smart' picker," according to Joseph White. Any way it was counted, it was a reasonable wage for an unskilled worker at a time when Union soldiers earned just thirteen dollars per month.

On the job, piecework took on a distinctive dynamic, one that was tied into a complicated set of changes that extended from fingertip to fingertip, from picking to recordkeeping. Pickers were not simply released to pick away on their own; rather, they were inserted into a carefully regulated environment. Having been planted in a grid, the now ready-to-harvest bogs were marked out in parallel rows using cords stretched across the ground a few feet apart. As soon as the dew was off the berries in the morning, workers were ordered to line up at one end of a row and with rectilinear logic, they progressed, picking their way along, never deviating outside the lines and leaving nothing behind but vines stripped bare of berries.

Not every picker was equally quick, of course, but White advised growers to keep their crews in lock step, marching with straight-line precision. To accomplish this, he recommended that the slowest pickers be assigned to narrower courses and the faster to wider, and as James Webb advised, "No one is allowed to leave his place and go elsewhere unless his section is thoroughly and completely picked." It is easy to see that course

assignments made all the difference to a piecework picker scrapping for pay, since rows were no more similar than pickers in quality. Along the edge of the bog, berries were sparser, meaning pickers could never earn as much as those assigned to the more prolific center, and a narrower row was naturally less remunerative. Not surprisingly, assignments often led to discord between the cords, pitting picker against picker and picker against management.

On this score and others, bog workers and bog owners did not always see eye to eye, and each side quietly (or not so quietly) tried to impose its will on the workplace. For their part, growers tried to shape their picking crews into hummingly efficient machines, starting with their equipment. At one time, pickers had been required to bring their own containers to hold the harvest as they scrambled along, but growers complained that this led to mishandling the fruit when the berries were "poured into bags, and used for seats by the pickers," as White wrote, "or thrown over their shoulders and carried half a mile or so, over a rough road." Even worse, the lack of uniformity in containers made for difficulties in recordkeeping and settling accounts, requiring each picker to have his or her harvest measured and recorded individually. Uniformity, they concluded, begat efficiency.

To this end, New Jersey growers in the 1860s adopted a standard peck-sized box to hold the pickings, with a six-quart measure following in Massachusetts by about 1880, and in both places, growers adjusted how they organized the harvest. Placing barrels or boxes directly on the bog at regular intervals, they sent pickers out with standard-sized pails in hand, and when these were filled, pickers were expected to shuttle over to the barrels and dump their pickings, receiving a ticket in exchange that could be redeemed for cash at the end of the season. Yes, season. The tradition of paying workers only when the harvest was complete began in the earliest days of commercial cranberrying, and despite the pickers' grumblings, growers were reluctant to change. With little cash on hand, tickets circulated locally as money or, in larger operations, were used for credit at company stores.

James Webb introduced the even simpler tally system in Massachusetts in 1886, which avoided the need even for tickets. Pickers were assigned numbered pails, six quarts in size, and when these were dumped, the overseer simply placed a check next to that number in a record book. With a certain flourish, Joseph A. Hinchman advocated using a different

colored pencil for each day of the harvest, allowing him to track progress through time—and to track each of his workers as the harvest progressed.

Tickets or tally, for this system to work, Eastwood insisted that "there must be a superintendent or overseer" or else the pickers "will be apt to slight them." With piecework, pickers aimed to gather as many berries as possible as quickly as possible, often gathering only the low-hanging fruit—or in the case of the confounding cranberry, the high-hanging fruit—leaving behind anything more difficult to reach. But this was precisely the growers' problem, for "the interest of the cultivator," as Eastwood wrote, "is to have his vines picked clean." A berry skipped was money skipped. The solution, as growers saw it, was to introduce proper policing and above all proper discipline. With determination and a firm hand, according to White, it would be possible "to properly discipline" pickers and insist they "pick clean" rather than fast. "This may be done," he suggested, "by calling them back in a pleasant, but decided manner, to gather any berries that may have been found after them. They will soon take the hint, and perform their work carefully." As the crew toiled away, then, overseers loomed on the side, eagle-eyed, calling out berries that had been missed and requiring pickers to return to the scene of their error and mend their ways.

What constituted a "pleasant, but decided manner" depended on where one stood or knelt. The dynamic of supervision and confrontation that developed on the bogs became a reflection of a much wider conflict between owners and workers, a conflict that was played out in the midst of a savage economy. Employment in Gilded Age America was notoriously insecure; it was unstable, brutish and frequently exploitative. It churned. And every few years, an economic crisis arrived to choke the lives of many in the lower classes, contributing to an ever-widening gap between poor and rich. Industrialists were highly effective in this environment at uniting behind a common set of interests, bending national and state policies in their favor like blades of grass beneath their heels, and workers, at least occasionally, enjoyed successes of their own, banding together to fight for the eight-hour day, better pay, better working conditions and, simply put, greater respect.

In their small way, and their small industry, cranberry pickers found many avenues, alone and in unison, to challenge ill treatment and exploitation. They were learning to be labor, and they resorted at times to remarkably subtle tactics to attain their goals. At the Halfway Bog

in Plymouth County in 1895, according to a report in the *Boston Globe*, owners were forced to switch from tin pails for collecting berries to paper because, as they complained, "the pickers are up to all kinds of tricks." After a few days of heavy use, a six-quart pail barely held five thanks to the "accidental" denting of the bottom and sides that reduced the volume. Covertly, workers made their point. Growers responded in turn by demanding that pickers present pails that brimmed over with berries to compensate for any bruised fruit, leaves or twigs they might contain, raising the stakes without addressing the core issues.

A subtle comment could be just as effective, if a story told about the Cranberry King Abel D. Makepeace is to be trusted. While workers were carting loads of sand across his bog one day, Makepeace stood by observing, greeting each worker as he passed with a hearty "Good morning" and receiving the same in reply. After watching one man carry several light loads in a row, however, Makepeace chirped, "Good morning, small load," to which the worker replied without missing a beat, "Good morning, small pay." Chastened, Makepeace raised each man's pay the following week.

As small as the cranberry industry still was, the spasms of the American economy transformed the crews themselves. In the mid-1880s, Daniel Rounds found a ready supply of pickers locally among the native-born Yankees, but ten years later, the owners of the Halfway Bog discovered they could not, largely because so many of the natives had turned elsewhere for work. With the acreage devoted to cranberries increasing and a decreasing willingness of native Yankees to accept such menial jobs in the 1890s, growers all across the cranberry lands turned to cheaper and supposedly more compliant immigrant labor, skimming off the latest destitute waves that crashed on our shores. Many immigrants stepped off their ships into the least-paid, least-skilled and least-secure sectors of the economy, riding the ups and downs of limitless uncertainty.

The cranberry crews on Cape Cod were surprisingly diverse. "Kanakas" (Polynesians) from "the western islands" could be found in early years, having come to the region as a result of New England's ties to whaling and missionary work; and Finns, Russians and Swedes were thick on the ground, according to the *Boston Globe* in 1892. There were French Canadians from Fall River, New Bedford, Providence and the cotton mills of Boston; and "Portuguese in whole families" came out, including both white Azoreans and black Cape Verdeans; along with

diminishing "swarms of native Cape Codders," who came "from the 'tip end' of Yankeeland and intervening points along shore." New Jersey and Wisconsin would pad the list to include northern and southern Italians, Poles and African American emigrants, Oneida Indians, Puerto Ricans and even German prisoners of war during the Second World War. One wave of immigrants supplanted the next in a Moebius strip of mobility.

At the turn of the twentieth century, Cape Verdeans dominated picking on Cape Cod, supplanting the Finns who had supplanted the Yankees. The first Bravas, as they were called after their port of origin, arrived during the autumn of the cranberry boom, and by the 1890s, small schooners known as "Brava packets" made regular runs to and from the islands, as the *Boston Globe* reported in 1892, with emigrants packed in "like herrings in a box" for the month-long voyage. Port cities like New Bedford had long been home to a Portuguese-speaking community thanks to the importance of the Atlantic islands to the whaling and fishing trades, and members of these communities spread throughout the local economy. These earlier immigrants, mostly Azoreans, were distinct from the Bravas, speaking a different dialect of Portuguese and, most importantly for race-obsessed Americans, being lighter in complexion.

In the cultural context of the day, African features marked Bravas as separate but unequal, and each immigrant group congregated in its own neighborhood, separate from the Yankees, French Canadians, Finns and others. With no Jim Crow laws on the books in Massachusetts, segregation was never quite complete—Brava children sat next to whites in school—but neither did integration come easily. "The Americans and French regard [Bravas] as most communities regard negroes," the *Globe* noted, and racial tensions simmered. Sounding like so many other opponents of civil rights, some whites on Cape Cod asserted that Bravas were "asserting" themselves or "making themselves more offensive" by deigning to ride in the front of streetcars, and Bravas were subjected to a steady patter of comments from whites on their manners and dress. With equal measures of fascination and revulsion, they were lauded for their industry and thrift in one breath and berated for their primitive ways and intellectual shortcomings in the next. "The Bravas have a much higher moral code than one would suppose," proclaimed the U.S. Commission on Immigration, "judging by their ignorance and their standard of life. They are efficient, faithful under close supervision, but very illiterate, and neither resourceful nor intelligent." Fortunately, or so it seemed, they

"rise to nothing higher, as a rule" than to become a lowly bog laborer, and on most bogs, they inevitably toiled under the eye of a white overseer.

Based on months of close study, the U.S. Commission on Immigration understood the seasonal rhythms of Brava lives. Every August, they reported, Bravas "emerge from the mills of New Bedford, from the docks in and about Providence and Fall River, from the oyster boats along the coast, from the ranks of the longshoremen, and here and there from out of the woods and wilds in the vicinity of the cranberry districts, and by twos and threes, by gangs, by hundreds, make their way to the fruit-laden bogs of Plymouth, Barnstable, and Nantucket." Ripening as the first bare touch of winter descended and work slowed into the stupor of hibernation, the cranberry harvest became an important mark on the calendar for many in need. This fruit, the most local of agricultural products, became tied in a new way into a larger world of work and identity, bearing new marks of our old economic history.

The seasons were felt with just as much intensity to the south, where the poor of Philadelphia washed to and fro across South Jersey in rhythmic waves, alighting wherever the vines set root. In industrial fashion, pickers were hired en masse, recruited by contractors, whole families at a time. This was not the jolly community of Cape Cod myth; this was not the hoi polloi:

> *Practically all these pickers who are heads of households or are past school age, have some occupation included under unskilled labor. A host of ragpickers are represented, many street sweepers, pick-and-shovel men, on streets, construction work, around the docks or on the steam railroad construction work; a fair percentage of the younger men and some women work in glass and cigar factories, some in machine shops or iron foundries. There are concrete mixers, hod carriers, garbage handlers, push-cart men, fruit dealers, a few workers in electrical or bicycle repair shops, a hotel porter or two, a keeper of a pool room, a barber, shoemakers, liverymen, and a large number who report that they "do anything we can find to do; some day streets, some day railroad, some day hod"... "Rags and railroad" is a frequent reply to "What occupation?"*

As winter receded in Philadelphia, contractors swept the city's Italian districts promising good wages, free fuel and rent, a chance for the family to work together and delightful fresh air for all. And the poor responded.

Working Cranberries

By mid-May, a high tide of workers swelled out of the city streets into rural Cumberland County to take part in the strawberry harvest for a few weeks and then shifted to Hammonton and Winslow for red raspberries and early blackberries, some making a brief trip home in between, others moving directly from field to field. By the last week of July, when the blackberries had played out, many pickers returned to the city on hiatus, but others trudged on to gather late berries or huckleberries; to work tomatoes, peppers or cucumbers; or to pull shifts in the canneries until the cranberry season commenced. When that, too, drew to an end in October, the children at last returned to school, and the contractor once again fell back on "his shop, factory, pool room, fruit stand, janitor work, or other occupation in Philadelphia." To the commissioners of immigration, this great migration was "the real work of a great body of laborers, not an incident, but a vocation."

With so much rambling energy, crews were drawn from farther and farther away, and owners found it necessary to offer housing to support their crews. Never luxurious, these accommodations were seldom more

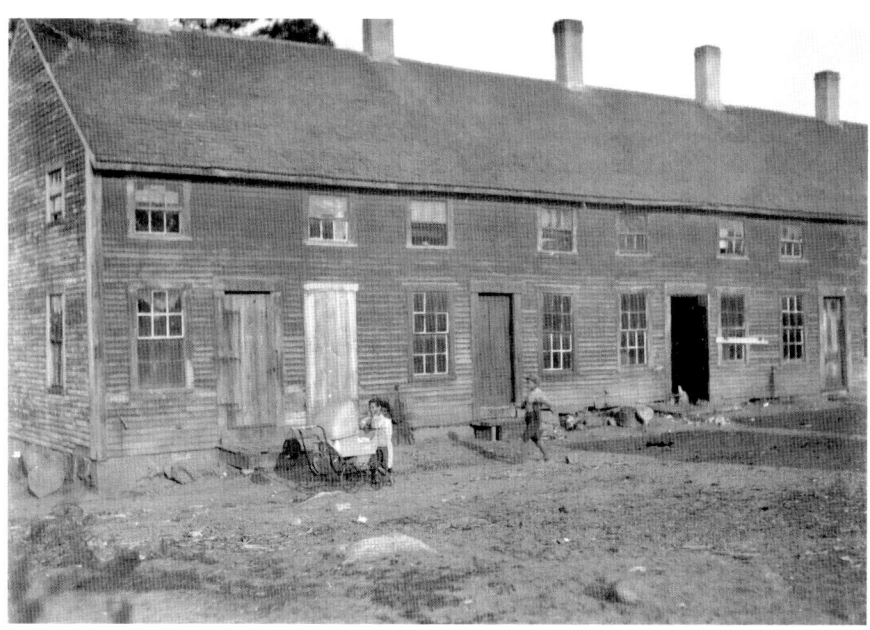

A crowded tenement used by cranberry pickers ("Bravas") or black Portuguese. Wareham, Massachusetts, 1911. *Photo by Lewis Wickes Hine, National Child Labor Committee Collection, Library of Congress.*

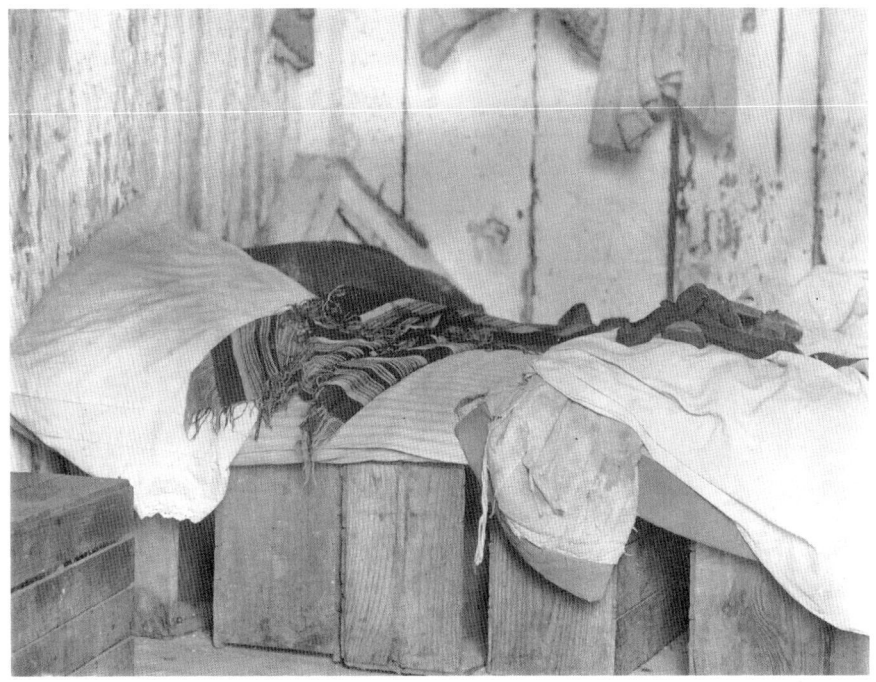

A small shack on Forsythe's Bog, occupied by the De Marco family of ten. Wooden toilets near at hand, and bushes used as such, gave forth offensive odors. Turkeytown, near Pemberton, New Jersey, 1910. *Photo by Lewis Wickes Hine, National Child Labor Committee Collection, Library of Congress.*

than "rude shanties...scantily furnished," ranging in size from tiny individual wooden shacks to two-story frame houses containing shared living space on the ground floor and sleeping quarters above. "There is rarely found in them any evidence of home comforts," one observer commented. Drafty and cramped, they often lacked running water or sanitary facilities, providing maybe a camp stove, a table or lamp and beds that were little more than palettes, "rude boxes filled with straw" or a raft of boards with a thin mattress slung on top, when slung at all. They were also crowded. On a bog near Spring Hill, Massachusetts, ten Finnish men and two women were reportedly packed into a shanty barely ten feet by twelve. According to the Commission on Immigration, the shanties were cleaned "periodically under the supervision of the superintendent," the all-seeing eye of the bogs, "but otherwise no attention is paid to sanitation." Some workers struck out on their own, living in abandoned houses, tenements or shacks thrown together in the woods.

Working Cranberries

If anything, the housing was worse on the bogs of New Jersey. As the Immigration Commission noted, the attitudes of growers matched the shanties:

> *The morality, health, and general well-being of these workers seem not to appeal at all to the grower. Although he may speak with disgust of their filth and low standards, it never occurs to him to ameliorate their condition or study their well-being. Every added comfort or decency is to him only an added expense. "Every year they ask for more improvements, they'll want beds next," said one wealthy grower who refused to furnish mosquito netting for their windows. Labor to many of these men is merely a commodity. The human element rarely enters...A picker's union would accomplish much, but the provincial jealousies must first be overcome.*

Such squalor earned only occasional comment in local newspapers, which were usually aligned with the interests of bog owners, and reporters usually explained the conditions away by asserting that pickers were there only briefly and came with "only one point in view—that is to make money and as much of it as possible." Exhaustion, poverty and the lack of alternatives might also have been considered, but seldom were, though one perceptive reporter made a salient observation: the owner's homes were "quite luxurious when compared with the dwellings which the pickers occupy." Luxurious might well have been an overstatement, but comparatively speaking, luxury it was, and disparity—in treatment, respect, opportunity—came to shape the bogs.

5

Cranberry Work

The *Dallas Morning News* of November 8, 1892, reported:

The streets of the towns [on Cape Cod] have an unwonted bustle. One meets groups of prospective pickers walking briskly along, each carrying a bright new tin measure or picking pail. Wagons loaded with men, women and children rattle along, and cranberry picking is on every tongue.

Cranberry time is a sort of subdued mardi gras to the poorer classes of Cape Codders, a prolonged picnic that means the earning of a comfortable little sum to lay by for the rainy days of the coming winter when work is scarce and there are no city folks to bleed. By the middle of September the little settlements that are scattered throughout the Cape are practically deserted; the inhabitants, one and all, have departed for the bogs. Most of the larger bogs have houses for the pickers, and those who come from a distance occupy them while the bog is being picked... The houses or "shanties" are furnished only with stoves and bunks built against the wall, one above the other. Many of the pickers bring their own cooking utensils, bedding, etc. The sleeping accommodations are not all that could be desired. Few of the shanties contain more than one room and the occupants of it are all piled in together at night; the more numerous the pickers the closer they are packed. For this reason the bogs that are more remote from settlements are obliged to employ foreign labor in order to get their cranberries picked, the better class of Cape Cod natives preferring to pick on bogs that are near enough to their homes to be reached conveniently by carriages.

Cranberry Work

> *Large numbers of Italians and Portuguese from New Bedford, Fall River and other adjacent towns flock to the cranberry region each fall, attracted by the easy work and good wages... This foreign element is rough and difficult to control. For this reason many of the more responsible of the native pickers are made constables to preserve order in the pickers' camps. Serious rows often occur, and there have been several murders among the foreign pickers during the past five years.*

If it bleeds, they say, it leads, and newspapers did plenty of leading when it came to cranberry bogs. The *Boston Globe* reveled in reports of strikes and bloodshed on Cape Cod, such as the 1893 incident in North Carver where several hundred pickers—identified as Irish and French Canadians from the cotton mills of Fall River and Boston—got into "two lively rows" after seventeen gallons of whiskey were smuggled into the shanties. While playing cards, "all hands being under the influence of liquor," a French Canadian named Louis Denneau was knifed while defending a countryman being beaten by the Irish, igniting a mêlée involving nearly seventy-five men witnessed by nearly one hundred more. So fierce was the fray that the doctor refused to attend to the wounded until the bog superintendent intervened, and even then things did not settle down. After a time, the local constable arrived to find the lights in the men's quarters ominously extinguished, and upon entering the room, he had his lantern blown out by a hidden figure, and from the dark, he heard a man cry out that he "would kill the first man that attempted to make an arrest." While being "hustled around" in the dark, the constable had his watch picked—these were pickers, after all—and a bottle was lobbed at him, leaving him to remark to the *Boston Globe* "that it was as much as a man's life was worth to go to that bog to make an arrest."

Nostalgia and jolly women aside, cranberry pickers were never highly regarded. Pickers were unskilled laborers, and when not romanticized by writers fascinated with the lives of the poor or eulogized by those who pined for some imagined past, pickers were stuck with a dubious reputation. In *The Cranberry Meadow* (1837), an oft-reprinted temperance tale "founded on fact," the protagonist was a cranberry picker, a strong and active man who had become so degraded through drink that "few persons were willing to employ him." Where did he turn? "He resorted to picking cranberries," the story went, "as the only means left him of obtaining what his appetite so imperiously demanded." Bogs may not

have been the last resort of the wicked, but from the *Cranberry Meadow* to Eugene Garside's 1937 novel, *Cranberry Red*, they were a wicked stop along the way. The bogs were a place, if reports were true, where violence and every variety of license flourished throughout the six-week Mardi Gras, a place where dark-skinned Bravas quarreled and sang and drank and fought with brass knuckles ("effective without being fatal").

Barely two decades into the cranberry industry, bog workers had evolved into a rough-hewn mix of impoverished immigrants, transients and people of color. They were no longer our neighbors, but foreign, unable (or unwilling) to speak English, and they came in an array of dark hues. They might be picturesque or colorful from a distance, but for middle-class whites, they were not us. When workers began to assert themselves, to agitate for better pay and working conditions, and when they began to demand respect, they became increasingly suspect. If anything was worse than a violent, drunken worker, it was a violent, drunken and assertive worker. Dented pails and skipped berries were only the first salvos in the labor struggle to come, as cranberry workers experimented with ways of fighting for their interests.

For the most part, agricultural workers had been ignored by the mainstream union movement, but cranberry workers were a special sort of agricultural worker, due to their seasonal connection to so many other jobs. It is difficult to know for certain, but it seems likely that as they shuttled from factory to factory, from the streets to the docks and from shop to field, cranberry workers would have been exposed to the ideas of the labor movement and its methods for organizing, advocating and resisting. Both Massachusetts and New Jersey were home to a strident labor movement, with skilled trades such as boot makers, carpenters and mechanics organizing well prior to the Civil War. Even if the skilled workers ignored the unskilled, the unskilled learned. Some cranberry growers certainly believed so. As early as 1883, the grower O.M. Holmes was aghast that his pickers were becoming "more independent" and "following in the footsteps" of the Knights of Labor, a powerful group that was part labor union, part fraternal organization. Like the Knights before them, Holmes feared, his pickers were learning to strike.

In addition to exposure to the ideas of the labor movement, cranberry workers were exposed to the ideals of middle-class activists, whose Progressive-era crusades ran from improving working conditions to improving public health. In 1910, activists prompted the Massachusetts

Cranberry Work

State Board of Health to investigate whether pickers were unnecessarily exposed to tuberculosis and typhus on the job, but it was the great cause of the Progressive era—child labor—that became the cause célèbre of the bogs. From the beginning, picking crews included both women and men, with women often preferred for planting and weeding and men for sanding and heavy labor, but picking was often a child's game. It was "customary in some regions," Eastwood wrote, to prefer children for picking because their nimble little fingers were well suited to the task. Any savvy six-year-old could wield a scoop, and according to an 1895 account in the *Boston Globe*, "a child of 12 years old will gather as many in a day as a person of 40 years; it is really children's work."

Children entered young into the bogs, virtually as soon as they could carry a bag, a box or a scoop, and sometimes even the littlest child worked side by side with a parent, picking up dropped berries or toting empty pails. In many ways, nothing about this was unusual. Children had always assisted with farm work, but commercial operations and family farms were not the same beast. In later life, former pickers sometimes

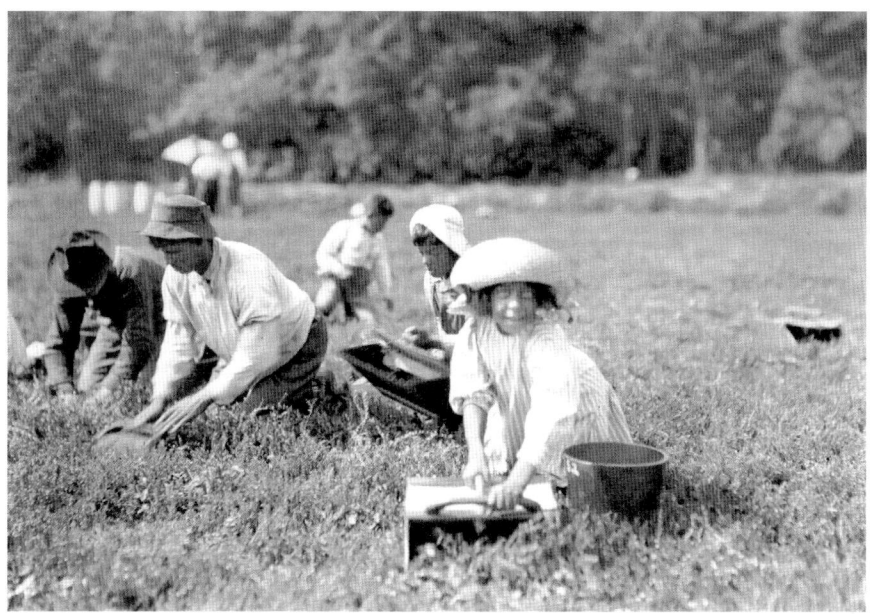

Two little pickers, Manuel Alvez, twelve years, and Marion Alvez, eight years. She picks nineteen measures. He picks ten measures. Baker Bog, Falmouth, Massachusetts, 1911. *Photo by Lewis Wickes Hine, National Child Labor Committee Collection, Library of Congress.*

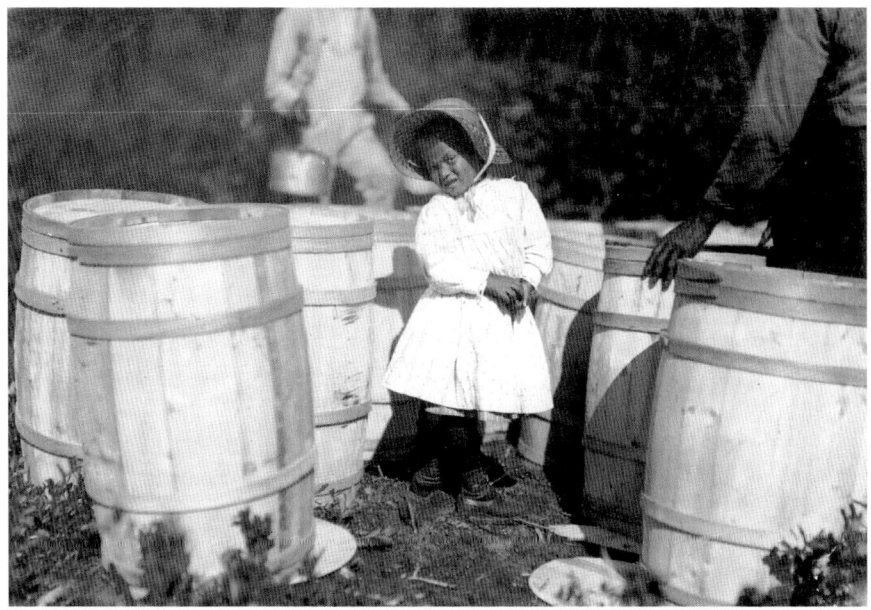

Mary Christmas, nearly four years old, picks cranberries sometimes. She is now picking up berries spilled by her grandfather. Grandpa says, "I make her pick sometimes, yes." Weeks Bog, Falmouth, Massachusetts, 1911. *Photo by Lewis Wickes Hine, National Child Labor Committee Collection, Library of Congress.*

looked back on moments of youthful horseplay and high jinks, but contemporary observers painted a more somber picture. "There is very little play during working hours," one man reported, "each one striving to keep up with the procession and hold his place."

This was certainly the impression captured by the reform-minded photographer Lewis Hine. Best known for exposing the crushing experience of child labor in textile mills, sweatshops and manufacturing, Hine toured the bogs for the National Child Labor Committee between 1910 and 1914, recording powerful images of children toiling in the fields, proud to be working, but filthy, worn and ragged at a frightfully early age. Typically, the newspapers reported the "benefits":

> *Cranberry picking interferes somewhat for a short time with the schools in the village, but it is too much of a bonanza to be ignored; the children that go to the meadows are bright and wide-awake and at the close of the harvest soon are up in their studies with their classes. There is one thing that this particular business has done for this part of Massachusetts.*

Cranberry Work

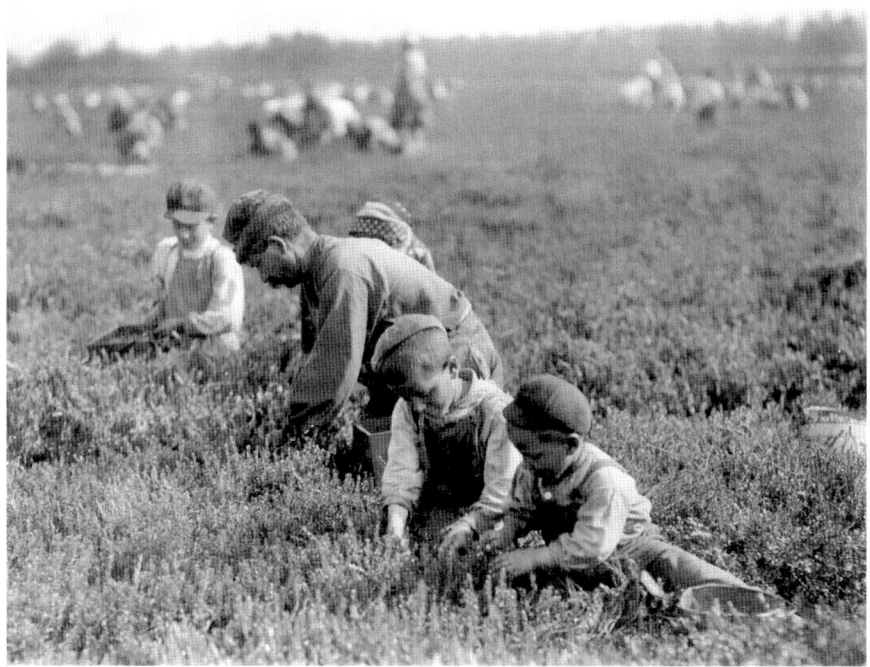

Arnao family, 831 Catherine Street, Rear #2. The whole family works. Jo is three years old, the boy is six years old and the girl is nine years old. Whites Bog, Browns Mills, New Jersey, September 28, 1910. *Photo by Lewis Wickes Hine, National Child Labor Committee Collection, Library of Congress.*

> *It has had a tendency to clear it from tramps, hundreds of whom have found their way to Cape Cod and there joined the army of cranberry pickers. A number of able-bodied ones have joined the North Easton contingent. They earn sufficient to buy some tobacco and move on to fresh fields and pastures new.*

In Falmouth and other towns on the Cape, schools were even suspended for two weeks so that children could assist in the harvest.

In the struggle against child labor, activists considered boycotting cranberries, just as their ancestors a century before had boycotted sugar over slavery, and they found support for the cause in organized labor. In theory, the laws of Massachusetts prohibited children under fourteen from working, but these regulations were widely flouted, and while nighttime child labor had been outlawed in New Jersey in 1910, daytime employment remained unchallenged for years more. Child labor was

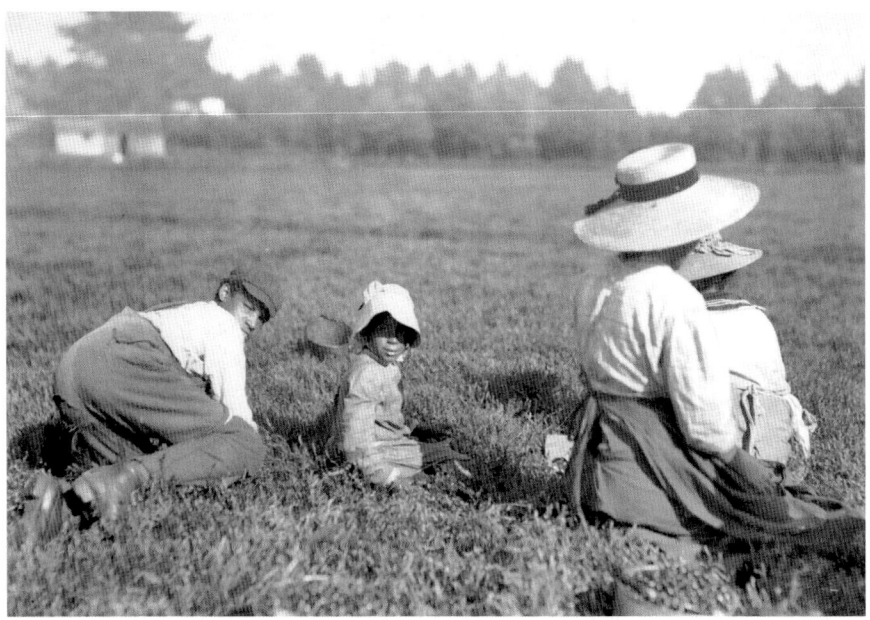

Anne, a small picker, seven years old. Eldridge Bog, Rochester, Massachusetts, 1911. *Photo by Lewis Wickes Hine, National Child Labor Committee Collection, Library of Congress.*

not easy to eradicate. In some bogs, children composed the majority of picking crews, and growers proved stubbornly resistant to change. Even though organized labor sought to end child labor, some of the pickers' families resisted, both because the extra income was vital and because it allowed families to remain together without the need for a caretaker. In practice, child labor continued to some extent on the bogs until the Fair Labor Standards Act of 1938 codified a national minimum wage, the concept of overtime pay and standards for the employment of children. Ironically, it was a great public health crisis that at least temporarily had the greatest impact on children on the bogs. During the massive polio epidemic of 1916, children were quarantined for their safety, and with so many children and women absent from the bogs, "gangs of adult pickers" reportedly began to display that dreaded "independent spirit," demanding "higher wages than they got last year or the years previous."

In reality, the pickers' independent spirit was deeply ingrained. As early as the 1880s, workers refused to pick thin or unproductive patches where pay would be low, and while owners often blustered that they could replace the uncooperative at once, it was not always so easy. Between natural

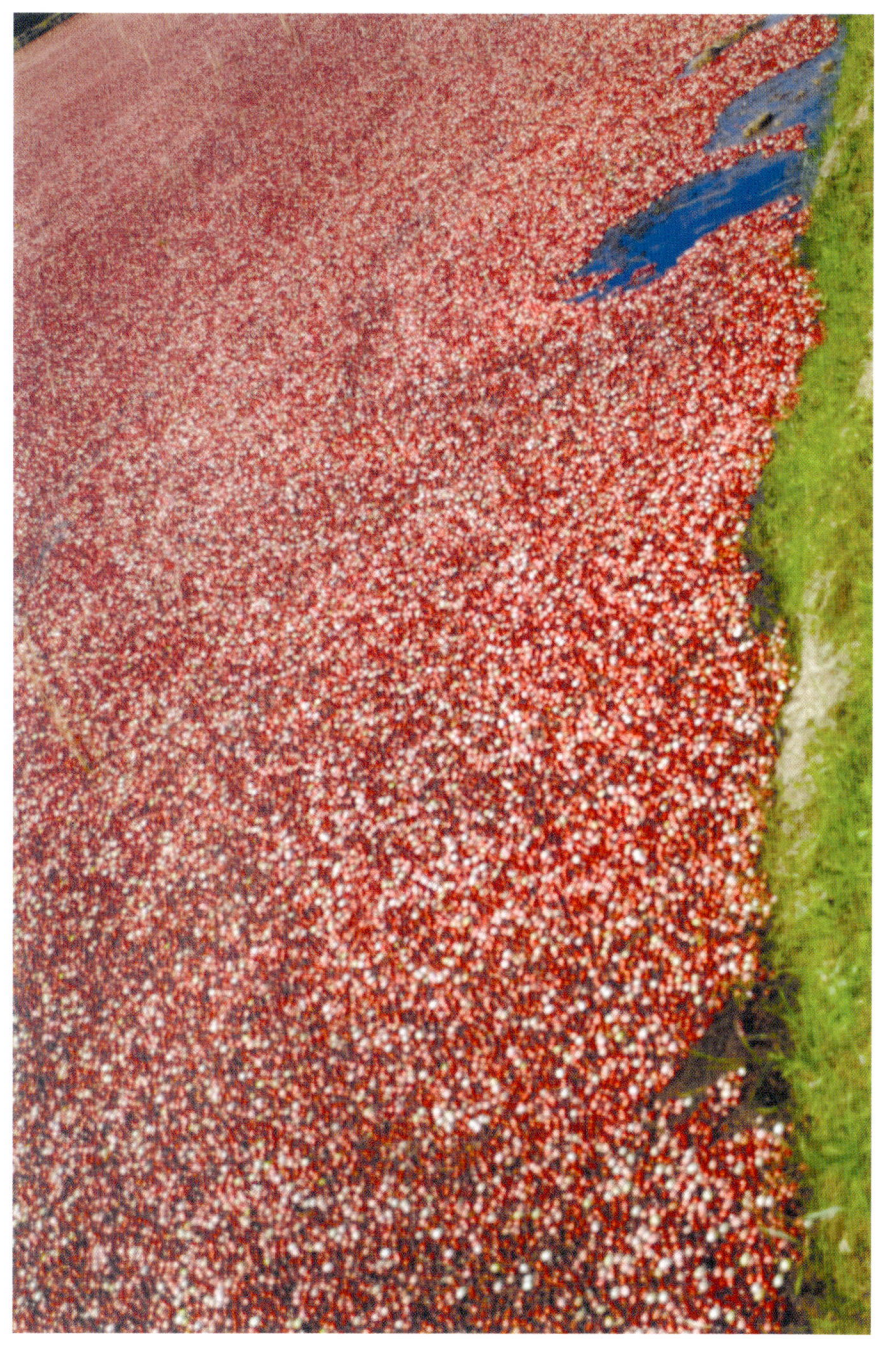

A bog ripe for harvest in Carver, Massachusetts, 2011. *Photograph by Jacob Walker.*

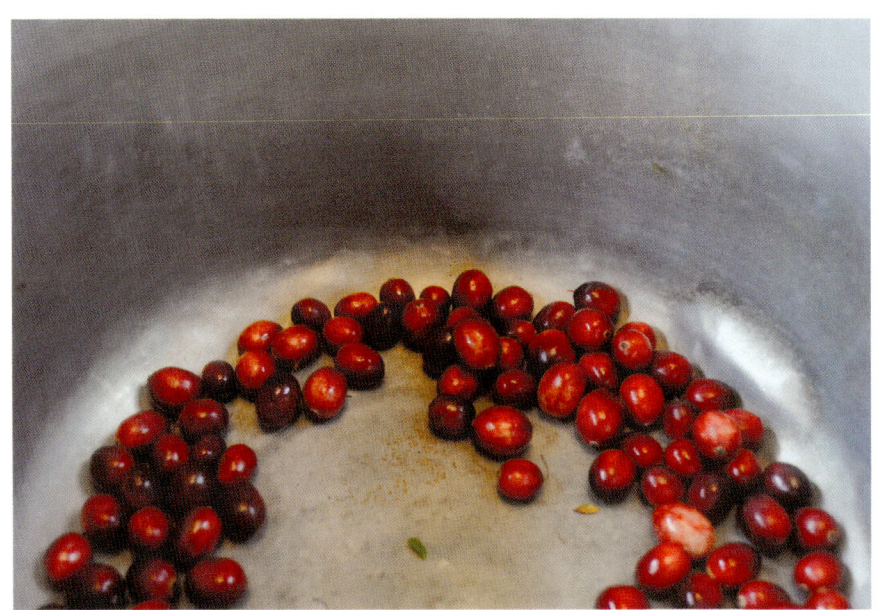

Above: Cranberries in a pail, 2011. *Photograph by Jacob Walker.*

Left: Jellied cranberry sauce in the sun, 2011. *Photograph by Jacob Walker.*

Cranberries sautéing with butter and sugar, 2011. *Photograph by Jacob Walker.*

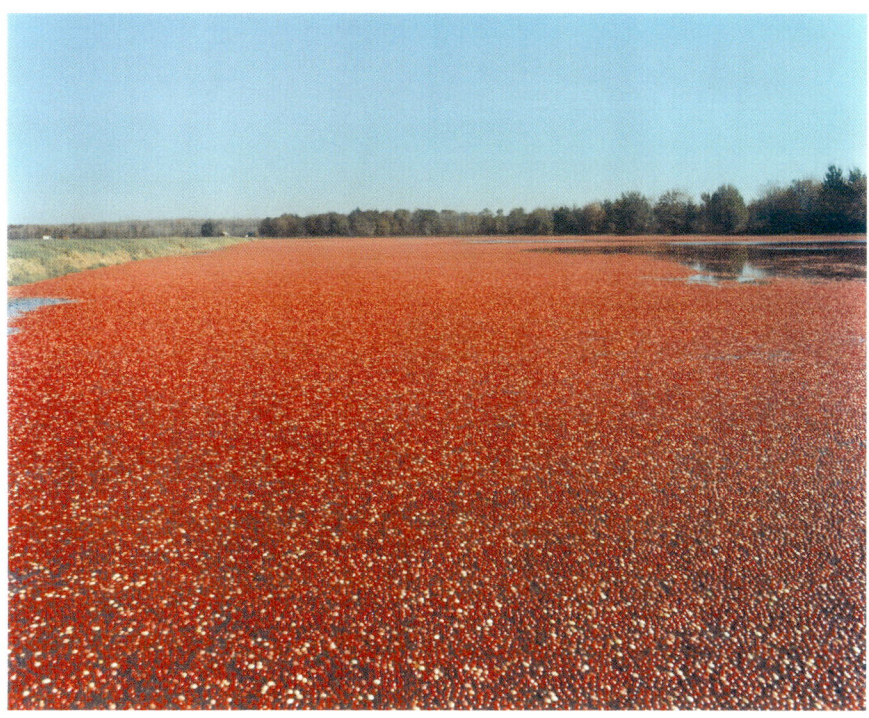

Cranberries ready for wet harvesting, undated. *Courtesy of the Carver Public Library.*

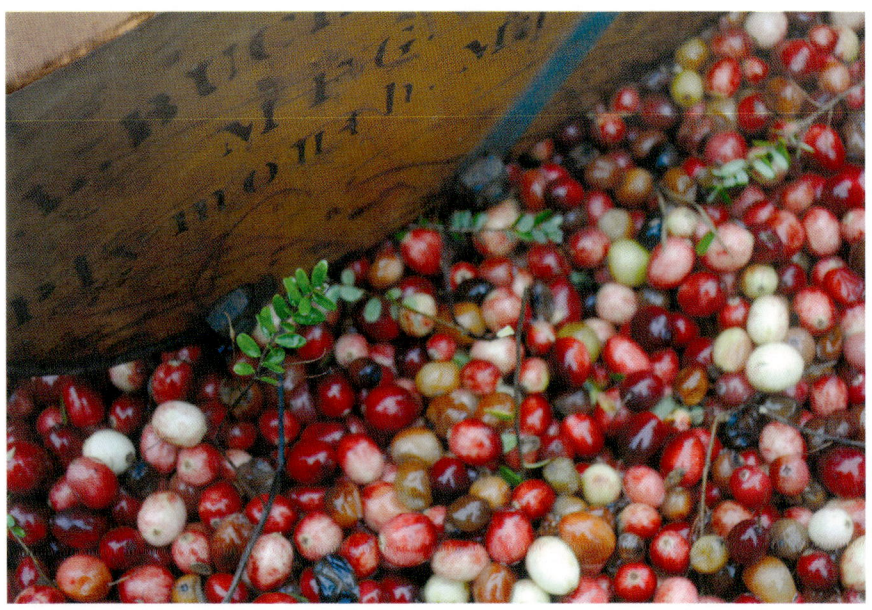

This page: Freshly picked cranberries, with field debris, ready to be sorted, 2011. *Photograph by Jacob Walker.*

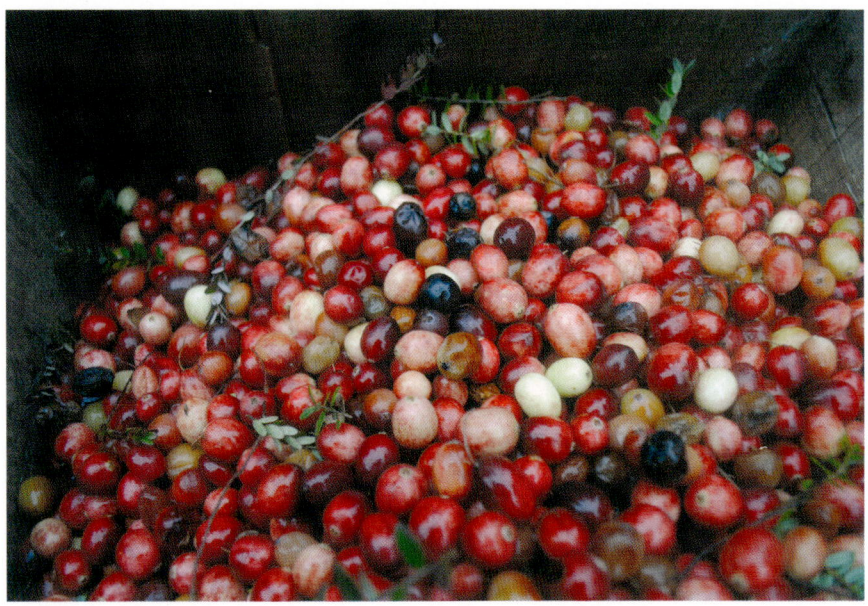

A can of jellied cranberry sauce, 2011. *Photograph by Jacob Walker.*

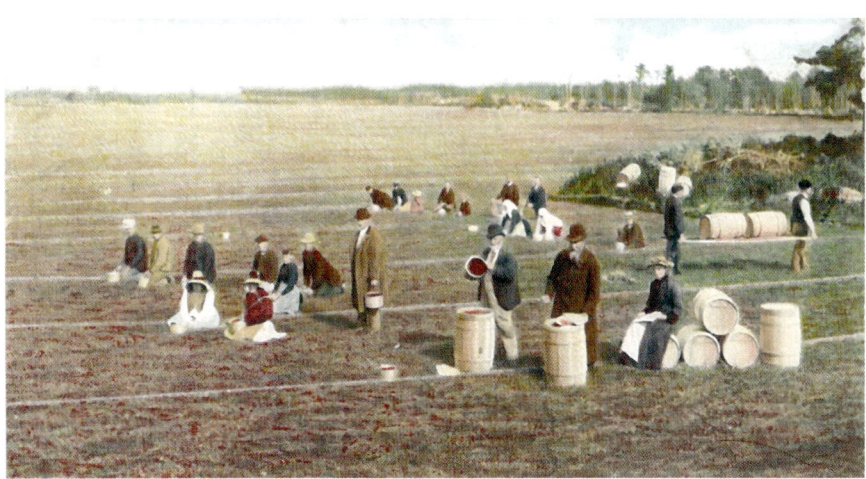

Cranberry picking on Cape Cod, circa 1910. A postcard of pickers, both women and men, set between the lines as barrels are filled and carted on shore. *Courtesy of Eliot Wentworth.*

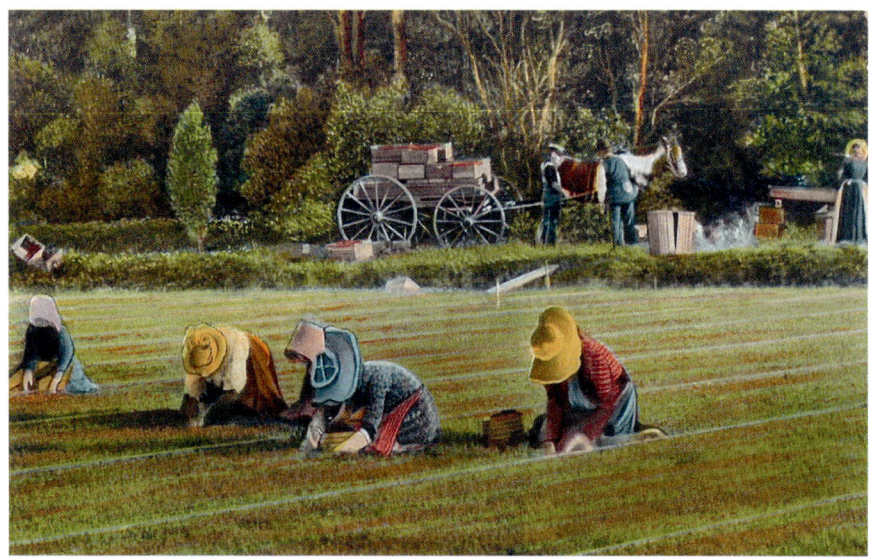

Cranberry picking, Cape Cod, circa 1910. Women hand pick cranberries with a horse-drawn cart and banjo board in the background. The women are dressed up in typical protective work clothing and appear to be using the standard six-quart pails. *Courtesy of Jacob Walker.*

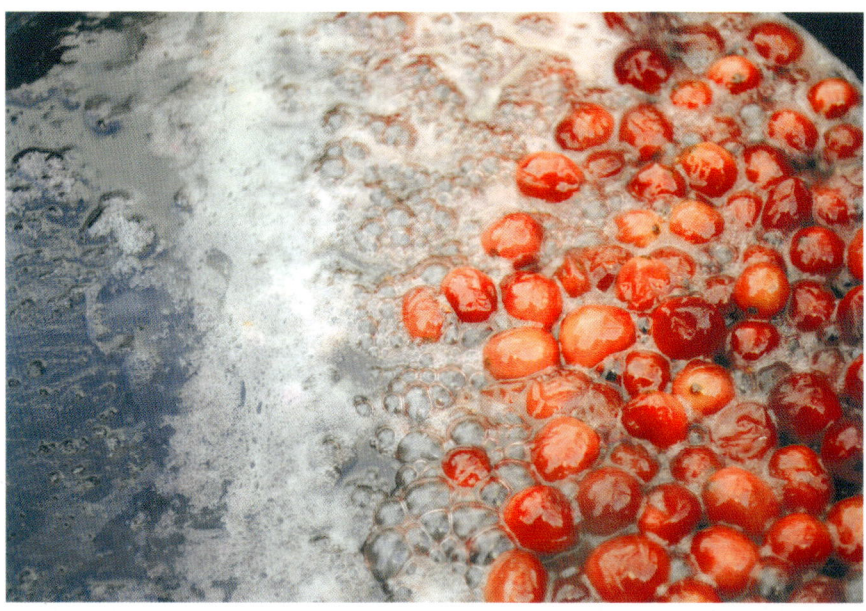

Homemade cranberry sauce reducing over a backyard fire, 2011. *Photograph by Jacob Walker.*

A crate label for Beaton's Cranberries (an independent), Wareham, Massachusetts. *Courtesy of the Carver Public Library.*

A crate label for Pride of Carver Cape Cod Cranberries, E.F. Harju, South Carver, Massachusetts. *Courtesy of the Carver Public Library.*

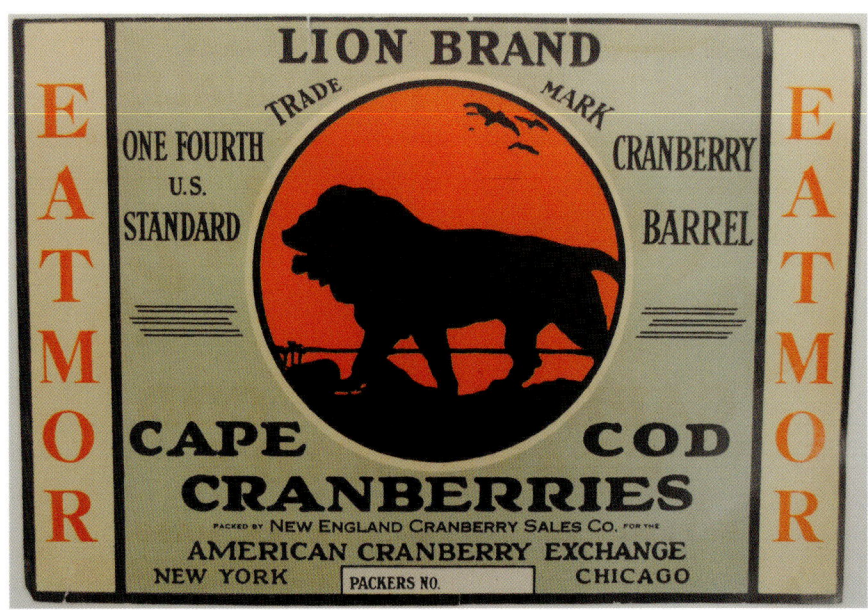

Above: A crate label for Eatmore Lion Brand, Cape Cod Cranberries, packed by the New England Cranberry Sales Co. and distributed by the American Cranberry Exchange. *Courtesy of the Carver Public Library.*

Left: An advertisement for Cape Cod cranberries, two pounds for nineteen cents, 1931. *Courtesy of the Carver Public Library.*

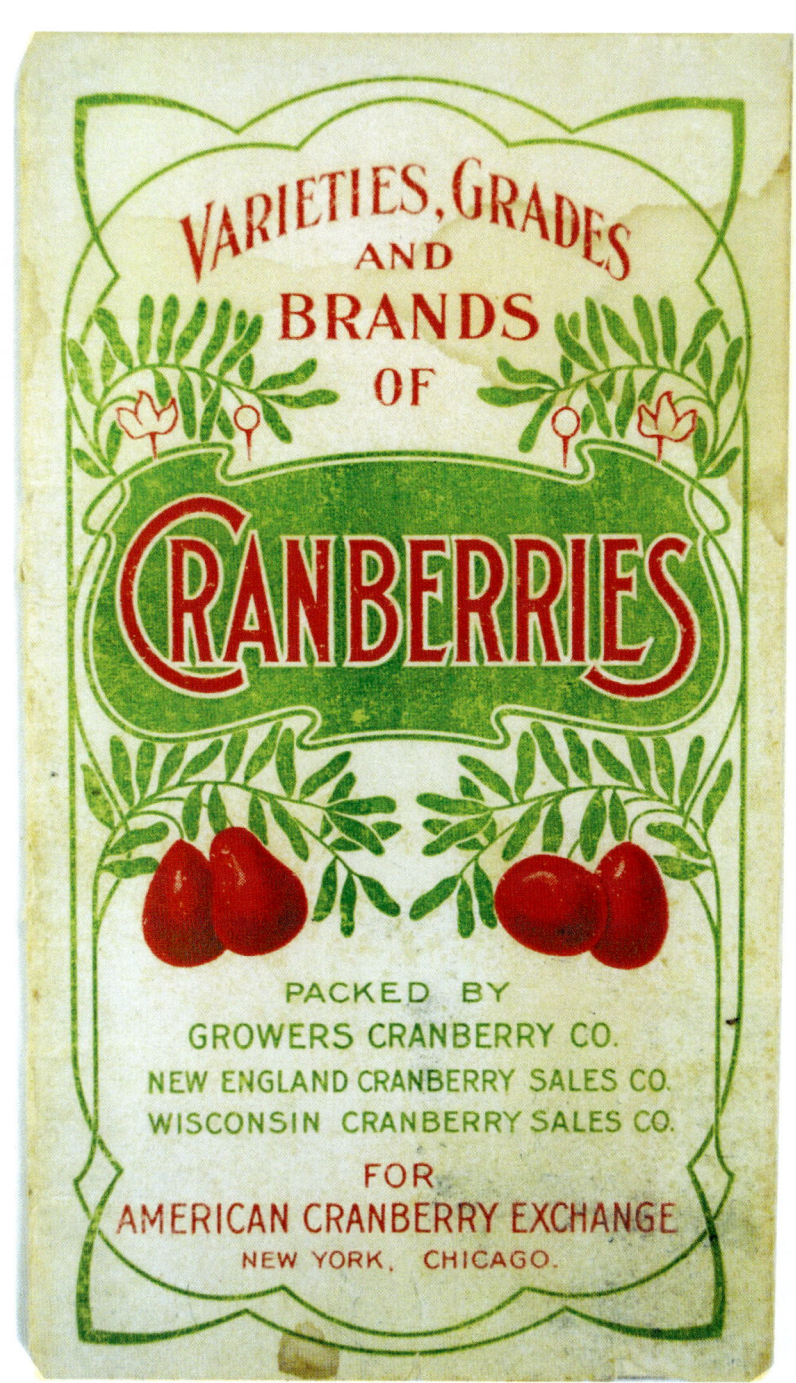

The American Cranberry Exchange list of brands: front cover of *Varieties, Grades, and Brands of Cranberries*, circa 1911. *Courtesy of the Carver Public Library.*

A ticket for one box of cranberries, Shaw Bog, Carver, Massachusetts. *Courtesy of the Carver Public Library.*

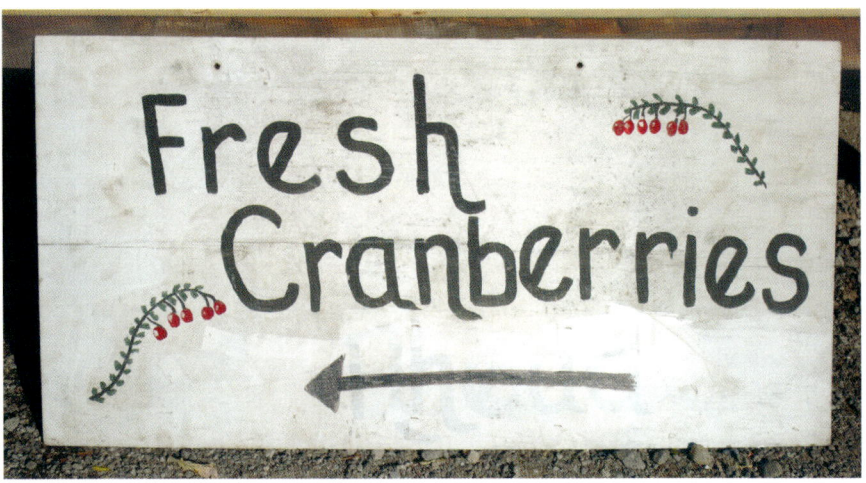

Fresh Cranberries sign, 2011. *Photograph by Jacob Walker.*

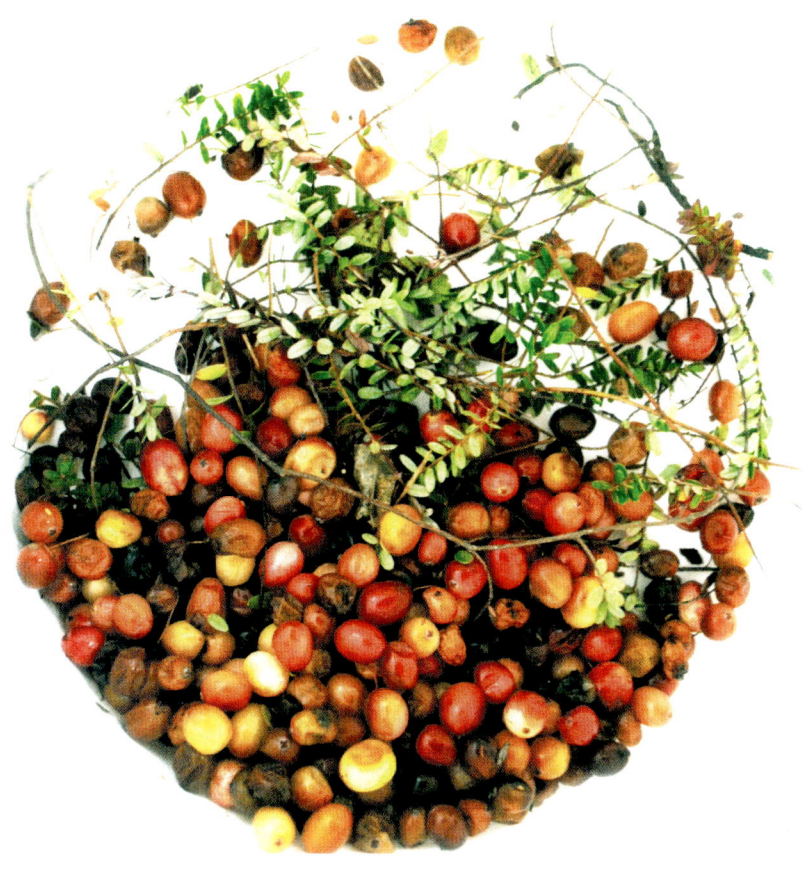

"A stunted barren thing"—cranberries at varying stages of ripeness, with vines, 2011. *Photograph by Jacob Walker.*

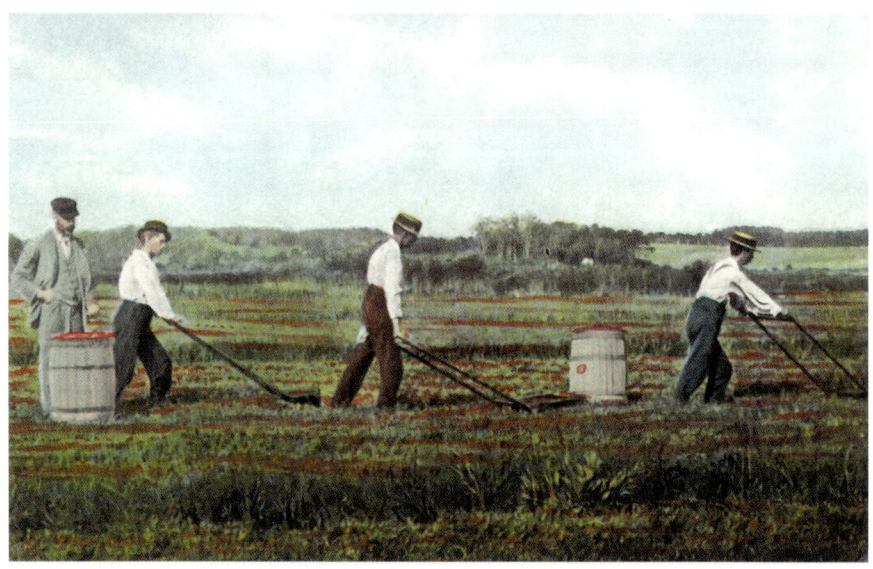

Harvesting cranberries using early wheel-mounted, non-motorized mechanical picking machines, circa 1910. *Courtesy of Eliot Wentworth.*

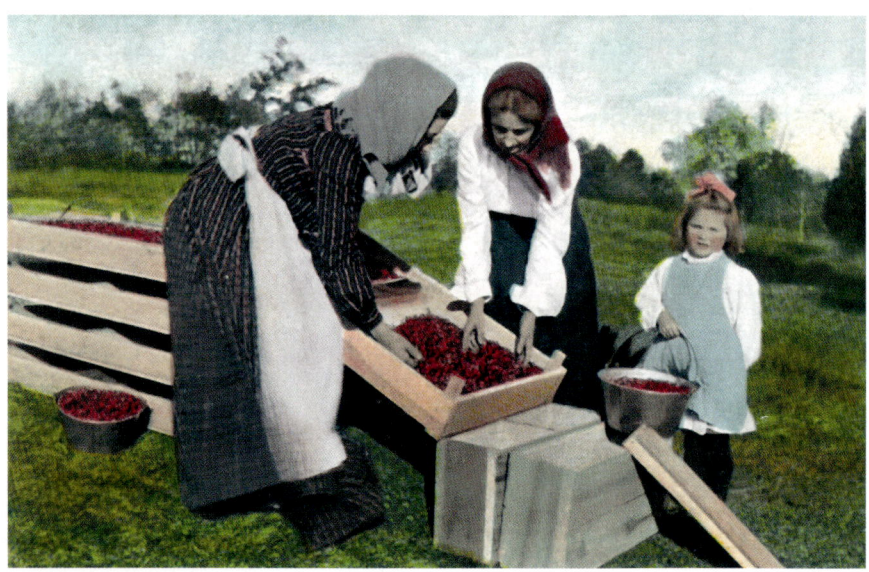

Women screening cranberries, circa 1910. *Courtesy of Eliot Wentworth.*

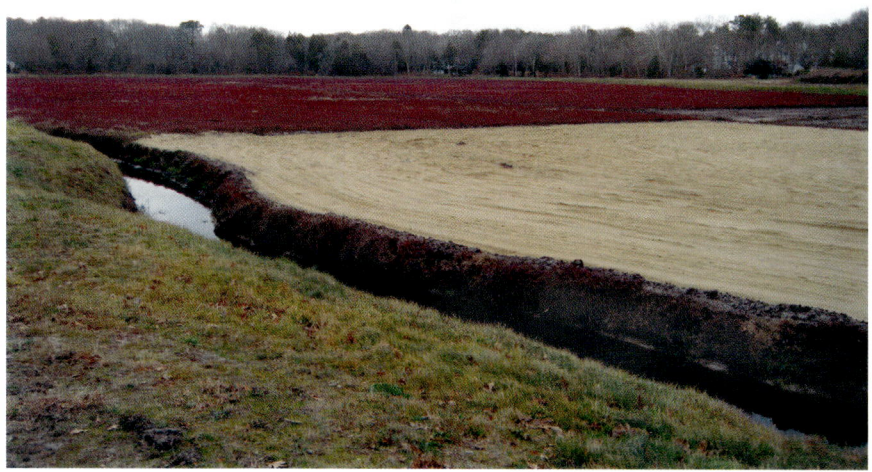

A cranberry bog near Centreville, Massachusetts, December 2011, with winter color in the back, resanded ground in the front and exposed muck at the far right. *Photo by Eliot Wentworth.*

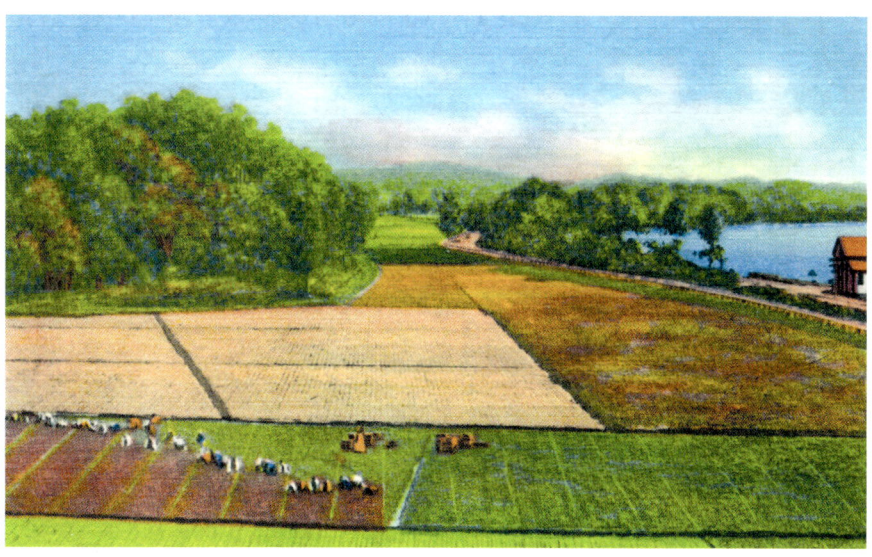

Cranberry picking on Cape Cod, circa 1915. A postcard of pickers working across a bog. *Courtesy of Eliot Wentworth.*

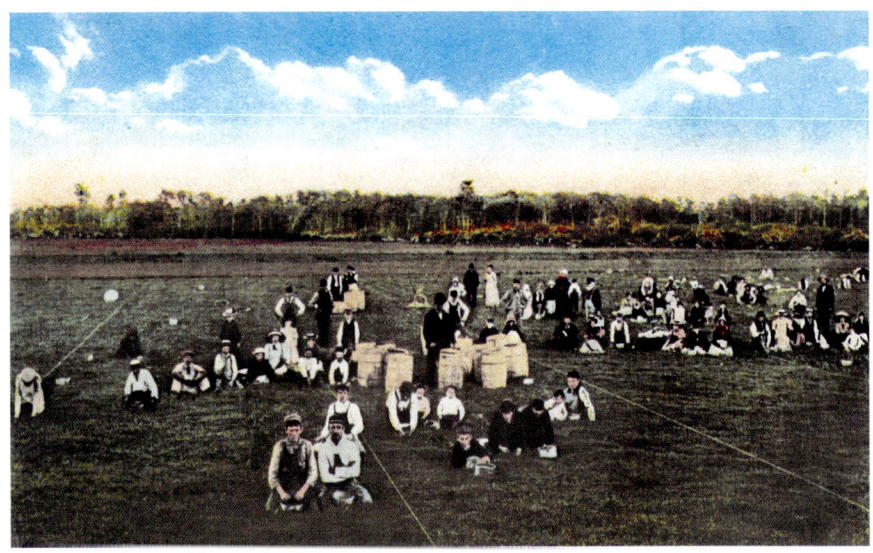

Cranberry picking, Cape Cod, circa 1910. A postcard of cranberry pickers at rest between the cords. The pickers have the standard six-quart pails, with barrels at the ready. *Courtesy of Eliot Wentworth.*

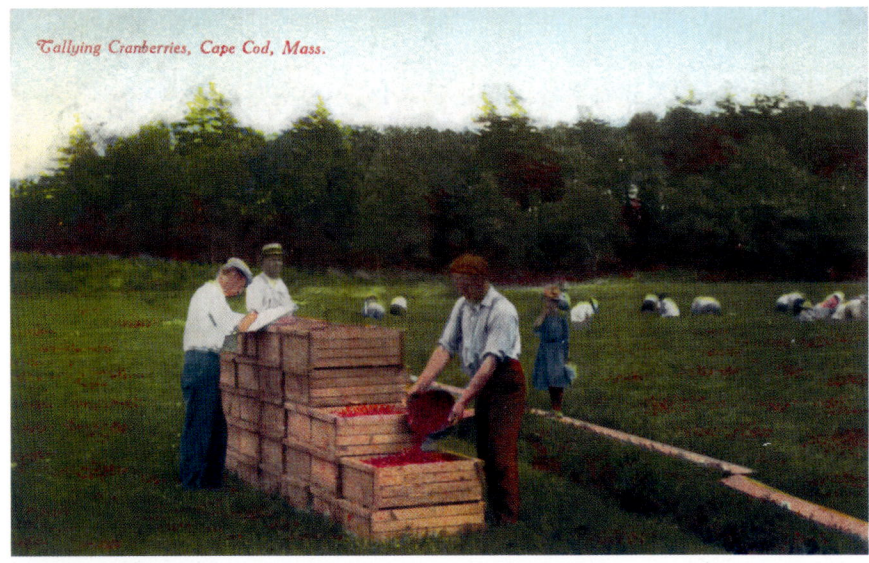

Tallying cranberries, circa 1910. A tallyman records another load of cranberries as they are dumped into a field box. *Courtesy of Eliot Wentworth.*

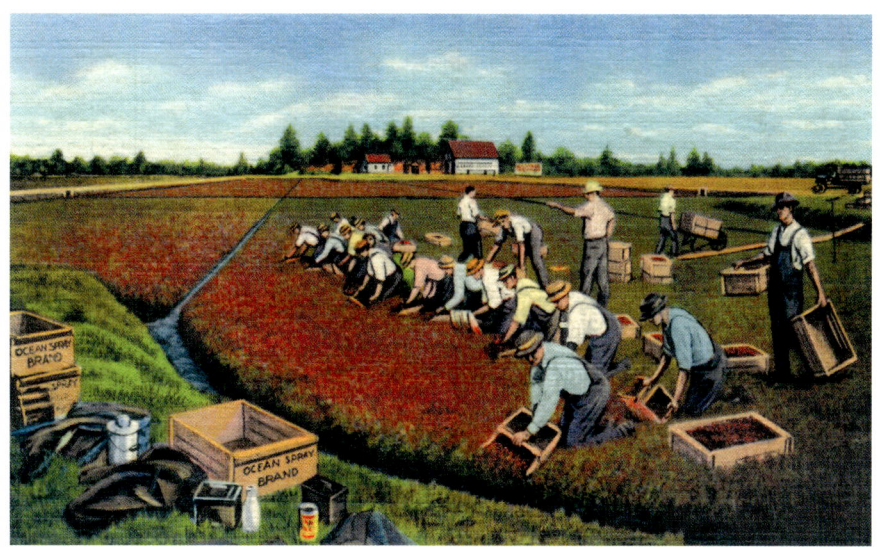

Above: Harvesting cranberries on Cape Cod, circa 1920. A postcard depicting a gang of pickers with scoops, Ocean Spray field boxes at the ready. *Courtesy of Eliot Wentworth.*

Right: Prickly dewberry invading the edge of a cranberry bog near Wareham, Massachusetts, August 2011. *Photo by Eliot Wentworth.*

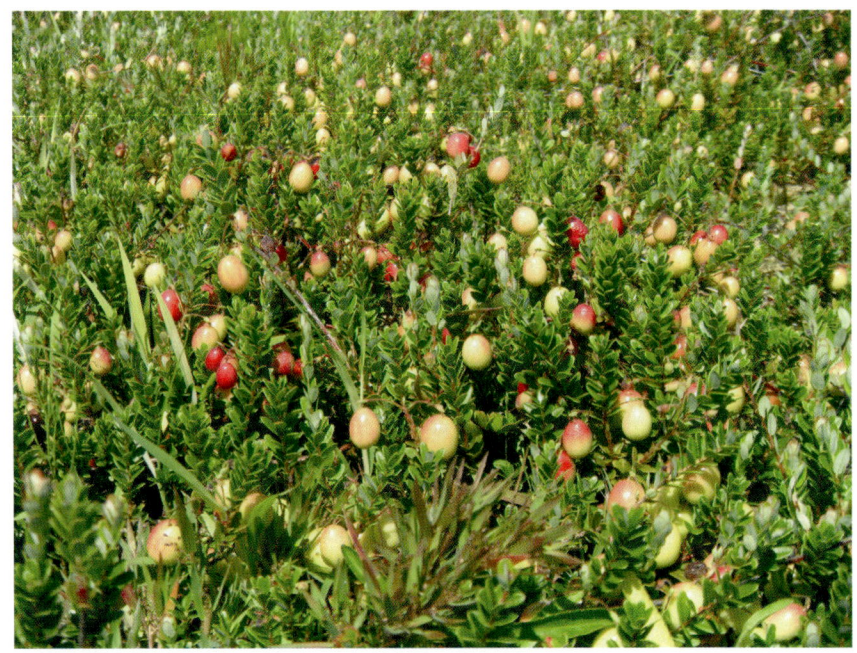

Cranberries nearing harvest time, Tihonet Bog, Wareham, Massachusetts, August 2011. *Photograph by Eliot Wentworth.*

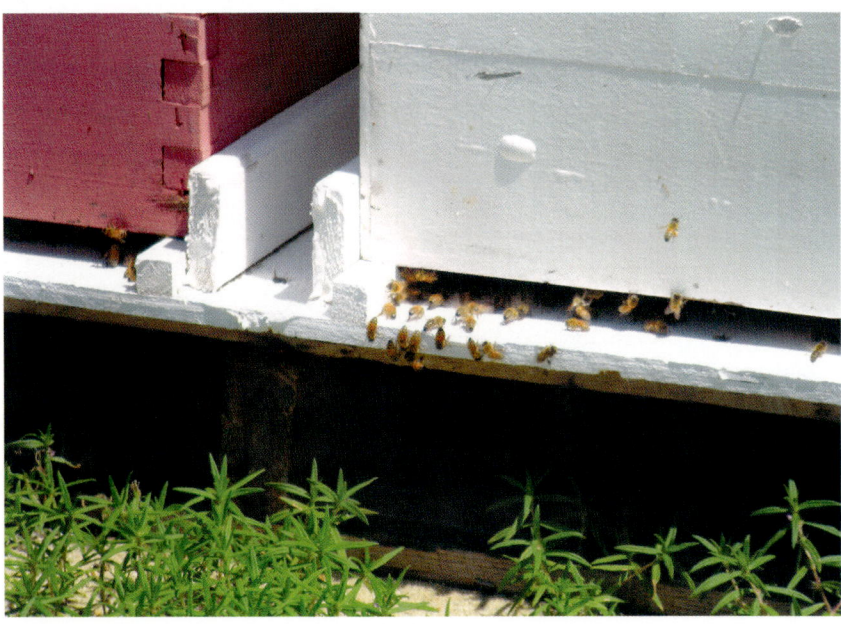

Bees at the Tihonet bog, near Wareham, Massachusetts, August 2011. *Photograph by Eliot Wentworth.*

fluctuations in the labor market, an abundance of smaller bogs in need of workers, the brevity of the harvest season and the possibility of ruin by October frost, workers had moments of leverage in negotiating with owners. Threatening to delay the harvest alone applied pressure when pressure was needed. No doubt, owners had greater resources on their side, and they enjoyed the support of trade groups such as the Cape Cod Cranberry Growers Association and the willingness of police and civic authorities to intervene when needed, but it was never entirely one-sided.

As it turns out, an independent spirit was not what really concerned growers; rather, it was solidarity of spirit. As long as the pickers were divided by race and ethnicity, and as long as there was a flood of immigrants and itinerants desperate for work, they faced an uphill battle with employers. But beginning in the 1890s, pickers began tentatively to carry out what they learned from organized labor, and they began to align in common cause. Near Tremont and West Wareham, Massachusetts, in 1892, pickers joined together to try out a radical tactic, according to the *Boston Globe*, the lightning work stoppage. Lured to work by promises of good picking and good pay, pickers discovered that "good" did not always apply when paid by the piece. Even at a healthy ten cents per six-quart measure, if it took twice as long to fill that measure, it was difficult to make a living: "There is the grind." To make their point, workers waited until the superintendent had laid out rows for picking, and then all at once, they gathered their belongings—men, women and children—and walked off as one. They returned the next morning to inspect the layout but announced that they would pick only the good areas, adding that they would abandon even these unless wages were increased.

Tremont did not tremble alone. The *Philadelphia Inquirer* reported that Italian pickers in New Jersey went on strike in September 1891 for an increase of ten cents per bushel, although they complained that even then the poor crop that year left them barely earning fifty cents a day. "They threatened violence for a time," the *Inquirer* reported, "but finally quieted down." Three years later, the marshes of Wisconsin also felt the sting, which the *Omaha World Herald* described with the sort of racially tinged condescension that was often directed at pickers:

> *The complaints that the American Indian will not conform to modern methods, and cannot be civilized, fall to the ground before the strike in the cranberry marshes, where several hundred Indians have declared*

for more pay or no work. It is nothing new for the Indian to object to work. The Indian of the masculine gender is a born aristocrat... Without knowing in the least what the particular wage is that is objected to, it is quite safe to say that it is not as large as a sense of justice in the owners of the cranberry marshes would cause it to be. Fortunes in cranberries are quickly made, especially where ignorant Indian or Canadian French labor can be secured. These people, born and raised in the semi-wilderness, make the best berry pickers in the world, and they are also the cheapest. As a usual thing they take what is given them and no questions asked. But the world moves, and though the Indian has been thought to be as stationary as Lot's wife after her little accident, yet it is evident that the Indian moves too. That he should have acquired a new weapon of defense shows unmistakable signs of development. His weapon, for the first time, is of the mind. It is a "strike." But when cranberries are rotting it is as sharp as a tomahawk and as terrible as an arrow of flint tipped with poison from the rattlesnake's bag.

Back in Cape Cod in 1900, two Finnish workers near South Carver "went among their fellow-countrymen" and walked off the job, according to a report in the *Boston Globe*, "and it is alleged tried to influence them to also stop." When the would-be organizers failed, they retreated to the edge of the bog and allegedly fired several gunshots, standing there "in a defiant manner" for all to see, making no effort to conceal themselves. The rest of the pickers were reportedly concerned, according to the *Globe*, and "steadfastly refuse[d] to resume work until they are satisfied that the two men whom they suspect did the shooting are put out of harm's way." Whether the pickers were genuinely afraid or quietly sympathetic to the would-be strikers, as would be the case in many later confrontations, might be difficult to discern at such distance, but although the police followed the offenders into the woods, they stopped short of arresting them for fear of violence.

The pattern of these early strikes reflects the basic weakness of labor's strategy, and what little effect they sometimes had was local and brief. While workers coordinated effectively, they most often did so by building alliances within, but not across, ethnic lines, shredding whatever potential solidarity might have survived the pressures of poverty, and they limited their strikes to one bog at a time. The more diverse the pool of labor was, and the more mobile the workers were, the less likely it was that a strike

Cranberry Work

could succeed. But several factors pushed matters to a boiling point. Most importantly, the pickers' options were declining as the cranberry industry experienced a stark consolidation early in the twentieth century, with fewer and fewer owners holding more and more land and becoming more and more strident in imposing their interests. The number of bog holdings plummeted by more than a third between 1924 and 1934 alone, and the average size of those holdings increased by nearly 60 percent. This concentration was particularly acute in Plymouth County, which in the early 1930s boasted thirty-two of the forty-one holdings in Massachusetts of larger than fifty acres, and it was these larger holdings that became the site of the most intense agitation.

Volatility in the cranberry market often triggered unrest. When cranberries plummeted from twenty-five dollars a barrel to five or six dollars a barrel in 1900, and many smaller growers were forced to sell out to larger ones, the *Boston Globe* reported that those left used their newfound power to suppress wages and refuse concessions. Though mightily pressed, workers had less ability to move to higher-paying situations, and the harvest season of 1900, like many to come, was "frequently interrupted by strikes at the large bogs, and changes at the small ones."

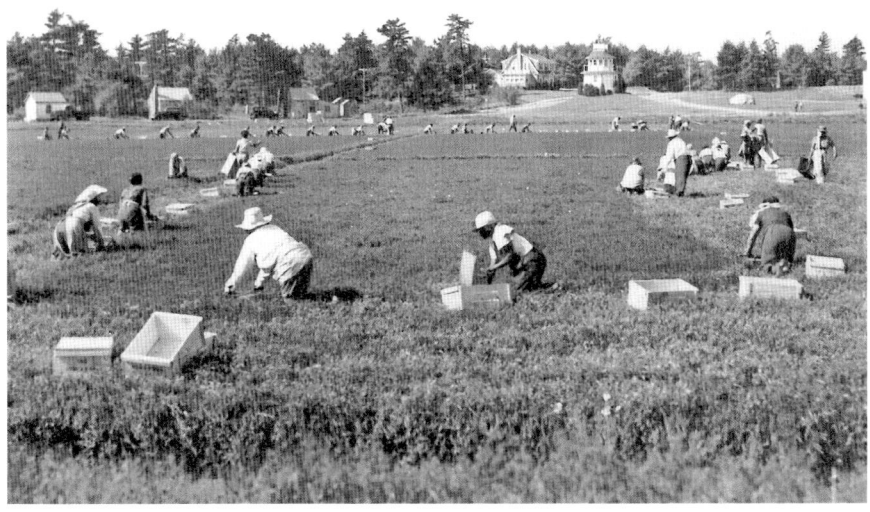

Cranberry pickers at Edaville, Carver, Massachusetts, circa 1950. *Courtesy of the Carver Public Library.*

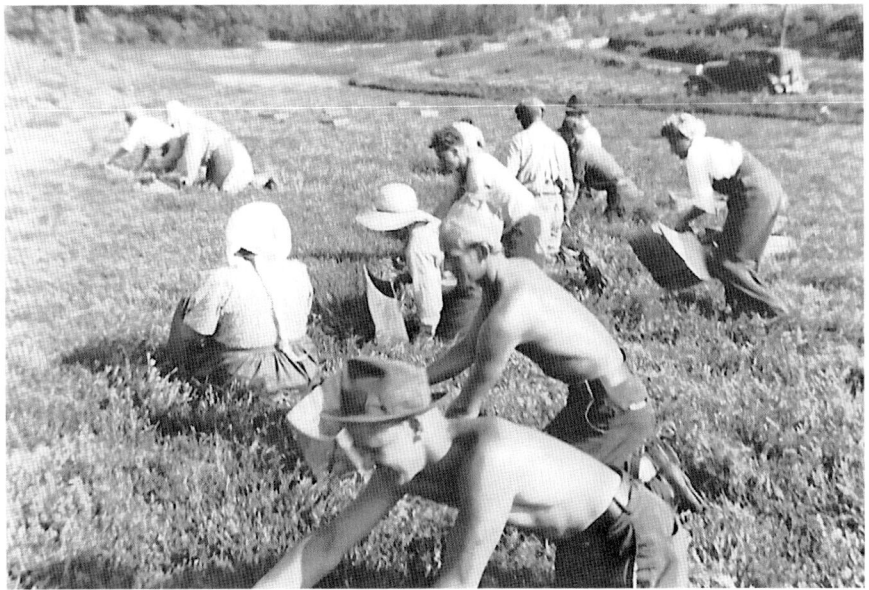

Cranberry pickers at East Head, Carver, Massachusetts, circa 1935. *Courtesy of the Carver Public Library.*

To manage such situations, some growers got creative. In Middleboro in 1923, growers tried hiring college students from Harvard, MIT, Tufts and Boston University, assuming they would make a more sympathetic workforce. In Falmouth, however, the Cranberry King Frederick J. Swift announced that he would stick by his old crews: "You can tell the Bravas what to do, and they'll do it," he insisted. "There's no time to fool around in this business. You have a few weeks to get your crop in, and you've got to hustle." In good years, he was right—agitation lessened, tensions eased and hustling ensued—but when prices went south, workers reacted to being pinched.

Growers also began gradually to shift away from piecework to hourly wages, partly in response to the annoyance of pickers skipping poor patches and tearing up the vines as they hustled for higher pay. For workers, hourly wages theoretically made pay more predictable and less subject to the vagaries of picking conditions, but when the crop was good, piecework allowed an industrious worker to earn more. Growers were well aware. One Cape Verdean worker from Onset quipped, "As it stands now, pickers are paid by the hour when berries are thick and by the measure when they are thin."

Witnessing this growing conflict, a handful of progressive owners responded more positively to the pickers' plight. Watson B. Kelley offered free transport for his workers from their homes in Tremont, stretching their ten-cent wage into something more like eleven cents, and his action seemed to spur his fellow growers to offer similar inducements:

> *The fact that the bog owners are coining money, realizing from $6.50 to $7 per barrel for what does not cost them to raise and harvest over $3.50 to $4, also adds to the prospect that the wage scale for picking is to be advanced all along the line. That the crop is large cannot be gainsaid, though some bog owners are not anxious to have this understood, as it tends to lower the market price for the berries.*

Depression-Era Strikes

The word "depression" has several meanings, all of which apply to agriculture in 1930s America. First, of course, there was the economic depression. From the sun-baked fields of California to the Oklahoma dustbowl and the rolling hills of New England, farmworkers were thrown into desperate straits by the stock market crash of 1929. As commodity prices collapsed and foreclosures rose, employers slashed wages, assured that the legions of bankrupt farmers, displaced tenants and unemployed factory workers would beg for work at almost any wage. No one was hit harder, then, than seasonal workers like cranberry pickers. During the best of times, they scrapped to make a living, but after years of pummeling by the economy, many stared out at a bleak world where their status seemed fixed in stone for years to come, as the U.S. Department of Labor later concluded, and in a world where "opportunities to rise had disappeared." With unemployment for Cape Verdean workers running above 50 percent and workers averaging eighteen months without a job, fixed with no future was no place to be.

In these depressing times, it may seem paradoxical that many of those who had jobs would be willing to walk out, but so it was. Initially, to be sure, the Depression quelled unrest among agricultural workers and put a crimp in the first flickers of unionization, but as the economy continued to founder in 1933 and farm wages plummeted, lagging behind even the price level, the nation's workers fell deep into a well of anger and

resentment. With the arrival of Roosevelt's New Deal, farm owners and operators finally received a measure of direct support from the government, and while the support was not always effective, it buoyed our nation's farms. Agricultural laborers, however, received only bare relief, and they simmered as the benefits that flowed to owners flowed no further down. Inequality, disparity, ill treatment and a lack of future prospects were more powerful goads than poverty had ever been.

As desperation mounted, labor organizers found a receptive audience, and in 1933, they organized a wave of sixty-one strikes in seventeen states involving over fifty-seven thousand workers. Many of these strikes were fanned by the most radical wing of the union movement, Communists inflaming them, but during the worst days of the Depression, the Communists were among the very few to carry the banner for the poorest Americans, and they were among the only whites who even considered the interests of people of color. The strikes brought a swift response, and strikers were routinely replaced, arrested and blackballed, and they were relentlessly attacked by the larger employers, police, public officials and vigilantes. Striking Filipino and Mexican agricultural laborers, even U.S. citizens, were targeted for deportation, and violence by both strikers and opponents was rampant, being greatest, according to a later report from the U.S. Department of Labor, where prospects had diminished most rapidly and where the disparities in wages and working conditions were greatest. That report concluded that unions and the promise of collective bargaining seemed to be "almost the sole means by which agricultural workers could seek to protect their meager earning power."

Although the cranberry bogs were nothing like the expansive orchards of California or the parched Great Plains, the realities of the Depression struck just as hard and the disparities it produced seemed just as great. Some simple figures fueled resentment. In 1910, cranberries had brought an average of $5.60 per barrel, from which growers paid out about thirty to thirty-five cents per hour to scoopers or eight cents per six-quart measure for hand-pickers. In 1932, that same barrel brought $7.80, with scoopers earning only forty cents and hand-pickers still mired at the same eight cents. To many pickers, it seemed that owners and workers were not shouldering the same burden.

The first signs of Depression-related unrest visited the bogs in September 1931, when about 50 workers at Ocean Spray Preserving Company's bog number one dramatically laid down their scoops and

walked off, demanding an increase from fifty cents per hour to seventy or seventy-five cents. News of the action spread quickly, and other workers soon joined in, until almost 150 were refusing work. But the bog owners reacted just as quickly, warning that replacements would "be given scoops in the morning if the strikers do not return to work." It was no bluff. While the strike may have swelled to as many as 300 workers, it remained more or less confined to Ocean Spray's bogs near Halifax, Pembroke and Bryantville, Massachusetts, and flamed out barely two days later when company president Marcus L. Urann met with labor representatives and insisted that since prices had fallen from ten to twelve dollars per barrel in 1930 to four to six dollars in 1931, he could do little to help. Growers one, strikers nil.

But 1931 was only a dress rehearsal. While the nation's economy continued its death spiral, organized labor reached to the bogs. As the harvest season of 1933 approached, two white organizers, Fred Wood and Daniel J. McIntosh, worked feverishly, more or less surreptitiously, to build a new union: Cape Cod Cranberry Pickers Union Local 1. In short order, they enlisted almost 1,800 workers, mostly Bravas, paying dues of one dollar each. "Exploitation on the bogs," McIntosh insisted, was "worse than in any other part of the state," and cranberry workers apparently agreed. With authorization from the New Bedford Central Labor Council, the organizers applied for a charter from the International Hod Carriers, Building and Common Laborers Union of the American Federation of Labor, and they crafted a list of demands that included increasing pay for pickers from forty cents per hour to seventy to eighty cents (approximately what they had earned before the Depression); forming a workers' committee with the authority to inspect living and working conditions; setting paydays at two-week intervals rather than at the end of the season; and establishing a minimum age of seventeen for bog work.

When 300 workers affiliated with the fledgling union walked off at three of the largest bogs on September 7, growers took it all in stride. With a unanimous vote at their annual pre-harvest meeting, "purposely not recorded," the members of the New England Cranberry Sales Company reconfirmed a "fair minimum wage" of forty cents per hour. Their provocation was met in kind. On the next day, September 8, the strike spread to 1,200 workers on fifteen of the largest bogs in Plymouth County, and a general strike of all 5,000 pickers seemed possible. In the war of words that played out in the press, organizers were consistently cast

as "outsiders" and "agitators" (remember that nearly all of the pickers were "outsiders," too), and as the *Springfield Union* reported, it was not long before Cape Cod natives, "famed for their spirit of independence, entrenched themselves to drive agitators from their cranberry bogs." Civic officials took the lead. Wareham selectman Theo Robinson announced that he had "no objection to duly authorized, decent representatives of labor" but added that he objected "most strenuously to the type of agitator who has been invading our bogs trying to incite the workers."

Despite the pressure, the Cranberry Pickers Union proved surprisingly resilient, and its organizers continued to confront growers. Trying out tactics that had been pioneered by militant workers in California, they sent out "guerrilla pickets" and large caravans of automobiles packed with strikers who descended on bogs, harangued reluctant workers in the fields and tried to convince them to join the cause. Reports flew in that some of the rank and file halted trucks on the highways to prevent deliveries, and when the growers began to post armed men on the trucks, the strikers narrowed their focus to the largest bogs and those owners who exerted the greatest influence in setting wages. The Federal Cranberry Co., A.D. Makepeace, Slocum-Gibbs, Ellis and Atwood, Benjamin and Stanley and A.H. Griffiths all came in for unwanted attention, with the bulk of them based near South Carver and Wareham in southern Plymouth County. In the northern part of the county, where bogs were smaller and more scattered, strikes were fewer.

The owner-members of the Cape Cod Cranberry Growers Association stood fast in refusing to negotiate, and in fact, they chose to escalate the conflict by calling out police from Plymouth to stand guard at the Manomet Cranberry Company. The particulars of the story get murky, with each side in the conflict telling only its version of events, but after asserting that strikers were intimidating pickers who chose not to walk out, Plymouth police chief Russell D. Dearborn and three officers stood guard as fifty strikebreakers were recruited, "mostly from the town's public welfare lists," pitting the poor against the desperately poor.

From this point on, the growers, with the assistance of police, selectmen and newspapers, took the offensive. Always hostile to the strikers, the *Boston Globe* decried the threats made by "agitators" against workers and foremen who refused to join the strike, and the Plymouth police used these threats to hunt down activists at LeBaron R. Barker's bog at Halfway Pond (the place of dented pails). There, Chief Dearborn scoured the

bunkhouses for agitators, and although he found none, he came out with a white oilcloth emblazoned in red paint with the word "Picket," under which he allegedly discovered a scrap of paper bearing the threat: "Keep off the bogs or you will be hurt." Barker, the bog owner, claimed that a dozen young men drove by in two autos and shouted death threats in Portuguese to those who remained on the job, while another man repeated the threats in English. The police drove off the strikers, and guards were called in to Halfway Pond and White Island.

The next step in escalation came from the strident selectmen of Carver, who swore in a dozen special officers for duty and cancelled the weekly Grange Hall dance because of the possibility of violence presented by such a large crowd. At the Smalley bog, forty workers were dismissed after a disturbance and were rebuffed when they asked for their jobs back later in the day. Predictably, and sadly, violence followed, although who precipitated it remains unclear. On September 12, the *Globe* reported that fifty special officers were sworn in from Wareham and another fifty from Plymouth with the intention, according to one of the selectmen, of "driving agitators out of the cranberry bogs." Suspicions ran wild. The police insisted to a *Boston Globe* reporter that stopping the strike was made difficult by the "the clannishness of the pickers" and the fact that they used Portuguese "to spread propaganda, so that owners and officers did not know which ones were inciting the trouble." Portuguese: their native language.

The police also targeted McIntosh and Wood, arraigning them on a bond of $1,000 for "obtaining signatures to application cards and receiving money by falsely representing themselves as working for the American Federation of Labor"—the claim being that they were collecting dues without proper authorization. The arrest did not deter McIntosh and Wood and did even less to quell tensions, as the next day a striker was shot and others wounded by pistol shots from Middleboro officers "that ricocheted." John Rose, a foreman at the Makepeace Co., was also beaten, and in a massive preemptive police raid that day, sixty-three strikers were arrested. "Although there was no evidence today that any of the strikers are armed," the papers reported, "police claim a pistol was seen in one of the automobiles used by the crowd."

In this whirlwind, even the hostile *Boston Globe* acknowledged that McIntosh counseled the rank and file "against any violence in their picketing," even while urging them to stand firm in confronting the owners. But the whirlwind was difficult to contain. On September 13, a caravan

of 150 "marauders" allegedly attacked a group of scabs, non-strikers and special police, while "inciting and frightening pickers, upsetting barrels of berries, and threatening death to any who dared hinder their activities." The marauders were routed by police at mid-day, and two were arrested: Jesse Gomes for attacking a special officer from Wareham, and Joseph Tobey, who was arrested at the Makepeace bog in the Myles Standish Reservation after he consulted with attackers, "returned to the pickers he was directing, and attempted to get them to quit picking." The arresting officer—Special Officer Russell Makepeace—arrested Tobey for assault and battery.

With supporters arrayed and the Depression available as a bludgeon to break worker solidarity, growers refused even to consider the strikers' demands. With some bravado, given the short season, they insisted that they could hire all the replacements necessary, and if it became necessary, they could flood the bogs to avoid frost damage. Rumors circulated that some bog owners had already turned to mechanized pickers to bring in the harvest, machines that were "forbidden by the unions," but the tone was set by the cadre of special officers equipped with clubs and badges who stood by defiantly "in order that the strikers may be met with a warmer welcome than they received today, should they return."

Adjusting again to the owners' aggressive stance, Wood tried a new gambit, calling for even tighter organization among his picketers and the use of small, fast, mobile squads instead of large caravans, arguing that small actions and the rainy weather that was moving into the Cape region would slow down the harvest enough that growers would be forced to negotiate. Amid reports of vandalism, pulling up flume boards to flood the bogs and threats to burn screen houses, Wood announced that he would inspect each car personally "to make certain that no picket is carrying any implement which might be construed as a dangerous weapon." Off they went, carrying signs with catchy slogans such as: "Berries canned in this factory come from bogs that pay starvation wages."

What Wood failed to foresee was the impact of rain and arrest. In the third week of September, four days of drenching rain settled into the bogs, putting a halt to all operations. At the same time, McIntosh and Wood were convicted of fraud and sentenced to sixty days in jail for collecting membership fees under false pretenses, given that the AFL had not yet approved the new union's charter. When the AFL granted the charter, the two were released, but not until the strike had whimpered to a wet close. In the end, nearly all of the strikers arrested had their charges dismissed.

The Wareham selectmen were defiant afterward, declaring in their annual report for 1933 that the mass arrests they had ordered were essential for order, adding that it was a "sad reflection upon our jury system" that the court dismissed so many of the charges, and they pointed the finger at "police laxity" for contributing to the violence. By their reasoning, a tough approach up front would have nipped the strike in the bud: "had the comprehension and attitude of the selectmen's office been catered to relative to the immediate stamping out of the unhealthy situation, less intimidation and terrorizing of the Portuguese and others would have ensued, and it is quite likely that shooting affairs, clubbing, and attempted burning of buildings would have been less in evidence."

The selectmen also predicted that unless bog owners, civic officials and judges got a "clearer vision of the situation," and unless "victimizing troublemakers are not eliminated, this heretofore peaceful section is to have an insidious obstacle to law, order, peace, and prosperity in its system." Their predictions had some merit. In 1934, the Cranberry Pickers Union was authorized as Local 368 of the International Hod Carriers Union (IHCU) and set up headquarters in Onset. Formulating their demands, the union submitted a contract to larger growers, who flat out rejected it, including their demand for minimum wage of fifty cents for sanding, weeding and all bog work other than picking; seventy-five cents for "scooping"; fifteen cents per measure for hand picking; and twelve cents for snap scooping. The wage schedule was repugnant enough to growers, but the rest was beyond the pale: the call for recognition of Section 7-A of the National Industrial Recovery Act, which guaranteed the right of workers to form unions and to have collective bargaining, a closed shop and a steward to arbitrate disputes, paid for by employers but chosen by the union. Why negotiate when you can dictate?

The harvest season of 1934 picked up where 1933 had failed, with the same actors reprising their roles. The Carver police began to carp about "outside agitators" in August, stating that "labor men from out of town [Providence, Quincy and other places] have been active among the pickers and meetings have been held nightly," but this time they were prepared. Even before the harvest began, they marshaled a "force of special officers ready at call, with riot guns and gas bombs, to combat violence of any kind." Despite the intimidation, 500 pickers voted to strike on September 3, and on the next day, 1,500 walked out of forty-one bogs.

Like the year before, police and growers were suspicious that many of the pickets refused to speak English, and they blustered that some bogs were already employing local whites. With the season about to begin, one foreman reportedly claimed that he could raise one thousand pickers the next day "if he had cranberry scoops for them." According to the report, owners feared only that strikers, "stirred by their agitators, may resort to intimidation and bodily harm in the families of the pickers who would not strike."

In a clever twist, the union, with little cash on hand to cover strike pay, sent its strikers to the Welfare Board in Carver to receive food, "as the Attorney General stated that the towns were obliged to feed strikers." The police, however, were not playing. Like the year before, their response was harsh, beginning with a raid on a boardinghouse reputed to be a center for the organizers, which the police shut down for violations of the health code. Considering the typical condition of shanties and pickers' residences, health violations would be no surprise. Once again, violence seemed imminent. A small riot in Wareham left a foreman (Thomas Souminen) grievously injured, along with a woman (Matilda Fernandez) who had rushed to his defense.

But the turning point of the strike of 1934 came early. On September 9, there were ten arrests on the ground but more importantly two in the sky. Fred Wood was arrested after hiring a plane to fly low over the bogs in Wareham and Carver. Charged with "intimidation," Wood was fined $200 and his pilot $10. Historians Stephen Cole and Lindy Gifford quote one witness to the plane incident, foreman Ernie Howes of Frog Foot Bog, who remembered the plane buzzing by, scaring and scattering the pickers, but another witness, Gibby Beaton, who oversaw picking on his uncle's bog, remembered it rather differently. The pickers, he thought, were having "fun with it," scattering into the woods, "hoping that the strike would benefit them. I mean, they kind of had fun at it, everybody'd laugh and joke and so forth." No two seats were exactly the same.

Though never requested, the State Board of Arbitration and Conciliation came to Plymouth County to help settle the strike, and they counseled workers to return to work without discrimination. When it came to the growers, however, J.J. Beaton, president of the Cape Cod Cranberry Growers Association, claimed that the association could not bind its members because it was merely a marketing association, with no authority to do more. Despite the intransigence, union officials agreed to terms and called off the strike

Town officials were even more apoplectic than they had been the previous year, with the Wareham selectmen fulminating about this "second appearance of devitalizing agitators" and predicting that "this communistic serpent will doubtless infest our hitherto peaceful community until Congress disfranchises, and literally regards, agitators who have never proved themselves of any worth to themselves or society as undesirable citizens." The selectmen even claimed that "one white American of communistic or maniacal trend...at a public meeting suggested that a bomb be placed under the Town House!"

Dissecting the failure of these strikes is an irresistible lure for the historian. It is challenge enough to organize transient workers, most from a racial minority, and to carry out a strike in a region dependent on the cranberry industry, but for all their energy, Wood and McIntosh made several missteps and at crucial junctures failed to keep reins on the rank and file. Facing the solidarity of large growers, civic officials and police, the strikers had little chance. A report from the U.S. Department of Labor was succinct: "The union was organized by outsiders and was composed predominantly of workers belonging to a racial minority. It almost inevitably faced intense hostility from communities in which the most prominent citizens, many of them holding public office, were themselves grower-employers."

After the Strikes

Having twice failed, the Cranberry Pickers Union fell apart in a haze of recrimination and legal bills, and the experience was enough to stunt later attempts to organize pickers by the National Committee to Aid Agricultural Workers and the United Cannery, Agricultural, Packing and Allied Workers of America. But the strikes were not a total failure. The State Department of Labor studied conditions of employment in the industry in 1935 and held conferences with growers where they attempted to eliminate "certain evils" in the industry and convince them to adopt a suite of recommendations, including:

> *sanitation in general: The furnishing of pure drinking water and the safe-guarding of the water supply; the methods employed for sewage disposal; sleeping quarters in buildings provided for pickers*

> *and other workers; kitchen quarters, and other requirements of this nature...compliance of laws regarding school attendance of children, providing suitable medical supplies for workers on bogs, prohibiting the employment of girls under 18 years of age at scooping berries, prohibiting the carrying of filled boxes by women and children, and requiring more uniformity in wage rates.*

The legal ramifications of the strikes took years to unravel. One striker, Alfred Gomes of Onset, sued Herbert Stanley, a grower from Carver, after losing two fingers on his right hand during a strike-related riot, and won a judgment from the Plymouth Superior Court for $1,500 for having been prevented from work, "although the sum named was in the amount of $50,000." An appeal was immediately filed by Stanley through his attorney, J. Frank Kiernan, alleging that he (Stanley) had been beaten by the strikers while defending his property and that Gomes's injuries proved he was not shot at a distance as contended but at short range while struggling for the gun. A bill considered by the state legislature in 1936 to compel cranberry and tobacco growers to pay their workers weekly was defeated by a vote of fifty-five to thirty-three after lengthy debate. Senator D.W. Nicholson of Wareham opposed the legislation, declaring it "unnecessary" and "detrimental to the cranberry growers of his district." Nicholson noted that some growers paid weekly, but "for a variety of reasons" many chose not to pay until the end of the season, "although it is customary for many growers to give pickers advances on their pay if they request it."

With barely incremental progress, labor pangs continued to be felt, though subdued. A strike was averted in 1937 after the Cape Cod Cranberry Growers' Association and the Cape Verdean American Citizen Taxpayers' Association negotiated a "working" scale that paid hourly rates ranging from sixty cents for an average scooper downward, with an average scooper being one who could fill three harvest boxes per hour. The price for picking by the box was set at twenty-five cents each, with hand picking set at ten cents per six-quart measure, a raise of 25 percent.

In looking back on the troubled 1930s, it is not hard to see that not everything played out according to a script where better alternatives were abundant. Although race played into the conflict, race was not a deciding factor. Whites stood side by side with Cape Verdeans on the picket line,

including the principal organizers, and several Cape Verdeans sided with the growers. Although the town selectmen were militant in opposing the strikes, not all were equally militant. Barnstable selectman Chester A. Crocker became a voice in the official wilderness by arguing that growers could well afford to pay eighty cents per hour for picking but refused to do so from sheer greed.

Among the growers, too, a few progressive voices, like Watson Kelley, recognized that working with the pickers, instead of crushing them, could be profitable for all. In one of the more extraordinary examples, a second-generation grower from South Carver, Ellis D. Atwood, drew inspiration from Roosevelt's New Deal, building a "model village" for the forty-five or fifty workers he employed. Touted in *Cranberries*, the magazine for the cranberry industry, the village was described as a tidy assortment of "small modern homes all in a little community" in which the workers lived "entirely rent free." The benefit this arrangement made in the pickers' lives can easily be imagined, but the benefits of the respect accorded by Atwood were even greater.

Atwood was no minor figure. He was a major grower who had become persuaded that most owners offered only "unsanitary and depressing hovels"—and as a director of both the Cape Cod Cranberry Growers' Association and New England Cranberry Sales Co., he had seen enough to know. By 1936, he had built about a dozen cottages for $500 to $700 apiece for a two-room shack and $1,000 for four rooms with a bath, and he planned to expand his village when the profits on his crops allowed. His village was remarkably planned, laid out on a landscaped street he called Eda Boulevard (the name coming from his initials), and the cottages were provided with electricity and some with electric pumps for water, not to mention streetlights, a store run by a Cape Verdean and even a small lending library. On one side of the street lived the Cape Verdean workers, and "the other side is for those of the white race," mostly Finns and a handful of Yankees. Segregation was a fact of life. "It is reminiscent of a Southern Plantation," the article noted without a hint of irony, "with the owner taking an interest in his workers, but of course without the ugly features of the old slavery days." Notably, Atwood's bogs experienced no unrest in 1933.

6
Fallout

The federal census of 1920 revealed that the population of Carver, Massachusetts, had dwindled by half in just ten years and had gotten so small, as one newspaper put it, that all four of its villages rolled together "could be served by one milkman and he would not have to get up very early in the morning, either." Yet Carver delivered. This one small town in Plymouth County produced one-eighth of the nation's cranberry crop, twice as much as the entire state of Wisconsin, and everything else seemed to have been overgrown by vines. The old Charlotte blast furnace that had once produced cannonballs for the War of 1812 had become a decrepit shell, shuttered all but the two weeks a year when it served as a screening house for cranberries, and across the road was the factory of one of the furnace's major consumers of iron, the Murdoch Parlor Grate Co., which had long since burned to the ground. John A. Windberg, a fifty-year resident of Carver, remarked that all of the industries save the cranberry had succumbed, one by one:

> There was the iron foundry—that's gone. I used to work there. They raked bog iron from the bottom of the pond and smelted it and sent it away. There was the grate factory—you seen the remains of it. There was the old "Bread Mill," they called it where they made shoelaces. That burned down nearly forty years ago. The boardinghouse where the help lived is still standing. This used to be a general farming country, but farming has gone the way of the ironworks. Across the road there is a farm where they used to keep fifteen or sixteen head of cattle. Now there

isn't a single cow. That's the way it is all over the town. The young men are going into the cities; the old folks who have ties here they don't want to break are raising cranberries.

Cranberries were built on memories like these, memories of industries past and landscapes gone, of bends in the road where all that remained were grates and ruins, shoelaces and handfuls of dirt left behind. The memories that still tied the few to the land were not always comforting, and the total commitment they made never made for easy times. For all the efforts of the early promoters, for all the innovation in agricultural technology and for all the commitment of whole towns, counties and regions, the cranberry market proved too volatile to be a reliable friend. A still-developing product in a niche market, its prices swung through chaotic highs and lows, its crop suffering gluts and failures, droughts and floods, fires and frost, leaving only the committed to abide.

By the turn of the twentieth century, growers had come to realize that cooperation, not competition, made good economic sense for a crop produced by so many small growers on so many small plots. And after all, cranberries were a cooperative fruit. In coming to such a conclusion, they were not alone. The cooperative ideal, as it was often called, first took root in American agriculture early in the nineteenth century, and fifty years later, cooperatives became something of a fad—a thoroughly necessary fad. By coming together, associating, small producers achieved what would they could not achieve alone by pooling their funds, spreading risk and sharing equipment, knowledge, labor and profits. Cooperation provided an economy of scale for the small producer; it provided stability in production, distribution and marketing that allowed them to survive and even thrive. It provided the chance that a small producer might survive trampling by the great. For cranberry growers, cooperation in distribution and marketing seemed particularly attractive, since theirs was a short-season fruit, consumed almost entirely in the months of November and December and prone to cycles of glut and shortage. The hope of wresting a moment of stability from the maelstrom of supply and demand made cooperatives ever more attractive in a country in which monopolies seemed to run unfettered and in which the wheels of modern capitalism seemed destined to grind the small producer into dust. For many, too, a socially responsive economy was a dream worth striving for.

Following European theorists such as the Scottish socialist and industrialist Robert Owen and the French communitarian Charles Fourier, Americans experimented with a palette of approaches to cooperation that ran a spectrum from sharing information to sharing lives. Milk and dairy producers were early to band together, African Americans in the Jim Crow South organized the Colored Farmers National Alliance and Cooperative Union and consumer cooperatives sprang up like mushrooms, which eventually spawned their own cooperatives. Ironically, the Sherman Antitrust Act of 1890, which aimed to rein in the repeated competitive abuses of large corporations, became a hurdle for cooperators. As a mechanism for members to secure fair prices for their products, cooperatives became vulnerable under Sherman for price fixing, and it was not until passage of the Capper-Volstead Act of 1922 that agricultural producers were exempted from the regulations made necessary by the Standard Oils of the world.

During the early years of the cranberry industry, growers went their own way when it came to marketing and distribution, and although many rode out the market to earn long-term success, nearly all were dependent on a handful of commission merchants in distant cities to get their product to market. Even larger growers were a small presence in this world, and the record of commission merchants for honesty and integrity in their dealings was mixed, to be generous. Legal niceties meant only as much as enforcement allowed; most growers had little chance of recovering an award from a faceless merchant halfway across the country, and disputes seemed seldom to settle in favor of the small producer.

The first tentative steps into cooperation were taken regionally and on a very limited basis. In 1866, the first of two Cape Cod Cranberry Growers' Associations was formed by Zebina Small of Harwich and compatriots "for the purpose of mutual benefit and protection…and to promote the general welfare of the association." The association served primarily as an information clearinghouse, with no mingling of finances, and for a few years its members discussed such topics as the "nature, habits, &c" of fruit worms, picking machines, crop and market conditions, standards and yields. A longer-lasting organization of the same name was founded in 1888 and continues to represent the interests of growers. Taking the next step forward in cooperation, the New Jersey growers Theodore Budd, Joseph White and J.A. White formed the American Cranberry Growers' Association in Vincentown in 1871 with

the more ambitious goal of cooperating in marketing and distribution. They were a progressive lot, pushing standardization, quality control and crop improvement, and they made efforts to work together to open foreign markets, though with limited success.

The scope widened incrementally in 1895, when several of the larger eastern cranberry growers created the aptly named Growers' Cranberry Company, with headquarters in the largest market of the day: Philadelphia. Keeping an eye on market conditions and opportunities, the Growers' Cranberry Company monitored the market and distributed produce efficiently and well, selling berries under the brand names growers had carefully, individually developed and distributing the profits just as individually. Like the locally focused Cape Cod Cranberry Sales Company, formed with similar intent in 1895, this was a limited endeavor, a civil union of convenience rather than a marriage.

Two years later, growers in the marshes of central Wisconsin established the more fully cooperative Cranberry Growers' Union. Unlike the Cranberry Growers' Company, the union introduced the more progressive idea of not only sharing marketing and distribution but also pooling their berries and profits across the whole season and paying each grower-member in proportion to his contribution. This model provided a measure of security for growers and a buffer against price fluctuations during the season. The union thrived. Growing rapidly, it was reorganized in 1905 as the Wisconsin Cranberry Sales Co., with offices in Des Moines, Iowa, and Chicago, and by the next year, nearly 90 percent of the state's growers could be counted in its ranks. The power of cooperation and the broader vision of the marketplace it enabled helped growers turn profits even in years when supply exceeded demand. Run adeptly and flexibly, the Wisconsin Cranberry Sales Co. could respond in a coordinated manner to market conditions in a way that few individual growers could ever hope to match.

Witnessing the stirrings in Wisconsin, eastern growers formed their own cooperatives on the union model in 1907—the New England Cranberry Sales Company and New Jersey Cranberry Sales Company—although the initial participation rate barely reached one-third of growers in Massachusetts and only half in New Jersey. The three regional cooperatives in turn cooperated by forming a selling organization that same year called the National Fruit Exchange, which consolidated with the Growers' Cranberry Company in 1911 to be

redubbed the American Cranberry Exchange (ACE). Massachusetts stood out for its relatively high percentage of growers who went it alone—"independents" they are called—but the exchange proved to be a critical step in the evolution of the industry.

At first, the key attraction of the cooperatives was having a central point for sales and distribution, meaning growers were not only freed of dependency on commission merchants, but they could also sell directly to small jobbers and to that great symbol of the century: the chain supermarket. Equally attractive to growers, they paid only a 7 percent commission, rather than the typical 10 percent, and 2 percent of that commission went straight back to help the local co-ops. In the longer run, the ACE played an even more important role by instituting a system for grading and branding cranberries, carried out by the state-level affiliates, which helped to build confidence in the purchasing public in the quality of the product. Each batch sold was guaranteed to be "dry, sound, free from frost or wormy berries," and each individual brand had to meet specific qualifications for the color, size and variety of berries. Just as important, the state-level cooperatives inspected and graded each shipment, slapping an attractive label on the barrel to advertise that the barriers rose to the bar.

The ACE quickly became the central agent for selling fresh cranberries, the vast bulk of the produce at the time, taking the fruit directly from the individual growers, providing additional cleaning and sorting as needed, conducting market research on prices and strategies for distribution and, above all, providing advertising for the fruit and its various brands. Coordinating rather than undercutting one another enabled growers to build public demand in a way never before possible. The enlightened president of the ACE, Arthur U. Chaney, devised a dizzying array of ninety brands, specifying in detail the requirements for each and whether they were worthy of bearing the famous consumer brand name Eatmore. Beyond the playful pun, the Eatmore name was intended to evoke a sense of quality, and it became so popular that the ACE surrendered to the inevitable in 1953, changing its name to Eatmore Cranberries, Inc.

Meanwhile, back on the ranch, new things were cooking in the cranberry world, and another player entered the field. The power behind this new organization was the redoubtable Marcus L. Urann, a native of Maine, an attorney and a longtime grower who had risen through hard work and ambition to become a board member of the ACE

Fallout

Eatmore Cranberry boxes. Donald McFarlane is on the left, circa 1954. *Courtesy of the Carver Public Library.*

and president of the six-hundred-acre United Cape Cod Cranberry Company. Urann knew his cranberries, but more importantly, he knew his market. By 1912, Urann had begun to rethink the challenges of marketing a fruit with a short consuming season, and he began to imagine the benefits of vertical integration. In that year, he set up cooking facilities at his packinghouse in Hanson, Massachusetts, and began to process the berries he grew to sell as canned cranberry sauce under the name of Ocean Spray Preserving Company.

As modest as this seems, Urann's maneuver was revolutionary. For a fruit that had been marketed almost exclusively as a fresh product, it was a radical proposal to cook and can. Although canned sauce took time to build favor, and even longer to appeal to growers, the benefits of canning were clear. Not only could growers make use of small and blemished berries that were unsalable as fresh fruit, but a canned and preserved product made it possible to stretch sales throughout the year, building deeper, non-seasonal demand. Best of all, if a glut threatened to send

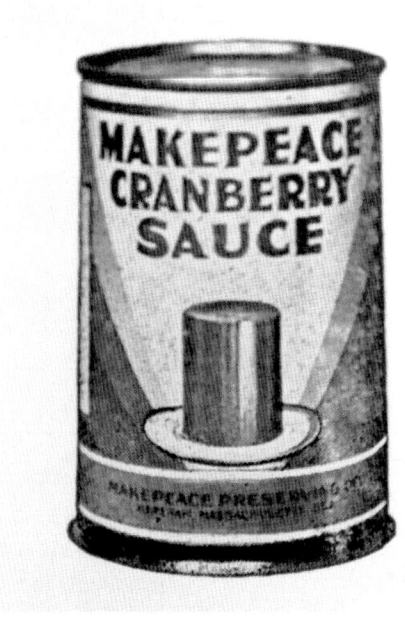

A Makepeace cranberry sauce advertisement.

prices downward, a portion of the crop could be processed and shelved for sale at a better time.

One of Urann's great gifts was his insight into the consumer mind. The ACE was masterful at raising brand awareness for the wholesale market and promoting standards that built brands, but Urann had his pulse on consumer tastes and an eye for detail for everything from the elegant bottles and labels to the advertising pitch that stressed healthfulness, wholesomeness and thriftiness. Despite the skepticism of other growers, Urann stuck to his steel pots, and by the 1920s, the evidence of his success at canning attracted competitors, including John C. Makepeace of the A.D. Makepeace Company, the nation's largest grower, and Elizabeth F. Lee of the New Jersey–based Cranberry Products Company. A shrewd businessman, Urann proposed that the three competitors merge, but when informed that antimonopoly regulations stood in their way, he proposed forming a marketing cooperative for canners, arguing that the agricultural exemptions provided by the Capper-Volstead Act should apply to food processors no less than producers. In 1930, the Cranberry Canners, Inc., was born.

The triple heads of this new Cerberus agreed to turn over all of their canning to the cooperative while keeping control of their personal growing operations, and after some delicate negotiations, they agreed to issue all of their products under Urann's Ocean Spray brand. From the beginning, the relationship between the three was fraught with mistrust, but on the principle that one should keep one's enemies closer than one's friends, the cooperative pursued a canned version of the ACE's fresh strategy, rationalizing production, distribution, quality control, marketing and pricing. Unlike the more democratic ACE, where every

The winner of the Miss Cranberry competition atop her boxes, Carver, Massachusetts, circa 1950. Growers became more adventurous in promoting an interest in cranberries during the 1940s and 1950s, sponsoring Cranberry Queen contests and other popular events to draw attention to their products. *Courtesy of the Carver Public Library.*

grower-member had a vote, the Cranberry Canners was unmistakably controlled by the triumvirate, with Urann wielding half the voting power and Makepeace half of what remained. Many growers, including Urann and Makepeace, were members of both cooperatives—the ACE for fresh product, the Cranberry Canners for processed—and pragmatically, Urann lured many growers to join his canning cooperative by announcing that they would need to commit only 10 percent of their crop, roughly equivalent to the fraction unfit for sale as fresh fruit.

While building his membership in the 1930s, Urann also helped develop a number of novel cranberry products, introducing the popular cranberry juice cocktail in 1933 and Ocean Spray Cran (a syrup for mixed drinks) in 1939, and promoting dehydrated cranberries. With such energy and creativity, the Depression years were expansive years for the industry as a whole, and in 1937, the Cranberry Canners announced that it had canned its millionth case of cranberry sauce, which was sent to President

Roosevelt for use at the White House Christmas dinner. Growers also came together to produce the trade magazine *Cranberries*, which hailed the cooperative spirit. The magazine, they wrote, was "devoted solely to the best interests of the cranberry industry."

> *This is not to imply that cranberry growers and others dealing with the fruit are unorganized or lacking in cooperative spirit. Indeed, we pay great respect to the growers' associations, the cooperatives for selling, which were among the earliest to unite agricultural workers in a single group and which have done so much to improve marketing conditions, or to the efficient federal or state workers engaged in full or part-time assistance to cranberry growers, or to individual leaders.*

But cooperation had its limits, and the fresh-centered ACE and canning-centered Cranberry Canners (renamed the National Cranberry Association in 1946 and Ocean Spray Cranberries in 1957) were operating in a town too small for the both of them. Urann was a wily and aggressive expansionist and to expand his market share meant putting him into competition with the ACE: cooperative fighting cooperative with velvet gloves. Luring growers away from his rivals, Urann convinced the New England Cranberry Sales Company to join his cooperative in 1934, with New Jersey and Wisconsin following suit in 1938 and 1940, respectively, selling their fruit through the ACE to the National Cranberry Association for processing and paying a modest commission (Urann paid no commission when selling his own fruit). His ploy worked. By 1942, 44 percent of the national crop was being processed, rather than sold fresh, and by the end of the decade the National Cranberry Association was outselling the ACE's Eatmore brand two to one. Urann and Makepeace further strengthened their positions during the war years when each, acting independently, sold dried cranberries to the military— different versions for the army and navy, which apparently had as much difficulty cooperating as cranberry producers. Nearly the entire harvest of 1943 and 1944 was dehydrated and shipped overseas, earning the industry an A Achievement Award from the War Food Administration. Interestingly, German paratroopers during the Second World War were also given dried cranberries (probably mountain cranberries) "to relieve what must be the tremendous nervous strain of this brand new type of soldier," as *Cranberries* reported.

As the war wound down, the struggle between the ACE and National Cranberry Association ramped up, and although there were bumps along the way, Urann almost always came out on top. He and Makepeace were sued by the federal government for antitrust violations in 1941, and even after pleading no contest, they were hit with only small fines. The National Cranberry Association was reorganized on slightly more democratic principles, but it barely skipped a beat in increasing its purchases of berries from members of the ACE.

The postwar years were a period of great stress for the industry as demand for cranberries fell and overproduction became the norm. The conditions particularly affected the cash-strapped ACE, though its greatest hurdle would be the wily Urann, technically a member of both the ACE and the association. When Urann set his sights on dominating the fresh market, the velvet gloves came off, and the ACE began to falter.

With the ACE and National Cranberry Association duking it out, the early 1950s became something of a lost weekend for growers, who eked by on small margins and slender profits. Having failed to find common ground, the ACE offered to merge with Ocean Spray but was rejected by Urann, who insisted on working only with individual growers, and so in February 1954, the New England Cranberry Sales Company succumbed and sold its assets to the National Cranberry Association. Ocean Spray had won out.

Although a number of growers still hold out as independents, in 2011, Ocean Spray took in almost 80 percent of the 685 million pounds of raw cranberries produced in the United States (valued at $465 million), and about 95 percent of the total is now sold as processed food, mostly juice.

PESTS AND PASTS

The crisis point of the cooperative fight over the bogs coincided with the crisis point for another, longer-term fight: the fight against pests. While struggling to raise, protect, gather and distribute their crop, growers were simultaneously locked in a mortal struggle with nature. These distinctive little monocultural plots, cranberry bogs, were as difficult to manage as any herd of cooperative cranberry growers.

Even before there was a cranberry industry to speak of, would-be growers squared off against myriad pests. Almost as soon as reports of

cultivation appeared, reports of pests followed. In 1830, the *Republican Star* of Easton, Maryland, noted that cranberry bogs "are liable to be eaten and destroyed by worms" in very dry seasons, and Augustus H. Leland of Sherborn, Massachusetts, a grower since 1838, reported that on his plots, the scourge of grasses and sedges was ever present, and his vines were eaten annually by the nefarious cranberry worm. With economic entomology still in its infancy, Leland believed the cranberry worm very much resembled the apple worm, "its appearance to the eye is the same, its operations the same, and it has the same faculty of jerking itself back as the apple tree worm." In some seasons, Leland feared "total annihilation," but in 1852, he announced that his experiments in flooding his bog a second time between the spring and July 1 were an effective countermeasure, leaving behind vigorous vines that produced "as handsome a lot of berries as ever was seen." He had gained a perspective on the crop, its hardships and pleasures:

> *It is more than twenty years since I entered upon the cultivation of the vine with high hopes, believing that the cranberry was a hard thing to exterminate, that it would destroy grass in all situations and all soils, and cause even hassocks to disappear. And after a trial and many years of observation, I find the cranberry a hard plant to destroy, except with the plough, and that it will not root out and destroy all grasses in all situations and soils. I find that in some soils the vine will not drive out certain kinds of grasses which in other soils, it may succeed.*

Like Leland, growers responded by using whatever means necessary to contain pest damage. It was not just a single species of worm or grass that troubled, but a seething army of the creeping forms of life, each with its own characteristics, each insulting the vines in its own distinctive way. Benjamin Eastwood was consumed with concern for "the worm," which he said comes in swarms to extract the moisture from cranberry leaves, and he alerted growers to the dangers of the fruit worm and rot as well. James Webb pointed his finger at the miller moth, which deposits its eggs on the underside of cranberry leaves, and the fire worm, its voracious larva. It is imperative, he wrote, to flood the bog within twenty-four hours of the first appearance of the moth, for once the eggs were laid, flooding had no effect. The cranberry fruit worm was relatively easy to control by flooding, he added, but greater effort was required to combat the legions

of girdlers that secreted themselves underground, cutting circumferences around the bark of vines and destroying the plant's vital circulation. Over the years, the timing, length and frequency of floods became the topic of considerable experimentation by growers, who explored the stages of the insects' life cycles in order to find the phase most vulnerable to a shot of cold water. The threat of pests forced growers to attune themselves to the natural cycles and rhythms of an insect's life in order to preserve their artificial cranberry realms.

Joseph White, too, saw the damage done by the fruit worm, which laid eggs under the skin of the berry and ate it from within, and the vine worm, he wrote, was nearly as bad. "The cranberry was not the principal food of the vine worm until it was brought under cultivation," he noted, "while growing naturally in bogs and swamps, where it was liable to be flooded during the winter and early spring, it was not well adapted to their requirements." Back then, the worm browsed through leatherleaf and huckleberry, but the vine worm had learned to adapt to cranberry bogs. White's insight was often ignored, but these most unnatural cranberry bogs presented unnatural problems. Some pests were surely specialists on cranberries and had fed on the vines in their wild state, surviving in a sort of dynamic equilibrium with their prey. For them, a monocultural island of cranberries was like an all-you-can-eat buffet where the grower had already paid the bill. But the cranberry bogs also attracted generalists and opportunists like the vine worm that might barely notice a cranberry in the wild. Whatever similarities cranberry bogs had to their natural forebears, they disrupted the natural relations between predator and prey, with consequences that would be hard to predict and harder for an agriculturist to control.

Henry J. Franklin, director of the Cranberry Experiment Station of the University of Massachusetts, made a valiant effort to categorize insect pests in ways that might help their control. There was an insect gang of four to despise, starting with worms that attack foliage, buds, flowers and fruits (including fire worms, spanworms, cutworms, hairy worms, fruit worms, bagworms and more); non-worms that attack foliage, buds, flowers and fruits (weevils, leafhoppers and mites); insects that attack the stems of cranberries (the cranberry girdler, scale insects and spittle insects); and insects that attack the roots (the cranberry white grub, grape anomala, cranberry root grub and striped colaspis). Any number of fungal infections and nematodes added to the threats, and making it all worse,

insects were known to transmit infections such as false blossom disease, caused by phytoplasma (parasitic bacteria). In the 1920s and 1930s, false blossom disease nearly wiped out the crop in New Jersey and wreaked havoc in Massachusetts for years before scientists discovered that the blunt-nosed leaf hopper was the vector for transmission, making it the target of trepidation and anger, not to mention unrelenting efforts at eradication.

Weeds were just as virulent as pests, and since the vines grow in densely interwoven mats low to the ground, weeds can be remarkably difficult to expel. However thorough growers may be at clearing a new bog, they face a wetland flora and lurking opportunists that have evolved to take advantage of conditions favored by the cranberry, and thus it was possible that the more a bog was made suitable for cranberry culture, the more it became suitable for its weedy foes. Eastwood advised particular vigilance during the first three years after a bog was planted and suggested annual weeding thereafter to keep "down any foul stuff which may have made its appearance," for foul stuff seemed never far away.

Cranberry weeds come in names straight out of Dick Tracy's catalogue of villains. The bristly and prickly dewberries spread rapidly when given a chance and can kill cranberry vines if not removed, and while late flooding can reduce their impact, removing them by hand may be the best alternative. The glaucous greenbrier (or silverleaf sawbrier) is just as malignant, growing in rapidly spreading patches, but its extensive root system is what makes it so obnoxious and difficult to destroy. In the heaviest infestations, a grower may have to tear down and renovate the entire bog from the muck up. Poison ivy has also been cited as a major problem (though perhaps the name is too pedestrian for the comics), but the chief of the rogue's gallery of weeds is the insidious dodder, a parasitic plant that attaches to cranberry vines when more attractive hosts are not present—and since cranberry bogs are monocultures, the vines readily fall victim. Dodder looks like delicate golden threads, beautiful but extraordinarily difficult to eradicate once established. When it grows, dodder penetrates the vine with outgrowths called haustoria, and even if pulled off, haustoria regenerate. Worse, if left to its own devices, a single dodder plant produces thousands of seeds annually that can lie dormant in the soil for a decade or more, a ticking time bomb waiting for a momentary lapse of attention to unleash destruction.

In the hearts of pest fighters, flooding was nearly equaled by sanding as a tool for control, and growers have long sworn by sanding for suppressing

Fallout

Experimental infestation of dodder in the greenhouses of the University of Massachusetts Experiment Station. Wareham, Massachusetts, August 2011. *Photo by Eliot Wentworth.*

weeds. Rightly so. But as with so many things on the bog, the picture is not so straightforward. The ways in which natural systems are integrated make any alteration fraught with the unexpected. As it turns out, the nice clean sand laid down can produce excellent conditions for the germination of many weed seeds, and a number of other wetland-loving plants like poison ivy respond like cranberries to the insult of sand: they thrive. Nevertheless, the benefits of sanding outweigh the deficits, and the process is considered essential to bog maintenance to this day. It is particularly effective at treating insect pests such as the tipworm, where the sand buries cocoons and prevents the emergence of adult flies, and by burying the "bog trash," the new sand cuts off the larvae of cranberry girdlers from the substrate they adore. A fresh layer of sand may also serve to reflect the sun back on the vines, increasing their photosynthetic activity, and it may contribute to a slightly warmer microhabitat, helping protect against frost.

But flooding and sanding cannot deal with all of the hydra-headed pests that threaten, and the scale of the problem demands action. From

the beginning, weeding and picking off insects by hand proved effective on small bogs, but as labor-intensive as manual work was, it could never translate to larger operations. Fortunately, the cranberry industry developed just as scientific agriculture was gaining a foothold in the United States, and growers learned from experience, experiment, word of mouth and study, showing the same inclination to innovation that they had shown when developing tools and techniques.

By the late 1840s, growers were already trying out any number of organic liquids, powders and solids in an attempt to control worms, trying to make the ground, cranberry leaves and vines as inhospitable to pests as possible. Austin Roberts advised spreading four acres of salt per acre, while Leonard Lumbert spread a mix of salt, wood ashes and lime. Other growers tried ashes (William Chipman of Sandwich, Massachusetts) or "tobacco water" (Joshua Cole of Eastham), a substance still used in organic pest reduction. Joseph White, as industrious as ever, scattered sawdust soaked in kerosene on the ground and tried attracting insects to a concoction of molasses and water in hopes they would drown, with stunningly unsuccessful results. With greater verve, he suggested that growers confronting a moth infestation might try catching the beasts in nets before they laid their eggs, though his most poetic suggestion was to make use of the moths' attraction to flame. As night fell, he suggested, growers should prepare their weapons:

> *A large ball of cotton is tightly wrapped in fine wire, and saturated with kerosene; it is then supported by wire over the middle of a cheese-box lid, for instance, with a handle attached, the lid being covered inside and out with fresh air. Several men, armed with these weapons of offence, proceed to the meadow at night, and, with the lamps lighted, march over the vines within touching distance of each other, all the while moving their lights from side to side. The insects are stirred up and killed in the flames, or caught by the tar.*

White was also in the vanguard of thinking about biological pest control, suggesting that bluebirds, "one of the greatest destroyers of small caterpillars and worms," be encouraged to take residence and that the European house sparrow could be introduced to hunt down vine worms. The consequences of introducing the sparrow barely occurred to White, but later growers gradually came to appreciate the unique value of the

swallows, swifts, purple martins, phoebes and red-winged blackbirds that flitted overhead.

It was not until the 1890s and the revolution in economic entomology and chemical production that synthetic pesticides and herbicides came to the bogs in serious quantities. When they did, they caught on quickly. In 1894, Frank W. Sempers advocated controlling the vine worm and fruit worm by mixing the arsenic-based poisons Paris green or London purple with molasses to make the concoction stick to leaves. Charles Henry Fernald, an entomologist from Massachusetts Agricultural College, believed that growers were prejudiced against the poisons due to the fears of toxic residue; however, he was certain they would come around: "When they realize how small an amount is used, and that this is entirely washed off before picking time, they will see that there is no possible chance for an accident."

Copper sulfate and pyrethrum were quickly adopted, applied with hand pumps, horse-drawn or motorized vehicles or shore-based sprayers. Major growers like A.D. Makepeace stepped in to distribute insecticides and herbicides, advertising to the industry black leaf 40, iron sulfate, weed killers, lead arsenate and sodium cyanide in the mid-1930s. Kerosene and petroleum-based products were tried out with success, at some expense, killing weeds but not vines. In the mid-1930s, adventurous growers tried out flame guns for weed control, applying intense heat for a few seconds to kill the invaders, not burn them, and at the same time, others began to experiment with spraying from "autogyros" (helicopters) and crop-dusting airplanes.

But there were worrying signs as well. Throughout the 1930s, veteran growers reported that pests that had been rare in their youth were becoming commonplace and were requiring ever-greater sophistication to keep in check. In 1937, Clarence J. Hall, editor of *Cranberries* magazine, fretted that the prevalence of insect pests and false blossom disease was becoming an increasing burden on growers, requiring them to invest in so much expensive equipment that smaller bogs were finding it impossible to remain profitable. Whether or not the insects and weeds that seemed so much more prevalent now than in the past were responding to the opportunity of acre upon acre of cranberries, where a diverse habitat had once ranged, the cranberry industry had become chemically dependent.

The Great Cranberry Scare

The cranberry season of 1959 was shaping up brilliantly, and having survived infestation, cooperation and stagnation, growers were again sensing profit. From Massachusetts to Wisconsin, from New Jersey to the West Coast, the crop promised to be the largest on record and the prices the highest in half a decade, and the industry's marketing plans seemed right on track as the all-important holiday season approached. But in a spare few minutes on Black Monday, November 9, their optimism died. At a mid-day press conference, U.S. secretary of health, education and welfare Arthur S. Flemming issued a single sentence that stopped the heart of an industry:

> *The Food and Drug Administration today urged that no further sales be made of cranberries and cranberry products produced in Washington and Oregon in 1958 and 1959 because of their possible contamination by a chemical weed killer, aminotriazole, which causes cancer in the thyroids of rats when it is contained in their diet, until the cranberry industry has submitted a workable plan to separate the contaminated berries from those that are not contaminated.*

Elegant prose it was not, but this single sentence could not have been more effective. It was effectively a sentence of death. Cranberries, the food marketed as healthful and wholesome, were revealed to be tainted, so much so that when asked whether he would advise American housewives to buy cranberries, Flemming demurred, saying that he would choose to be "on the safe side, and wouldn't buy any." The grim news was blared from coast to coast, sales of cranberries ceased, orders were canceled and fruit was exorcised from store shelves. At this, the most important time in the cranberry season, distribution ground to a halt. Poised for the largest sales of any year on record—an estimated six million cases of processed goods—growers now seemed destined for ruin.

The perils of poisonous chemicals and tainted foods are as American as apple pie, but in the apple pie 1950s, relatively few Americans focused on them. Although it is something of a caricature, most Americans regarded scientists, government and even industry with a degree of confidence, even deference, and when assured that a spray to control weeds or insects was safe, for instance, most accepted that assurance at face value. A few

pesticides even enjoyed a certain cachet. DDT was often regarded as the chemical that won the Pacific War by controlling malaria-infected mosquitoes, and it was sprayed freely in Korea, too, becoming almost a part of a soldier's uniform. With the agricultural and chemical industries touting the life-saving benefits of sprays and chemicals, and with the government singing harmony, the public rested content.

And yet a quiet concern began to ferment. As far back as the mid-1930s, the use of lead arsenate as a pesticide on tobacco and apples stirred widespread concern among consumers (Lead? Arsenic? What's not to like?), and by 1949, veterinary scientists began to document the collateral damage to animals done by DDT. In both cases, government and industry quickly dismissed the public's fears as unfounded, and they dismissed any studies that indicated otherwise. But the National Audubon Society and similar groups of wildlife enthusiasts were not so easily convinced, particularly as scientific evidence mounted on the physiological and reproductive changes that pesticides induced in birds and fish.

The disappearance of the peregrine falcon over much of the East Coast was widely seen as a harbinger of ill, and as pesticide use spiraled upward in the 1950s, increasing six or seven fold, unease spread over a series of incidents that exposed the consequences of wholesale spraying. The effectiveness of massive campaigns to eradicate the fire ant in the South and mosquitoes in the Northeast was not notable—the fire ant marched on—but the devastation visited upon songbirds was easy to see. In 1957, the great naturalist Robert Cushman Murphy filed a landmark case against the U.S. Department of Agriculture for the aerial spraying of DDT to control gypsy moths on Long Island, and although he lost and his suit was denied review by the Supreme Court, his eloquence in a major media market combined with Justice William O. Douglas's sharply worded dissent to galvanize public concern. This rising tide of concern for wildlife and pure foods, in part, is the backdrop that made Rachel Carson's *Silent Spring* such a clarion call two years later. The public had been primed to hear her message.

The challenges facing cranberry growers in the 1950s made aminotriazole an attractive option. Costing only about $10 per acre to apply, it was more effective at controlling weeds than alternatives that ran up to $150, and it had been approved by the government for post-harvest use—the crisis was eventually traced to a few growers who applied it

pre-harvest. But as Flemming noted, aminotriazole was a suspected carcinogen, though not yet a proven one, and in keeping with the so-called Delaney Clause to the Food, Drugs and Cosmetic Act, passed in 1958, any food or chemical additive found to be carcinogenic was to be prohibited. In the public interest, Flemming felt compelled to act quickly.

In response to Flemming, the cranberry industry mobilized its spokesmen and aggressively staked out its position. Ambrose E. Stevens, general manager of Ocean Spray, issued a press release at once assuring the public that all cranberries currently on shelves were "pure and wholesome and untainted by any dangerous substance," and he took the first of many shots at Flemming's "inflammatory statement" about what was still only suspected contamination. Suspected berries had already been isolated, Stevens insisted, and Ocean Spray growers had already been instructed to cease using aminotriazole. There was nothing more to see. Stevens followed up with a morning appearance on Dave Garroway's popular *Today Show* on NBC, reiterating Ocean Spray's vigilance against contamination. Joining him were some surely uncomfortable representatives of the Food and Drug Administration and American Cyanamid, the manufacturer of aminotriazole.

For all of Stevens's protestations, consumer confidence was hammered. Things grew so dire so quickly that in Wareham, Massachusetts, the independent Beaton Distributing Company and Decas Brothers shut down their packing plants on November 10, even though none of their growers had used the chemical. Confusion within the federal government over the scope and scale of the problem, or whether there was a problem at all, fueled the uncertainty, and conflicting claims undercut everyone's credibility. Barely a week after Flemming's infamous press release, federal researchers were pressing forward with the laborious process of testing the crop for aminotriazole, and the industry began to fine tune its media strategy.

To begin their campaign, cranberry growers called in all the political pressure they could muster from politicians representing cranberry havens. Senator Leverett Saltonstall from Massachusetts became a staunch ally, as did his counterparts from New Jersey. Representative Hastings Keith, whose district covered the bogs of Massachusetts, wrote a sharply worded missive to President Eisenhower denouncing Flemming for too hastily going public with news of the alleged contamination. "While protection of the public is paramount," Keith wrote, "it closely follows that the public should be equally protected from concern which may be totally

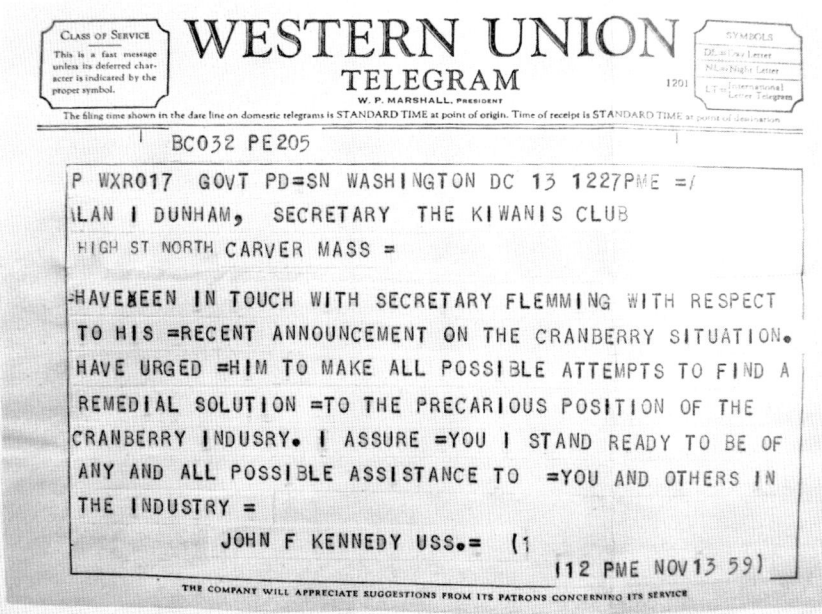

John F. Kennedy's telegram to Alan I. Dunham of Carver, Massachusetts, pledging support for cranberry growers. Washington, D.C., November 13, 1959. *Courtesy of the Carver Public Library.*

unnecessary." According to Keith, Flemming should first have held a fair hearing on the matter, rather than feeding the fears of the panic-prone, but "rightly or wrongly," he concluded, the crisis "has seriously damaged confidence of the public in an important agricultural product."

The political campaign was paired with an all-out media assault that promoted the idea that the scare was overblown and that only a small fraction of the crop had been affected while at the same time reiterating the point that they had been injured by an overreaching federal government. In the cranberry regions, many were receptive. On November 16, WPLM radio in Plymouth, Massachusetts, held a party for five thousand "thirsty children" where over one thousand gallons of cranberry juice was served, and in early December, growers in Wareham organized "a new Boston Tea Party," a group howl about unfair treatment. A few tests on cranberries were even televised, and most samples turned up only minute traces of the chemical, far below any injurious level. Wisconsin berries were said to be entirely free of taint, at least according to tests run at the University of Wisconsin.

Then there were the photo-ops. Secretary of Agriculture Ezra Taft Benson went on television to say that he had eaten cranberries and would do so again on Thanksgiving, trying as hard as any politician could to straddle the fence: "I'm concerned that we don't have any chemicals on fruit that will be injurious to the public's health," he said, "and I'm concerned too, that we don't destroy the cranberry producer's market." Vice President Richard Nixon knew his side of the fence, grumbling that he had eaten four helpings of cranberries, and while lambasting the media's "hysteria," he added, "I am not concerned about the cranberries I ate. I am confident that my hosts would not serve contaminated cranberries." The Senate would respond, too. John F. Kennedy drank cranberry juice in public, and fellow Democrat Richard L. Neuberger of Oregon spread word that he was drafting a bill authorizing the government to purchase non-contaminated berries to cover losses for the industry.

As representatives from the cranberry industry scheduled a summit with Flemming in Washington, D.C., slated for November 18, the early returns on crop tests rolled in. By November 15, 3 of 202 shipments tested were found by federal researchers to be contaminated, 2 in Oregon and 1 in Wisconsin, and while this was small evidence, it suggested ominously that the problem was not confined to one rogue grower or to just the West Coast, for that matter. At their summit, Ocean Spray representatives pressed the government, and especially Flemming, to issue a clear pronouncement that cranberries were safe, but as he did so, a shipment of sauce canned in Massachusetts in 1958 was seized, and to double the pain, the U.S. Army said it would ban cranberries on Thanksgiving.

Unsettled, George C.P. Olsson, president of Ocean Spray, asked that the cranberry regions be designated federal disaster areas, and at the government's insistence, the industry hastily drafted a five-point plan for dealing with the problem, stating it would ban all future use of aminotriazole, segregate contaminated berries, test all batches of the 1959 crop, destroy all contaminated berries and promote continued research and cooperation with government agencies. By November 20, the number of shipments seized had risen to eight, representing 84,000 pounds. But as huge as this sounds, it represented less than 2 percent of the 4.8 million pounds tested. Half the shipments impounded originated in Wisconsin, two in Oregon and one each in Massachusetts and Washington. For once, New Jersey escaped the chemical sweepstakes.

By Thanksgiving, the numbers were even more stilted: 116,630 pounds had been impounded out of 13.1 million tested—less than 1 percent—and the amount of tainting was also called into question. Many in the industry insisted that the traces were too small to matter and began to attack the scientific basis of the alleged threat from aminotriazole. Edwin B. Atwood, a professor of medicine at Tufts University, was widely quoted: "If you ate 2,200 pounds of cranberries labeled as 'badly contaminated' every day of your life, the effect would be the same as if you had eaten one turnip daily, and neither would cause cancer."

By this point, the response from the public had become both volatile and complex, with anger cutting both ways. Flemming was reviled in the cranberry regions, and his name, according to Frank Falacci of the *Boston Globe*, was mentioned "with a distasteful sneer, clenched fists and/or disdainful silence." Outside the bogs, however, there was a groundswell of support for Flemming, particularly when he was seen as being attacked by "commercial interests." The *New York Times* reported that letters to the government were running seven to one in favor of Flemming. The secretary was even urged to go after other food products: "I should like to see this issue blown up into the furore that has happened in the case of the television quiz shows," one writer insisted, thinking of the rigging scandal involving the popular quiz show *Twenty One*. The morals displayed in both cases, he wrote, were identical. Other writers asserted that no chemicals should ever be used around foods until proven safe, while others simply thanked Flemming for his bravery: "You are the only one who protects the public. The selfish interests use huge sums to protect their interests."

To stem the crisis, the cranberry industry turned to time-tested methods, unwrapping a new seal of approval to mark batches as "certified safe." At a meeting at the Hotel Statler Hilton in Boston at the end of December, it resumed its offensive, voting unanimously to cooperate through the Cranberry Institute for the common good of the industry. More radically, it demanded indemnification from the government. By speaking directly to the press during the height of the marketing season, the cranberry industry insisted, Flemming had departed from "accepted policies" of the FDA. Without prior notice, without even a hearing, this government official had singlehandedly "destroyed the cranberry market, probably for some years to come," and since the government's intervention was unprecedented, and economic disaster had been wreaked on "thousands

of innocent people," the government had an unprecedented obligation to redress the wrong. Stepping up the pressure, Ocean Spray announced in early January that it would lay off one-third of its workforce as "a direct result of government interference."

On March 30, 1960, the Department of Agriculture responded, announcing it would indemnify growers for losses, though not for contaminated berries, and at the same time, the Department of Health, Education and Welfare initiated a program for growers to test and certify future crops. "These actions," it announced, "represent an effort to ensure the wholesomeness of all cranberries offered to the public, restore consumer confidence in the product and assist cranberry producers who suffered an impairment of their market." Clarence J. Hall, editor of *Cranberries* magazine, continued to demand that Flemming personally clear the crop. "It was government allegations which produced the so-called 'cranberry scare,'" he wrote, overlooking the actual contamination, "and it seems only justified that in view of the facts that such a clearance can now be issued."

Yet even with indemnification, victory for the industry was far from complete: most importantly, it had asked for $27 million but received only $10 million. Hall remained philosophical. "Assuredly," he wrote, "$8.02 a barrel is better than nothing. This is better than letting the fruit rot, without any return other than that already received." The indemnification proved essential as cranberry prices fell an average of 20 percent between 1958 and 1959 and another 6 percent in the two years following before finally rebounding to 1958 levels in 1962.

Uncertainty over the long-term impact of the cranberry scare continued to plague the industry, but as summer came, business as usual seemed possible. The pages of *Cranberries* consoled growers with hope that the corner had been turned, that things were back to where they had been, and according to the *Boston Globe*, cranberries were set for the best comeback "since Paris revived short skirts." But growers became understandably defensive about their use of chemicals. The tone in some commentaries provided an indication of the direction of future crisis management. "Only a few growers brought trouble to the whole industry through misuse of the weed killer amino triazole," according a June 1960 article reprinted from the *American Fruit Grower*, and

> *the situation is further upset by the organized attack of two groups—wild life clubs and food faddists. A growing public opposition to all spraying*

> *is being systematically fed by their vociferous leaders who are experts in the use of propaganda. They make capital of incidents like the cranberry scare. They successfully keep people stirred up despite a preponderance of evidence pointed to the importance of sprays to safeguard our food crops, save our timber resources, protect us from insect-spread epidemics, and make it possible to feed our growing population...There is only one way to defend against unwarranted attack and that is to present the facts to the public. This means a continuous public relations program through radio, TV, newspapers and magazines telling consumers of the results of scientific research and analysis. At the same time the public should be kept constantly informed of the safeguards being used to protect the foodstuffs they consume. Only through these tactics will the scare stories of sudden death to wildlife or poisoned food supplies be blunted and refuted.*

Although the issues that produced the 1959 scare have not recurred, this was not the last time that chemicals and cranberries collided. In 1997, the Massachusetts Department of Public Health discovered traces of a suspected carcinogen in more than a dozen bogs in the towns of Falmouth and Mashpee on Cape Cod. This time, the source of contamination was ethylene dibromide, an additive to aviation fuel. The fuel had been dumped at Otis Air Force base decades before and had slowly infiltrated into the groundwater, spreading outward in several plumes beneath the surrounding communities, where reports cropped up of high incidences of cancer and water tainted with explosives. This time, the cranberry industry was simply in the wrong place at the wrong time—victim—but its fruit became unsalable just the same. In December 1997, members of the Massachusetts congressional delegation inserted a provision in an appropriations bill that mandated the Department of Defense to set aside $800,000 to compensate growers for their losses, indemnification for an industry in need.

If the story of 1959 seems oddly familiar, it is no surprise. The dynamic of how the episode played out has been repeated often in years since, and both agribusiness and environmentalists have learned much about engaging and framing the debate, while the government has become increasingly gun shy about confronting violations. Complaints about "vociferous leaders who are experts in the use of propaganda" and about those who make "capital of incidents like the cranberry scare" are now part of the agribusiness arsenal when responding to any crisis.

At the core of the problem are two incompatible ideas about public utility, and assuming the sincerity of both sides (a perilous assumption, for sure), both sides view themselves as operating in the best interest of the public. On the one side, chemical producers advance a utilitarian argument that chemicals benefit humanity by suppressing pests and disease, decreasing the costs of agricultural production and ensuring higher crop yields for a world desperate for nutrition. Their arguments are often larded with "free market" ideology or, more recently, with anti-regulatory fervor, but at the core of their utilitarian calculus, the "indirect" harm done to wildlife or to some small percentage of humans, when acknowledged at all, is of secondary importance to the direct benefits that accrue to (some) humanity.

Environmentalists, on the other hand, stress a broad evaluation of risk and reward, highlighting the inherent complexity of interactions in the natural world that make total assessments of damage difficult to determine, particularly in the long term. But what can be determined in the short term, they say, can be appalling. In part, they differ in how they evaluate and measure the value to human life, factoring wildlife and ecosystems into the calculus of benefit, while often discounting private gain. Like their opponents, their argument is fundamentally utilitarian, and they often mirror chemical manufacturers in insufficiently considering their opponents' terms, sometimes failing to weigh the putative benefits of chemical use, and like their opponents, they prefer simple, clear statements over murkier realities. At some level, both sides speak the same language and may even use the same terms, but the different meanings they apply to those terms, their different metrics, become the stuff of conflict.

The 1989 panic over the use of the chemical alar on apples bears striking similarities to the cranberry scare, but it is the differences that reveal unsettling things about the direction the nation's civil discourse has taken, particularly when it comes to scientific debate. First introduced in 1968, alar (daminozide) was sprayed on apples to regulate ripening, but by 1973 it had been flagged as a potential carcinogen based on lab studies of mice fed extraordinarily high doses. This study triggered reviews by the Environmental Protection Agency in 1980, 1984 and 1987 (delayed after closed-door meetings with alar's manufacturer), but when the carcinogenic potential was confirmed yet again, the product was banned.

Unlike 1959, environmentalists played an organizing role in the debate. At the center was the National Resources Defense Council, which was

waging a campaign to bring attention to the problem of pesticides in the food supply. The council's report, "Intolerable Risk," was fed to the media and picked up by the CBS news magazine *Sixty Minutes*, which called alar "the most potent cancer-causing agent in the food supply today." Soon, school systems across the country were banning apples, supermarkets removed them from the shelves and farmers dumped crops. Despite the government's reassurance that apples were safe, prices collapsed.

Responding to the crisis, growers voluntarily stopped using alar (though at least some use continued surreptitiously), and Washington State growers reported losing $125 million in the six months after the scare (though much of this loss may be attributable to preexisting market conditions). But here was a difference from 1959. While the cranberry growers had certainly waged an aggressive campaign to defend their position, agribusiness interests led by Elizabeth Whelan and the American Council on Science and Health conducted an all-out guerrilla war to discredit and blame their detractors in environmental organizations and the media and to lay the foundation for a much broader assault on all governmental regulation of the food supply. Alar became a wedge for a much larger agenda.

Echoing the worst tendencies seen in the cranberry scare, the alar debate dissolved into a series of one-sided position papers, little more than flat assertions paired with attacks on their opponents' purported agendas. It became science by lawyers. In the law, each side argues a half-truth, alleging that the process will be additive. But too often, the process is multiplicative, and instead of rendering the whole truth, a quarter results. Stridency, blunt repetition, lack of nuance and implacability are the soul of this game, with the intent not of arriving at a fair understanding of risk or impact but of arguing a brief favorable to a client while destroying any countervailing interpretation. The success of Whelan's relentless and well-funded campaign has planted the notion in the public mind that the alar incident was a product of a sort of "Chicken Little environmentalism" and was nothing but anti-business hysterics fanning a sensation-mongering media flame. Their shrill allegations of "junk science" have been picked up repeatedly by industries that prefer to remain unquestioned. The result, and possibly the goal, is to annihilate scientific credibility, even one's own if necessary, so that the more demanding aspects of rational inquiry dissolve away. Scientific confusion can then trump scientific accuracy, and given the

scientific illiteracy of much of the American public, particularly when it comes to statistical issues like risk assessment, the strategy sadly works. When the cynicism of the law and politics infects the sciences, little hope remains.

But with the cranberry scare, and to some extent alar, certain key issues are hard to dismiss. Some growers were using toxic chemicals, some had violated standards for safe use, some portion of the crop was actually contaminated and the chemical was determined to be carcinogenic. Setting aside the theatrics and verbal pyrotechnics, there was a problem, and the debate should have been how much of a problem and whether one should err on the side of public safety and accountability when dealing with a potential health hazard or on the side of corporate stability and profit. In 1959, no less than today, the question remained unanswered. Too often today, the question remains unasked.

Epilogue

With cranberry culture fast approaching its third century, the industry can look back at its sometimes-turbulent past to see a reflection of its turbulent self. This marvel of tart taste has come a long way from home rakes and public bogs and has grudgingly adapted to a world that has changed around it. The geographic center of the cranberry world has slowly processed westward, and by 2011, Wisconsin was producing more than twice as much fruit as Massachusetts, with Massachusetts producing almost twice as much as the rest of the states put together. Production and sales have risen relatively steadily over the past half century, and the industry has become enormously creative in developing new products and opening new markets. Ocean Spray's introduction of juice blends, beginning with Cranapple in 1963, has been a smashing success, and Craisins (sweetened and dried fruits introduced in 1993) and white cranberry juice (2002) have pleased palates in numbers. Domestically and internationally, cranberry sales are growing as strongly as any time since the post–Civil War boom.

But the lion-like economy still lurks, and cranberries have experienced occasional plunges in price and competitive challenges. Most recently, when rising supply and decreasing demand sent prices below the cost of production in the late 1990s, Ocean Spray suffered. Competition from Northland Cranberries, Inc.—a partnership of growers who broke away from Ocean Spray in 1987—reached a head in 2003, when Northland offered to purchase its struggling mother. But the cranberry form of cooperation took hold. In 2004, Northland and Ocean Spray became

partners, with Ocean Spray agreeing to process berries from Northland's growers and Northland continuing to bottle, market and sell its own juice brands. Both thrive together.

And together seems to be the operative word. A fruit grown on the former wastes of our former industries, a fruit that relies on a geological history of millions of years, the cranberry has always had a remarkable penchant for connection—urban and rural, worker and owner, industry and agriculture, purity and pollution all come together within its ambit. In the end, the cranberry remains, stubbornly, a seasonal fruit, its past embedded in our experience of autumn, its memories tied to our memories of holidays, home and family and to an imagined past of communities gathering on meadows. The small red fruit on thin vines does more than slink a boggy way; it binds.

Bibliography

Averill, Anne L., and Martha M. Sylvia. *Cranberry Insects of the Northeast*. Wareham: University of Massachusetts Cranberry Experiment Station, 1998.

Briggs, Richard. *The English Art of Cookery, According to the Present Practice; Being a Complete Guide to All Housekeepers...with Bills of Fare for Every Month*. London, 1794.

Cole, Stephen, and Lindy Gifford. *The Cranberry: Hard World and Holiday Sauce*. Gardiner, ME: Tilbury House, 2009.

Eastwood, Benjamin. *A Complete Manual for the Cultivation of the Cranberry*. New York: C.M. Saxton, 1856.

Eck, Paul. *The American Cranberry*. New Brunswick, NJ: Rutgers University, 1990.

Farley, John. *The London Art of Cookery, and Housekeeper's Complete Assistant*. Dublin, 1783.

Frazer, Mrs. *The Practice of Cookery, Pastry, Confectionary, Pickling, and Confectionary, Preserving*. 3rd ed. Edinburgh, 1800.

Garside, E. *Cranberry Red*. Boston: Little Brown, 1938.

Labor Unionism in American Agriculture. U.S. Department of Labor Bulletin 836. Washington, D.C.: Government Printing Office, 1945.

Leslie, Eliza. *Directions for Cookery, in Its Various Branches*. Philadelphia: E.L. Varey and Hart, 1840.

Lightfoot, John. *Flora Scotica: or, a Systematic Arrangement, in the Linnæan Method, of the Native Plants of Scotland and the Hebrides*. London: B. White, 1777.

May, John Birchard. *The Cranberry Grower's Interest in Birds*. Boston: Massachusetts Department of Agriculture Division of Ornithology, 1931.

McMahon, Sarah F. "'All Things in Their Proper Season': Seasonal Rhythms of Diet in Nineteenth Century New England." *Agricultural History* 63, no. 2 (1989): 130–51.

Murphy, Priscilla Coit. *What a Book Can Do: The Publication and Reception of Silent Spring*. Amherst: University of Massachusetts Press, 2005.

Peckham, Ann. *The Complete English Cook; or, Prudent Housewife. Being an entire New Collection of the Most General, yet Least Expensive Receipts*. Leeds, UK, 1771.

Sempers, Frank W. *Injurious Insects and the Use of Insecticides*. Philadelphia: W. Atlee Burpee, 1894.

Simmons, Amelia. *American Cookery*. Hartford, CT: Hudson and Goodwin, 1796.

Thomas, Joseph D., ed. *Cranberry Harvest: A History of Cranberry Growing in Massachusetts*. New Bedford, MA: Spinner Publications, 1990.

Tudor, William. *Miscellanies*. Boston, 1820.

Webb, James. *Cape Cod Cranberries*. New York: Orange Judd, 1886.

White, Joseph J. *Cranberry Culture*. New York: Orange Judd, 1870.

Wisconsin State Cranberry Growers Association. *Wisconsin Cranberry Growers Centennial Heritage Book*. Dallas, TX: Taylor Publishing Co., 1990.

Zimmerman, Albright G. "James Logan, Proprietary Agent." *Philadelphia Magazine of History and Biography* 78, no. 2 (1954): 143–76.

About the Authors

A former paleontologist and molecular biologist, Rob Cox received his doctorate in history from the University of Michigan and currently works at the University of Massachusetts Amherst. He is author of *Body and Soul: A Sympathetic History of American Spiritualism* (Charlottesville, 2003) and editor of and contributor to *The Shortest and Most Convenient Route: Lewis and Clark in Context* (Philadelphia, 2004). He and Jacob Walker published previously with The History Press: *A History of Chowder: Four Hundred Years of a New England Meal* (Charleston, SC, 2011).

Jacob Walker spends most of his time along the coast of Massachusetts. He is the creator of the New England Chowder Compendium, a nationally recognized project at the University of Massachusetts Amherst devoted to examining all things chowder.

Visit us at
www.historypress.net